The Wrightsman Lectures
Rembrandt and the Italian Renaissance
by Kenneth Clark

Problems in Titian, Mostly Iconographic
by Erwin Panofsky

Byzantine Art and The West
by Otto Demus

Raphael
by John Pope-Hennessy

1 (FRONTISPIECE) Velázquez: *Las Meninas*

PAINTING AT COURT

MICHAEL LEVEY

The Wrightsman Lectures
Institute of Fine Arts, New York University
Delivered at The Metropolitan Museum of Art, New York

NEW YORK UNIVERSITY PRESS

This is the fifth volume
of The Wrightsman Lectures,
which are delivered annually
under the auspices of the
New York University Institute of Fine Arts

Library of Congress Catalog Card No. 75-124528
SBN 8147-4950-X
Published in England by
George Weidenfeld and Nicolson Ltd, London
Printed in Germany by
KG Lohse, Grafischer Grossbetrieb

CONTENTS

To the memory of another giver of the Wrightsman Lectures, **Erwin Panofsky**

PREFACE

This book is based on lectures given at the Metropolitan Museum, New York, in 1968, in the annual series founded by Mr and Mrs Charles B. Wrightsman. It is intentionally a record of those lectures, but I have taken the opportunity to supplement the text with some bibliographical references and notes. Nevertheless, I have not attempted to disguise the fact that lectures were given. Indeed, what characterizes this enlightened foundation is exactly the fostering of such an opportunity: to talk, not to construct articles which would better appear in the small print of learned journals.

Working over such a wide area, one incurs many debts. I have no space to list all those people who have encouraged me, saved me from gross error, or provided useful information. But I must gratefully name Cecil Gould, Gregory Martin and Oliver Millar for help on specific scholarly points. Miss Edith Standen kindly brought me up to date concerning the Angers Apocalypse tapestries. Mrs Margaret Mann Phillips was equally helpful in kindly bringing me up to date about the aspect of Erasmus with which I was dealing. Robert Cook read, typed, and even listened to, all the original lectures; with deep gratitude I recall his patience and help.

Like every lecturer, I remain grateful to my audience, especially as mine was notably generous in its reception of a stranger. More directly and personally, I am grateful for the reception I received from the staff and students at the Institute of Fine Arts of New York University – from, above all, Professor Craig Hugh Smyth who did so much to sustain me, from the moment I was honoured by being invited to lecture. Finally, I must acknowledge, however inadequately, my gratitude to Mr and Mrs Wrightsman: their kindness, encouragement and consideration helped the lectures and forwarded this book.

ML

And when you hear historians talk of thrones,
And those that sate upon them, let it be
As we now gaze upon the mammoth's bones,
And wonder what old world such things could see.

Byron: DON JUAN

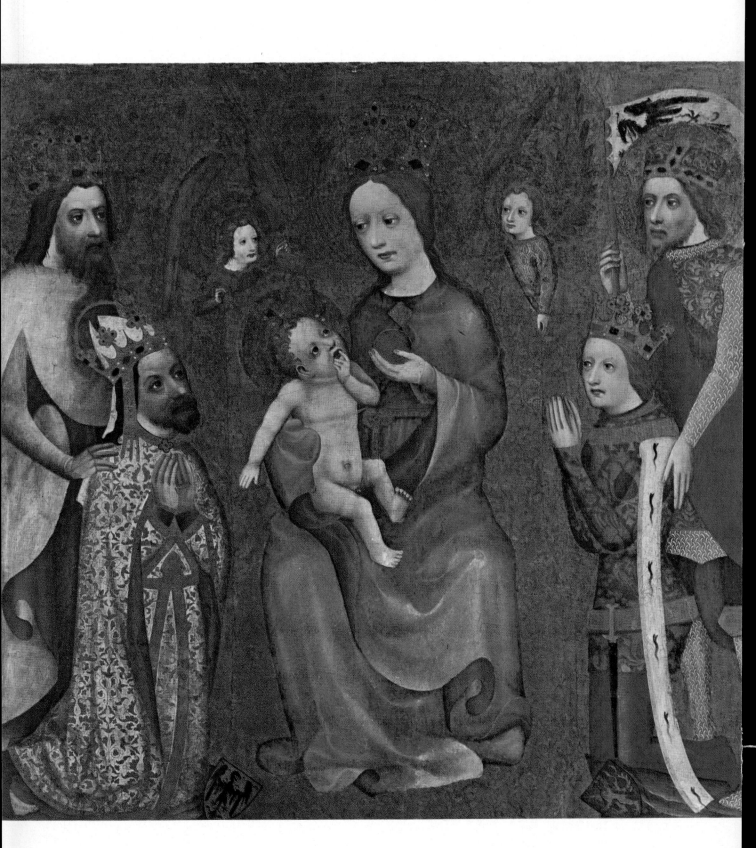

1 THE COURT OF HEAVEN

At all courts, at all periods where there has been art, there has been a tendency to enlist it. It has usually been part of the ruler's policy to require visual aids, expressing through images the fact of his power, his virtues, his pleasures and, of course, his actual appearance; and I think there is in all the art executed for courts some reflection of personality. A record aspect is present even in the sort of work not obviously connected with portraiture or commemorative objects: the record of a personal taste – even in the lightest of decorative commissions. After all, one can learn quite a lot about a person from his tastes.

Monarchs have usually been placed in positions where they can indulge theirs. Alexander singled out Lysippus to be his favourite sculptor, because he liked the character given him in Lysippus' busts. As for his friendly treatment of Apelles, this created an ideal of the patron-painter relationship which haunted the Renaissance and was still being cited by Napoleon. The seventeenth-century Mughal emperor and great artistic patron, Jahangir, having seen turkeys for the first time, ordered them to be drawn by his painters, noting his reason 'as these birds appeared to me very strange ...'[1] Most of the work illustrated here bears – in one way or another – the impress of a personality that is not the artist's, but is used to commanding in other spheres. The art may represent ideals far removed from the artist's own. But for these very reasons there is, to my mind, something fascinating in the results: shaped at times by a peculiar, possibly narrow ethos, art may actually enjoy the constriction. In this game there are no straightforward moral rules. A blameless court – or a virtuous republic – may well prove artistically less stimulating than a tyranny.

Granted the record tendencies, we can easily admit that the artistic results are likely to be very variable as well as varied. Much emphasis is often laid nowadays in art history on patrons – and perhaps here and there I shall be laying some of my own – but we must never forget the artists. The greatest ruler, however intelligent, however eager to be a great patron, cannot command *art*; he may or may not be lucky. But although we shall encounter some isolated oddities – and indeed shall examine one very sad case quite closely – I have generally selected places and periods where art – as far as we are concerned, with painting, that is – and court combine in interest and aesthetic value.

In doing that, I have detected not so much a unity but certainly a

11 *Charles* IV *and his son before the Virgin*: Očko of Vlašim Diptych

13

development in the examples chosen, within the limits I have set myself – if one can call the field of European painting between the fourteenth and nineteenth centuries limits. Actually, this restriction of medium is a real one, and – oddly enough – a useful one. And sometimes the similarities have also struck me. An impressive row of Christian rulers have sought reassurance by being depicted received into heaven – a medieval concept but one that was assigned in 1816, perhaps for the last time, when Girodet was commissioned to execute a *St Louis receiving Louis XVI and his family into heaven*.[2]

A very good description of the first court I want to mention – the Court of Heaven – is given in the *Book of Revelation* by St John the Divine. The author, who might almost for our purposes be called the artist, paints a picture of heaven full of intrinsically precious, uniquely beautiful works of art: a sea of glass like crystal, a wall of jasper, gateways of pearl and a rainbow round a throne, 'like unto an emerald'. This is of course the abode of the King of Kings, where he sits surrounded by four and twenty elders wearing 'crowns of gold'. And though they are humbled before God – casting their crowns before his throne – they have yet been singled out by him, made

1 *Elders before the throne of God*; Angers Apocalypse Tapestry

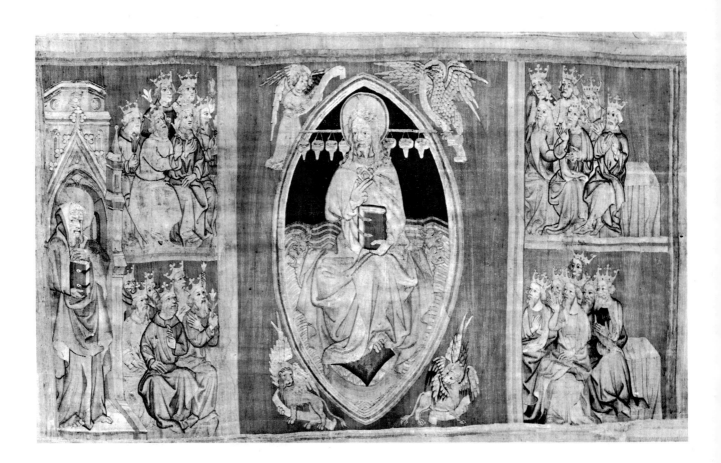

kings and priests who proclaim: 'and we shall reign on the earth'.

This essentially aristocratic and rich, literally jewelled, prose haunted the imagination of all sorts of people – poets, architects, painters, mystics, as well as kings and priests – at several periods of European history. It inspired the vast series of Apocalypse tapestries ordered in 1377 by Louis d'Anjou [plate 1], for long believed to be intended for that royal patron's own castle.[3] Some later artists like Dürer and Blake, for example, have managed to assimilate the imagery and re-express it in ways that transcend mere illustration. But between Dürer's concept of a religious text and Blake's deeply personal vision of the 'new Jerusalem', there is of course a very great difference. With Dürer something of medieval authority and literalness is still present. And when we go back to actual medieval times it is to encounter not only a steady current of concern with catastrophic apocalyptic events – the aspect most commonly emphasized – but also some concern with the coming of one great ruler, the Emperor of the Last Days, a figment of the Sibylline oracles, those apocalyptic writings which had accrued round the whole fascinating theme of the revelation of the future.[4]

It is scarcely surprising that dynasties in the West utilized the possibilities of imposing in this way: catching at the tail-end of the tradition of the Roman emperors, but supported also by the Christian tradition of being the Lord's Anointed and God's vice-regent. David and Solomon are human prototypes, but the crowned Godhead, either enthroned or handing down decrees, is the most glittering, divinely majestic prototype of king and court. How far reflection of the Godhead in the monarchy could be carried is shown by an entertaining example, admittedly from Byzantium, in the seventh century AD. In 669 the soldiers there elected two further emperors, in addition to the reigning one, with the explanation, 'we believe in the Trinity; we crown three Emperors'.[5] In various guises the idea of the ruler who is a mirror-image of God became accepted fact. We shall be encountering one particular Holy Roman Emperor – but the very title is reminder enough of the supposed sacredness of the office, derived of course from the divine title of the pagan emperors. Thus the birthplace of that 'Wonder of the [medieval] world', the Emperor Frederick II, could be compared to Bethlehem, while the sun and moon were said to bow down before his face. Long before Louis XIV, we find another medieval German emperor hailed as 'the sun-god'.

At the same time, there remained that ambiguity recorded in *Revelation*, and depicted in the Angers tapestry, that though kings may reign on earth, they are humbled before God. It is this duality which lies behind so much of the art with which we shall be concerned in this chapter. Perhaps duality is the wrong word, for it is

super misericordiam ↄ ↄonturbat ↄ e nalde ↄ
laxate sunt oͤs aͤie q eunt i iscuͤuͤ ↄ
clamalaͤt noce magna dicetes buͤ
dicimus te xͤpe fili dei miun q dignaͤ

es nob ufengenuꝯ take lh diei ↄ hͦ noc
tis quam totum temp q uiuimus
lͤe eiͤa. ui ergo qui tuuͤo duit diͤe ↄͤa
qn xͤpi heͤbuͤr. ꝑteͤ tui scis i sͤeͤla seͤloͤr.

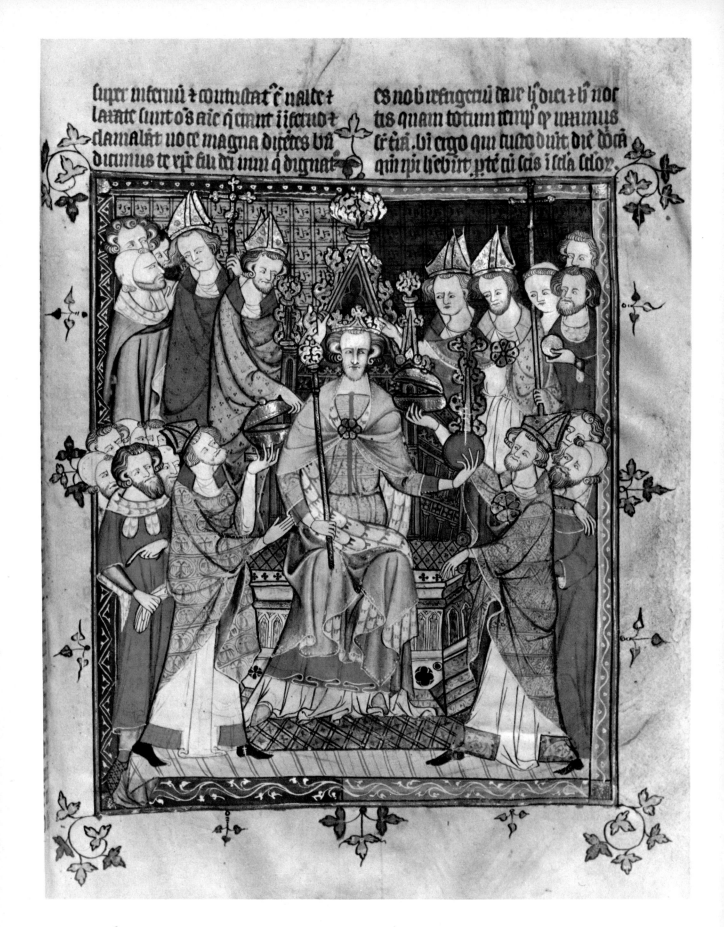

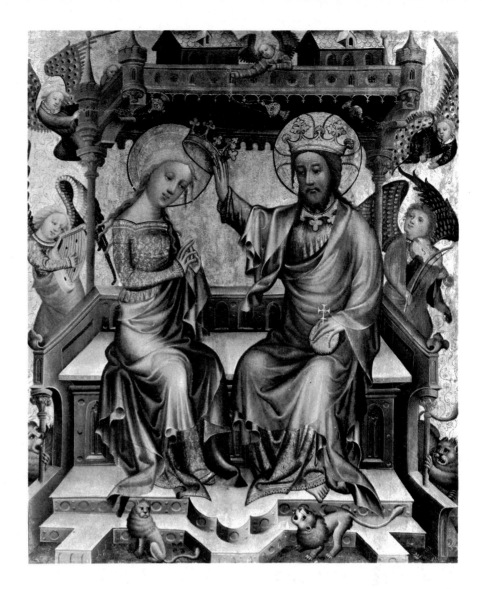

2 (*Opposite*) Miniature from fourteenth-century English coronation *Ordo*

3 (*Right*) Master Bertram: *Coronation of the Virgin*

really a single vision which places the king at the apex of earthly society, and thus has him already more than halfway to heaven. In his very humility before the vision of the Saviour, his subjects may see expressed one aspect of his fitness to rule them: he is God-fearing. We are dealing with a world not of paradox but of presumed literal fact, one whose reasoning may be strange and alien, but which does reason, and is indeed almost desperate to impose order. We must remember, however, that this means the order brought by God, whose ministers crown the king [plate 2] and who is himself the crowner of his mother in what is often a very courtly heaven [plate 3]. His kingdom is fixed in eternity, himself the supreme monarch. I think it is no accident that it was increasingly painting which proved so popular a medium for such concepts. It seems fitted for complex messages by its flexibility, its combination of colour with monumental scale (thus proving as vivid as illumination, and as large-scale and publicly effective as sculpture).

Very early in the fourteenth century, Simone Martini produced
for King Robert of Naples the quintessential coronation picture
which overpoweringly states heaven's royal concern with earthly
dynastic events [plate 4].[6] Not every monarch was as fortunate as
King Robert in having a saint for a brother – canonized twenty years
after his death, in 1317, when this picture was painted. St Louis of
Toulouse had renounced the throne of Naples in favour of his
brother, and he here hands out of heaven that crown while angels
crown him above his mitre and, as it were, through his halo. Gilt
and heraldry do not merely give pictorial splendour but emphasize
the composition's courtly, dynastic air, with the youthful saint en-
throned like God the Father, and adored by the comparatively
smaller figure of his kneeling brother. King Robert not only com-
posed the office for St Louis's feastday, but had spent a good deal of
money on research in establishing the requisite miracles wrought by
him before canonization. If he had previously striven to get his

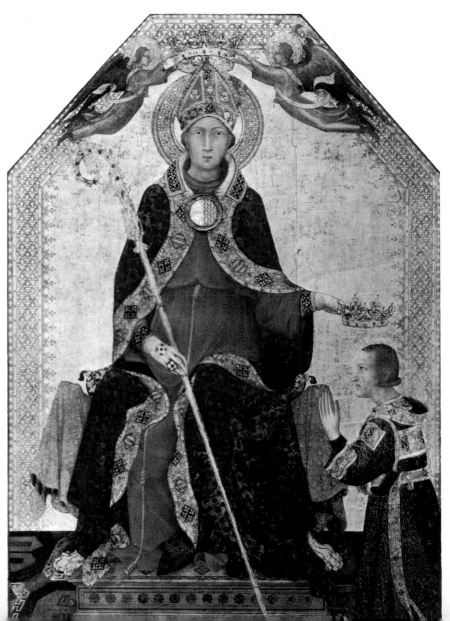

4 Simone Martini: *St Louis
of Toulouse*

brother recognized as a saint, in this picture he arranges for that brother to recognize his right to a crown on earth.

How much less effective it would have been to commission a simple coronation scene, or even to make the renouncement of the crown an incident from the predella pictures of St Louis's life which run under this composition. Something with more authority was needed. The fact is that King Robert's claim to the throne was not uncontested. But here it is – not argued, not attested, but ratified by heaven. It is spiritual adoption, of a kind not depicted previously – as far as I know – in Western art but which has prototypes in tenth-century Byzantine art. This [plate 5] well illustrates the idea of the Emperor, Constantine VII Porphyrogenitus, crowned, as the inscription says, 'through God'.[7] And there is of course political significance, and timely reminder-cum-warning, in such depiction:

> 'Not all the water in the rough rude sea
> Can wash the balm from an anointed king.'

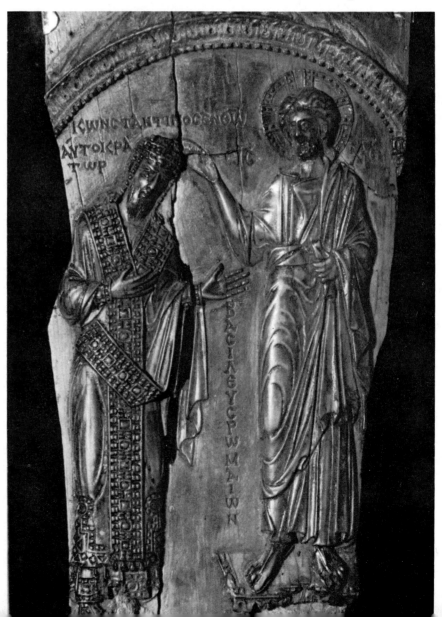

5 *Coronation of Constantine* VII
Porphyrogenitus

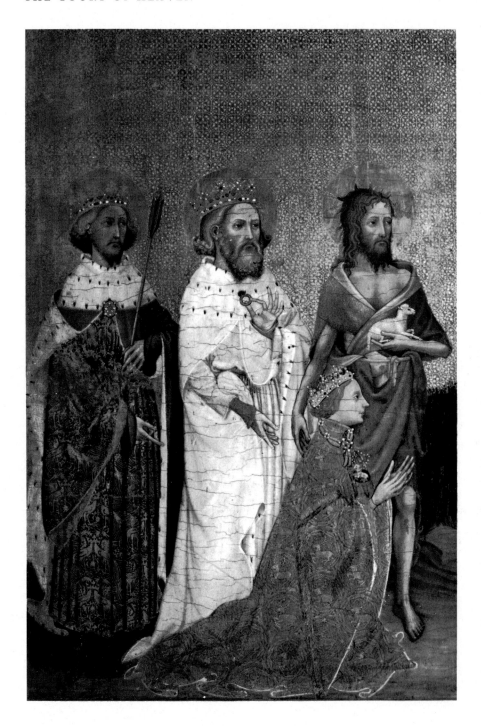

It was inevitable that sooner or later I should need to quote from Shakespeare's *Richard II*. The most poetic of all expressions of the divine right of kings, it is powered by an unquestioning, lyrical confidence that God will summon 'armies of angels' to fight on a monarch's behalf. Angels are certainly enlisted in the king's service in the *Wilton Diptych* [plates 6 and 7], probably the most famous of all juxtapositions – one of the most truly, literally, balanced – of

6 & 7 *The Wilton Diptych*

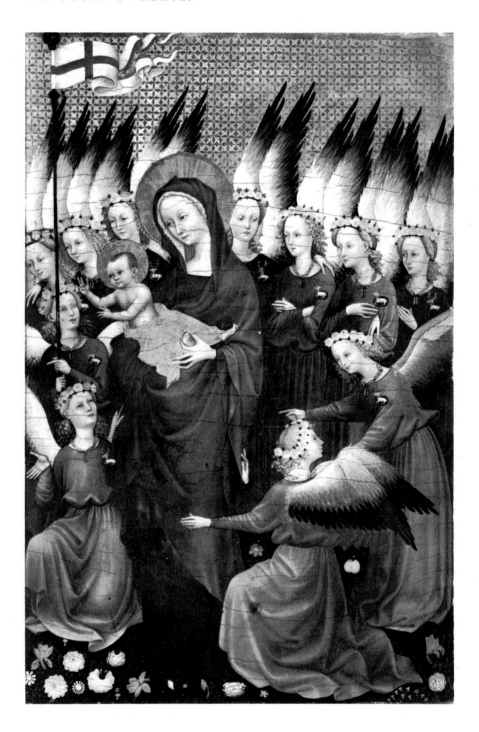

earthly and celestial royalty. Scholarly debate continues over whether we see here the young Richard II, newly-crowned perhaps, enjoying a private vision of heaven in his lifetime; or whether this is one more of those scenes of a ruler personally received into heaven after his death. The latter tradition was already established in art before the fourteenth century; an English manuscript drawing of the previous century shows a royal saint, Edward the Confessor, being

8 (*Right*) *St Edward the Confessor received into Heaven*

9 (*Opposite*) *The Duc de Berry received into Heaven by St Peter*

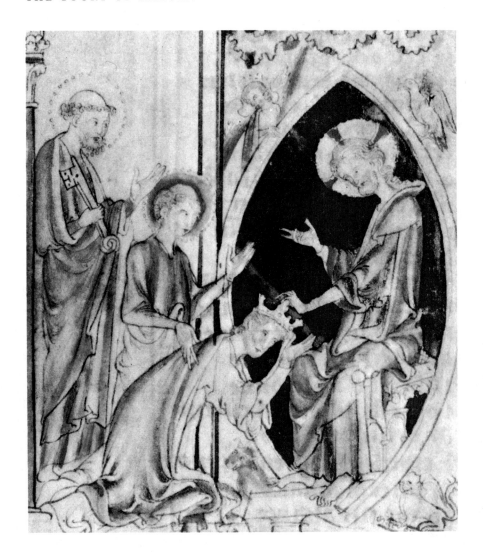

admitted into heaven [plate 8], while the accompanying text speaks of how the king's 'good friend', St Peter, opened heaven's gates to him.[8] This smooth, privileged, essentially aristocratic way of making one's progress from earth to heaven is shown most vividly of all in a beautiful miniature of a great patron, the Duc de Berry, personally taken by the hand [plate 9],[9] and we shall later on find Erasmus making cruel play with the same tradition in the satiric *Julius Exclusus*, where Pope Julius II, counting on gaining admittance to heaven in the usual way, is firmly rejected by St Peter – no 'good friend' to that Pope.

The *Wilton Diptych* is stamped all over with the individual associations and heraldic devices of Richard II himself: when closed its exterior resembles a book, and it remains a highly personal object, with its delicately-painted royal white hart, more living creature than heraldic emblem. This is the badge worn by the angels, who thus become virtually the king's courtiers; and heaven becomes an

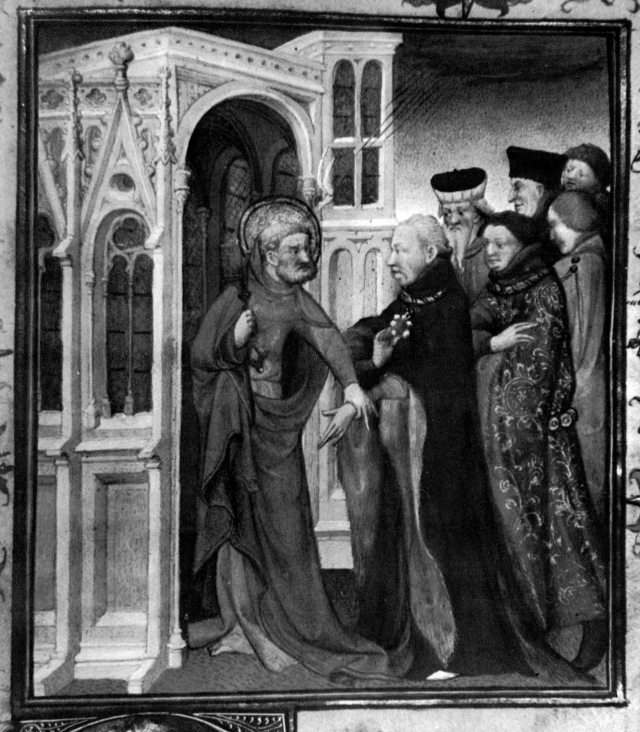

Gtis in adutto
rium meum in
tende.

10 *Gian Galeazzo Visconti
received into Heaven*

extension of his realm, in very much the same way as it became an extension of Gian Galeazzo Visconti's, about the same date [plate 10]. Here the court of heaven has been taken over on the occasion of the Milanese ruler's entry into it: holding his banners, angels stand in attendance while, in full regalia, he is received with particular cordiality.[10]

Yet none of these rulers, in different ways so splendidly singled out for heaven's protection, could lay claim to any very great importance on earth. What is more, the *Wilton Diptych* and Simone Martini's *St Louis* are each apparently isolated instances at the court in question.[11] And, having seen the tendency of such rulers to place themselves, not so much in the context of their earthly existence but rather in the gilded perspective of the eternal court, I think it is worth concentrating on the court of a politically and symbolically much greater ruler than Robert of Naples, Gian Galeazzo Visconti, or Richard II of England: the Holy Roman Emperor Charles IV. It happens – or perhaps there is more than that to it – that under Charles IV a very sustained artistic atmosphere was created in his capital of Prague.[12] Here we have a great figure of the fourteenth-century European stage – fascinating in himself but also someone whose very title combines pagan and Christian, spiritual and temporal monarchy – actively concerned with fostering an artistic climate courtly and religious in almost equal parts. The result was certainly sufficiently civilized to win complimentary references from Petrarch. Perhaps there is in these an element of surprise. He had visited Prague on a diplomatic mission, and on being commiserated with modestly by an outstanding Bohemian cleric, scholar and patron, replied that he had never seen anything less barbarous or more humane than the emperor and the circle round him: they seemed Athenians born and bred.[13]

In many ways, this circle – for all its Italian humanist contacts – was concerned, however, less with Athens than with the new Jerusalem. The Emperor himself was a visionary – not in any political sense, for there he was shrewd and practical – but privately in his almost mystic concern with visions and even strange poltergeist happenings, noted down in some detail in a fragment of auto-biography which luckily survives.[14] His mysticism is part of a marked strain in Bohemian religion; and his fondness for painted images also remains typical, even with the Hussites. Apocalyptic interests of the period – already apparent in Louis d'Anjou's tapestry series – are reflected in Charles IV's nearly contemporaneous chapel in his castle at Karlštejn, completely painted and decorated with scenes from *Revelation*, massed saints, glittering gold and precious stones, culminating in the hypnotic, apocalyptic Godhead [plate 11],

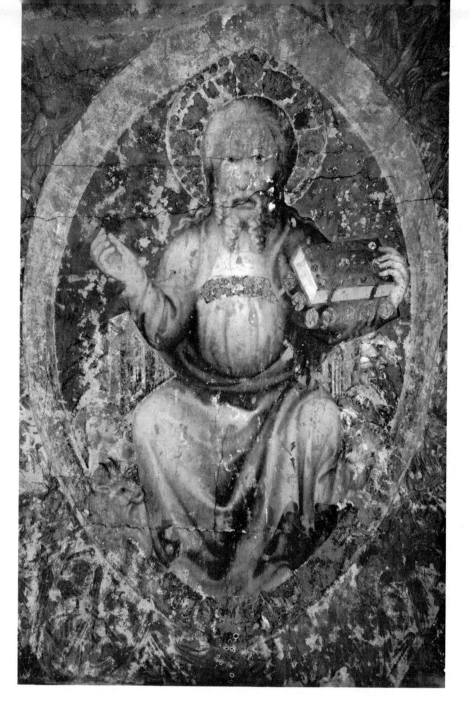

still somnambulistically impressive despite being damaged. This vision is suitable at the heart of the chapel of an Emperor who dramatically describes mysterious footsteps and overturned glasses on a winter night in his bedroom. He records how once in Italy he had a vision of the Virgin – something he was to experience rather similarly in painting. He tells how in youth he and his tutor, a French bishop, Pierre de Rosiers, each prophesied the other's future: the bishop saying, 'you will one day be king of the Romans' and the obscure Bohemian prince replying, 'you will one day be Pope.' It is a nicely underplayed moment of autobiography when the Emperor adds that both these events came true.

25

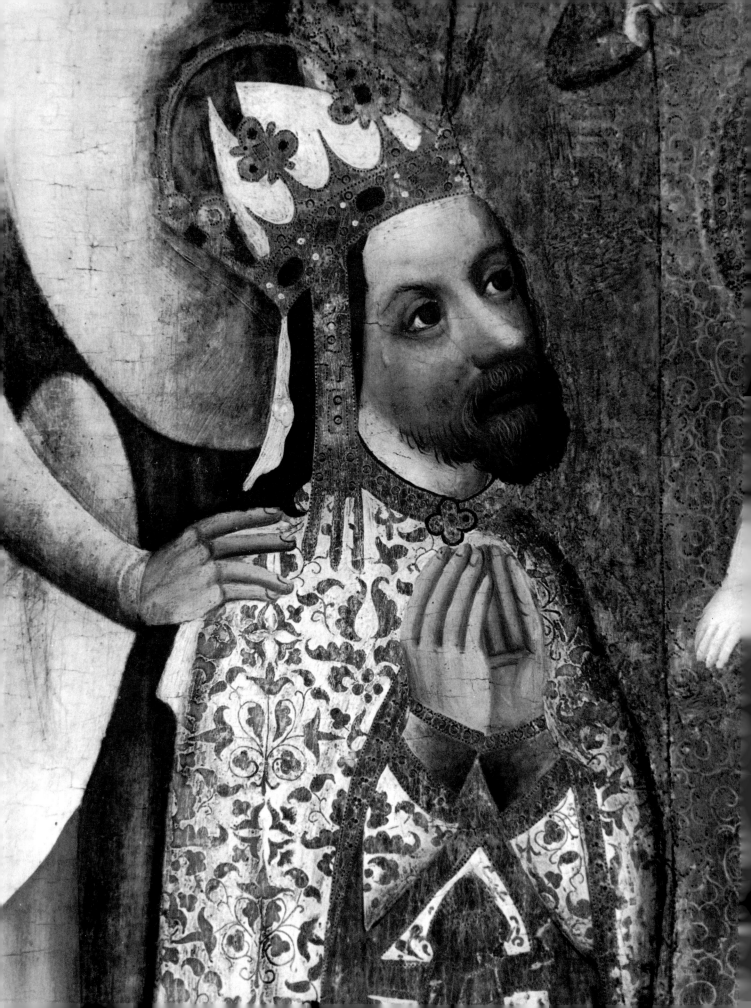

12 *The Emperor Charles* IV: Očko of
Vlasim Diptych (detail)

The result of the Emperor's interests was the growth of a particular
kind of court art where emphasis is laid on the relationship of ruler
and kingdom to the religious structure of God-created cosmos. It
had indeed already been stated, with public dynastic emphasis, by
Simone Martini, whose *St Louis* was painted when Charles IV was
only one year old. There is an extreme refinement of it, though on a
small scale, in what is basically a private work of art, in the *Wilton
Diptych* [plates 6–7] painted, at whichever of the dates proposed we
care to accept, almost certainly after Charles IV's death. Neither of
them would have been quite out of place at the Emperor's court;
both might well have been, in other circumstances, personal com-
missions from him. What he did commission often fits neatly
enough into the same ethos.

Before turning to those commissions, something more must be
said about the career and court of the commissioner whose ideals –
and whose features – will be found in the works of art which he had
executed [plate 12]. Some contemporaries found him an insignificant
person to look at, but here – imperially robed – he seems individual-
ized and yet impressive enough. This portrait speaks of achievement.
It is certainly hard to recognize the uncertainly-placed, foreign-
seeming young prince who had inherited a kingdom – that of
Bohemia – which he himself was to describe in his autobiography
as 'a wilderness'. His first task was to establish a national conscious-
ness, a task which he perhaps performed the better for having to
carry it out also on his own character. The son of a Bohemian
princess and the romantic Luxembourg ruler, King John, the blind
king of Bohemia,[15] he was brought up in Paris at the French royal
court. When he returned to Prague in 1333, to a city he had not seen
since he was seven years old, he could not remember his native
language. Even his name had been changed from the native Wenzel,
or Wenceslas, to Charles; he did not change it back, but his own
elder son was to be christened Wenceslas and to become king under
that name. Along with his father, Wenceslas appears in this composi-
tion of divine favour shown to the Emperor and his son, anticipating
the *Wilton Diptych*. There they kneel in adoration at the feet of the
Virgin and Child, accompanied by the national saints SS. Sigismund
and Wenceslas [plate II].[16] Throughout there is a noticeable
emphasis on royalty: royal saints, connected with the dynasty of
the Emperor, are chosen to introduce the living royal father and
son into the presence of the enthroned, crowned Virgin, Queen of
Heaven, with her Child. And it is no subordinate place that Charles
and Wenceslas take – either in scale or position within the picture
area. These are patently portrait figures, accompanied by their
shields, heraldically splendid – the Emperor costumed in the imperial
robes – but also physiognomically vivid.

The achievement represented is political and artistic: artistically its affinities are with Simone Martini and Avignon; politically too Avignon, as the seat of the Papacy, is concerned, but also proclaimed are Charles's achievements – as emperor and father – after his own father's neglect of the kingdom and past hostility to his son.

The fact that Charles returned – not yet emperor, not even king, but simply as Margrave – to the Prague that was 'a wilderness' gave him the opportunity to create unhindered. He inherited nothing; what he was able to bequeath was a complete, sophisticated and artistic environment.

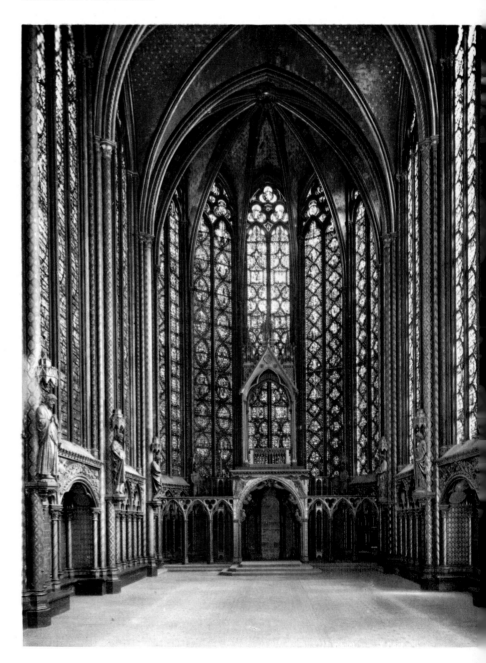

13 Interior of the
Saint-Chapelle, Paris

In the very idea of creating a capital city which would have artistic and intellectual importance, he was inspired most obviously by Paris and the court he had known there. In buildings like Notre-Dame and the Sainte-Chapelle were enshrined medieval extremes – the Sainte-Chapelle no fantasy glass chapel of the kind to be read of in romances but accomplished fact: an almost weightless actual building, built to contain – like a vast reliquary – the precious relics of the Crown of Thorns and the fragment of the True Cross which Louis IX had acquired. And in that royal building [plate 13] there met the double concept of medieval theocratic authority, summed up by Pope Innocent who said that Christ had crowned King Louis with his crown.[17] It became a national shrine. The relics themselves bolstered the king's position as 'most Christian king' and as – once again – *imago Dei*. One should pause over the words because they represent so completely the concept to be taken over by Charles IV, himself an avid collector of relics, who was to build his own peculiar version of the Sainte-Chapelle in his castle at Karlštejn. From Paris he would receive two thorns from the Crown, brought to him personally by the Dauphin, the future Charles V of France. From Aachen he received scarcely less sacred relics, part-political, part-religious: three of Charlemagne's teeth.

The young Charles IV had to build both a cathedral and a city palace, as well as the castle at Karlštejn. He began by summoning from France Matthew of Arras and the cathedral of St Vitus at Prague was begun. But it was on the hill at Karlštejn that Charles achieved the most distinctly personal of his religious monuments, in the castle there. No less than three chapels were constructed, to form an ascent in literal terms to the 'new Jerusalem' located in the uppermost of the three, in that private shrine which was the Emperor's personal chapel. From the first, the whole castle at Karlštejn was imbued with religious significance. The foundation stone was laid on 10 June 1348 by the first Archbishop of Prague, Ernest of Pardubitz, Petrarch's correspondent and himself an artistic patron. Charles originally intended the castle to hold the imperial treasure of coronation regalia, themselves of both political and religious significance. To them was added, however, in April 1356 the French king's gift of the two thorns from the Crown of Thorns. Thus Charles had come to the position of Louis IX from the point of view of relics. And in his case it was no piece of rhetoric to claim that Christ had crowned him, for he had indeed been crowned as Holy Roman Emperor only the year before, 1355, by the Papal legate.

So important was the transfer of the relics from France that the actual scene of their handing over to the Emperor was recorded at Karlštejn [plate 14]. It is formal, typically royal scene, flanked by the private moment, also depicted, of the Emperor's placing of them

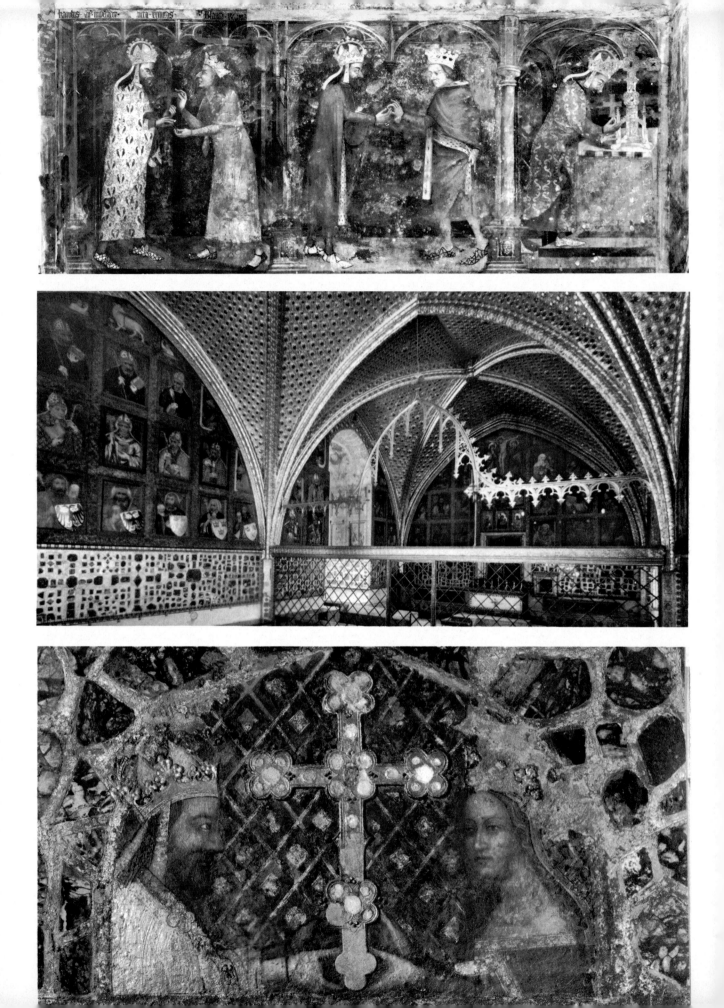

near his particular treasure, the reliquary cross, over which he bends with holy glee – the actual object being hidden in the wall behind where the frescoes were painted. But this cross was later to be given a much more important place, made the focal point of that personal paradise which is the final chapel to be reached at Karlštejn, the Chapel of the Holy Cross [plate 15]. Here the Emperor joined the apocalyptic witnesses, often approaching the shrine barefooted, himself in ecstasy before the vision which he had arranged to focus about the reliquary cross. While it was actually contained in this chapel, it was depicted again elsewhere; in a third smaller chapel at Karlštejn, that dedicated to St Catherine, the Emperor and his wife are seen holding it between them – as if loth to let it from their sight – in a fresco above the doorway [plate 16]. There it has become almost like a symbol of unity. Whether or not this was executed before the Empress's death in 1362, Charles is likely to have been eager to emphasize both her importance and his unity with her.

It is no coincidence that elsewhere in Karlštejn there seems to be stressed a symbolic identification of the apocalyptic 'woman clothed with the sun' with the Empress, Anna von Schweidnitz. Like the woman of St John's vision, Anna gave birth to a son: an important event for the dynasty, since the Emperor had no surviving male heir until this birth in February 1361. The importance of the event scarcely needs stressing, but it is stressed in effect by the Emperor's own autobiography (written after the birth of a second son) addressed throughout as a personal document to those 'who shall after me sit on my two thrones' – the opening words of the autobiography. And the dynasty, whose posterity had been assured in real life is traced backwards in art along the walls of the Great Hall in the palace portion of Karlštejn.[18] Charles's ancestors are not merely the straightforward factual ones of the Luxembourg dynasty but rather surprisingly include Shem, son of Noah.

It is indeed part of the claim made tacitly by such figures that Charles IV is descended from the great kings and heroes of antiquity, from the Roman emperors, and that he is – if not quite a saint – himself holy, as well as being imperial and Roman. Unlike Simone Martini's use for Robert of Anjou, the painter of this dynastic cycle at Karlštejn did not need to bolster a shaky claim to the throne. It was indeed only after his coronation as Emperor in 1355 that Charles had the cycle executed. Its purpose was to display his lineage – a display badly needed compared with the world's familiarity with the Capetian dynasty in France or the Plantagenets. It runs from persons like the lanky, plainly-dressed Shem, through shadowy but historic couples to culminate in the living Emperor, become already a personage of history. This is the most imperial and icon-like of all images of the Emperor, the sole figure in the genealogy to

be distinguished by three crowns [plate 17]. His figure alone serves as example of that persistent medieval tendency to see the whole fabric of history and mythology woven into a single seamless garment – a positive tent, rather, which arched over human life. Oriental philosophers, Biblical patriarchs, the planets, and the Merovingian emperors, were all part of Charles IV's pantheon: they consolidated and led up to the eminence of the present, as it looked from his throne.

Despite the self-glorifying aspects of this cycle, the emphasis at Karlštejn is on the goal of heaven not earth. And it is ultimately the next world which sets the standard. Once again, it is the Emperor's autobiography which gives the tone of this possibly remote but fascinating climate; he begins his story by reminding his readers that there are two lives for everyone: the earthly life, sustained by earthly bread, and the spiritual life sustained by the food ordained by Christ as his body. It is the paradox of human existence, sharpened by the exalted position of the writer, so vividly illustrated here. The second chapter of his autobiography is a direct lesson of *vanitas, vanitatum* directed to his heirs. 'Remember,' he says, 'when you wear the royal diadem after me, that I too once wore it, and I have become dust and mud with the worms.' Thus, it is with a sort of humility that his heirs should carry that proud Bohemian crown, satisfyingly solid and jewelled, which he had had made.

Already at the time called – not altogether fairly – 'the priests' Emperor', Charles naturally selected for his court chiefly leading churchmen of the country. Their taste too was enlightened, encouraged doubtless by the Emperor's example. Like him, they had usually travelled, sometimes been educated, in Italy. Such churchmen as the Archbishop of Prague, Ernest of Pardubitz, and the imperial chancellor, the bishop Jan of Středa, represent patronage that remained religiously-motivated, refined and yet with national or personal emphases. Jan of Středa, another correspondent of Petrarch's and the first humanist scholar in Charles's Bohemia, commissioned some illustrated manuscripts which are in sheer artistic quality perhaps the finest of all work produced in the court circle. His *Liber viaticus* – or travelling breviary – [plate 18] is the most Italianate in style.[19] The initial B, for the text of the first psalm beginning 'Beatus vir', contains the majestically-enthroned Saviour in a heaven which is quite three-dimensionally realized, in a style both delicate and strong. The psalm is particularly appropriate to the commissioner, reminding the imperial chancellor that the blessed man is he who delights in the law of the Lord. Earth's judges will be judged in heaven. Even richer and more linear is the almost Celtically elaborate *Annunciation* [plate 19], from another of Jan of Středa's manuscripts, his missal. And now, instead of King David

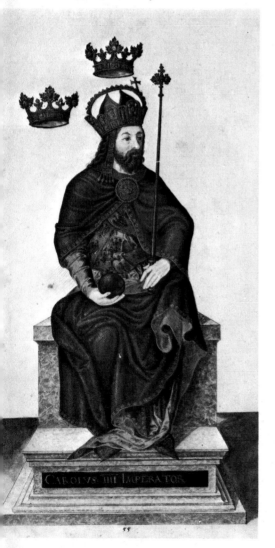

17 (*Below*) *The Emperor Charles* IV *seated* (watercolour copy)

18 (*Opposite*) Initial letter from the *Liber Viaticus* of Jan of Středa

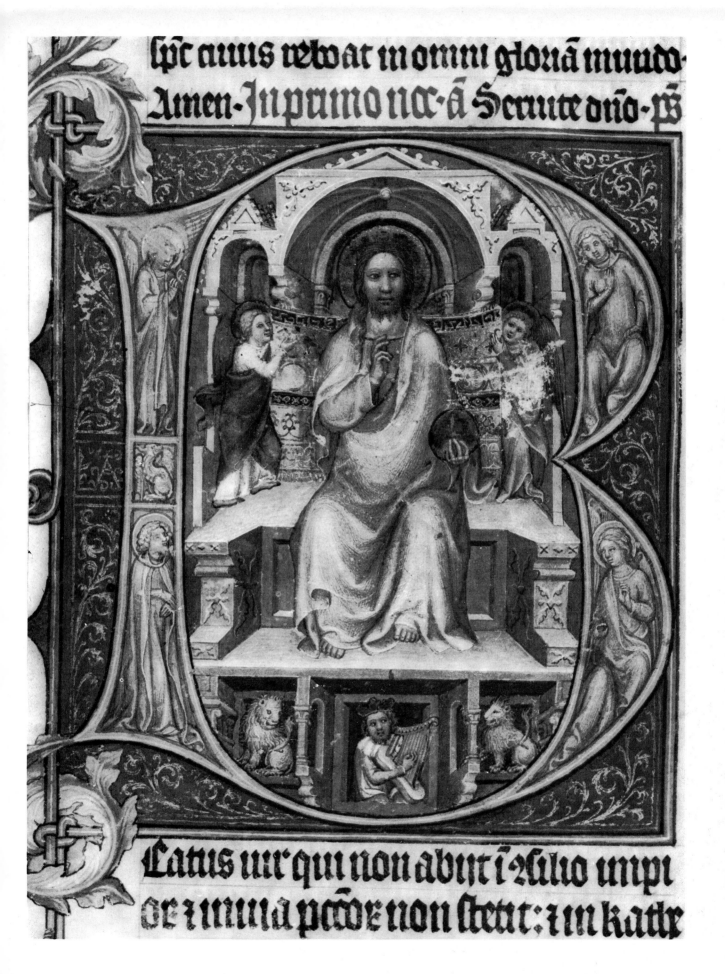

19 *Annunciation* miniature from the Jan of Středa missal

harping below the throne, a niche is found to accommodate the bishop-commissioner himself – a careful miniature portrait – with his coat-of-arms hung up on the Virgin's throne. He personally enjoys a vision of the Annunciation in his own missal. And it is as a solemn courtly scene that this is treated: the Virgin is already raised up, crowned and seated in state, even before the Angel distinguishes her as the future mother of the Saviour.

Artistically, the intensely linear vision which is so patent here can be compared with the intermingled style of another *Annunciation* [plate 20], one panel from a series of pictures once at Višší Brod in Southern Bohemia. No longer are we dealing with the illumination of a private patron's own book, but with paintings to be seen by the

20 *Annunciation* from the
Vìšší Brod series

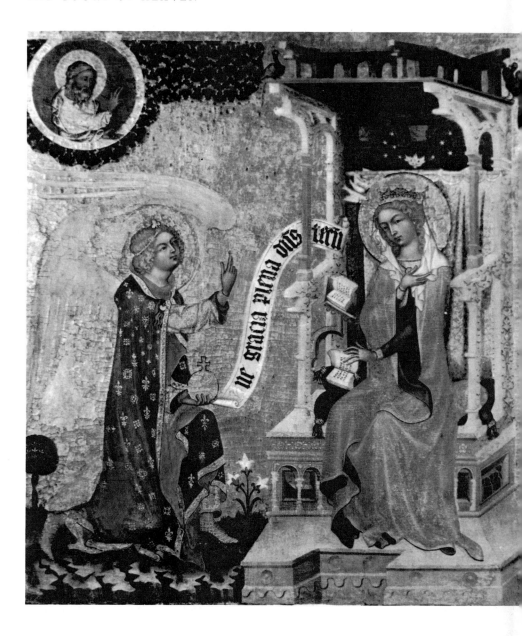

public in church, remaining richly coloured but moving some way
towards a more recognizable symbolic reality – an earth fissured like
pieces of jig-saw puzzle, on which the angel kneels. To some extent,
the miniature is completely within one convention – the angel
sweeps in and kneels in a rush of importance, bearing a heavenly
sealed letter – and one hardly bothers to notice the absence of loca-
tion. The mood of the Vìšší Brod *Annunciation* is calmer, more
luxurious in its symbolic peacocks, its courtly angel with an orb, and
its extraordinary jewelled richness – a sensuous blaze of colour which
probably mattered much more to its commissioner than any so-
called realism. As Jan of Stˇreda had been present in his own book,
so the unknown commissioner is introduced prominently in another

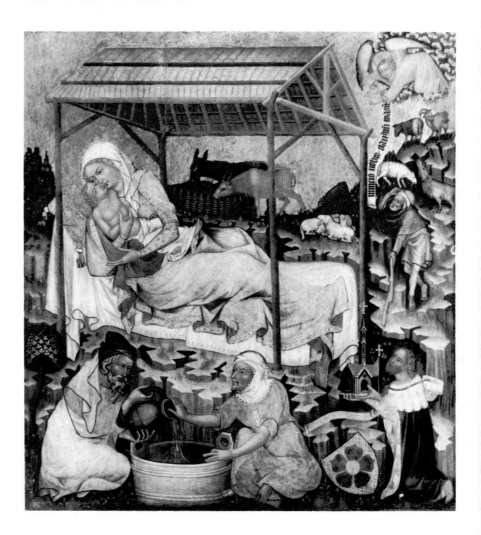

panel, that of the *Nativity* [plate 21].

We can make quite a good guess at the identity of this donor, who would anyway be likely – from his coat of arms – to be of the Rozemberg family, and probably from the Emperor's own circle. Iesco de Rozemberg is mentioned as one of the obviously important personages witnessing, along with the chancellor Jan of Středa and the archbishop Ernest of Pardubitz, Charles IV's document ennobling an Italian family, that of the Guarzoni, in 1355.[20] It is clear, I think, that this donor is not an ecclesiastic but a lay person, probably a doctor of law or the rector of a university. If indeed it is Rozemberg, then we know he was in Italy with the Emperor in 1355; perhaps he even saw Giotto's fresco of the *Nativity* at Padua where one encounters the motif of the Virgin taking into her arms the newly-born Child. Indeed, a glance at that composition shows that the Rozemberg master derived his inspiration from it; and what he did not borrow, whether directly or otherwise, from

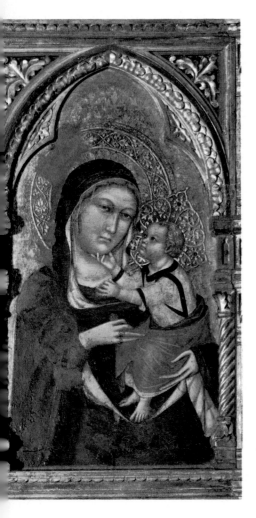

that, he took perhaps from the Giottesque fresco of the subject at Assisi.

But it is what he did with it which is most worthy of comment. The *genre* scene of the midwife and St Joseph, with tub and water pot, may recall Giottesque humanity, but the Virgin and Child live in quite another world, more mystic and ecstatic, lying on a bed which has a gold-embroidered pillow and gold-edged sheet. Indeed, the application of gold to the delicate colours and swaying graceful draperies guides us to those portions of the picture which the painter is eager to emphasize: not only the sacred personages for whom convention demands the richest of pigment and metal, but the donor with his church and his coat-of-arms – all touched in with gilt, staking his claim to the Virgin's interest and protection.

Such a luxurious mood is confirmed amid the spiky, jewel-encrusted chapels of the cathedral at Prague, or in the studded walls of the chapels at Karlštejn. The cathedral at Prague would now seem bare to Charles IV and his contemporaries. At Karlštejn the Emperor certainly had at least one Italian altarpiece by Tommaso da Modena who probably did not visit Prague.[21] As sheer *objet d'art* this gilded, pinnacled, virtually embroidered, work stands for a whole style of meditative, almost luxuriously mystic pictures – typified by its *Virgin and Child* [plate 22]. The sheer visual splendour of Bohemian churches was to be remarked on by the future Pope Pius II, in his history of the country, commenting on the luxury there of the vestments, colourfulness of stained glass and elaboration of goldsmiths' work. In the pictures there is a steady reduplication of the theme of Madonna and Child – rarely the Madonna of Humility, and more often crowned, enthroned, bespangled with stars: glorious royal beings who are the Queen of Heaven and her divine heir. Earthly symbols of splendour and the ritual magic of regalia stand for heavenly qualities and for an after-life which will consist in being clad in soft garments and seated on embroidered cushions. And it remains necessary to conjure heaven's protection in this world.

The most splendid of all such painted statements came not from the Emperor's commission but from that of his Archbishop, Ernest, who commissioned one large-scale altarpiece of which only the central panel survives [plate 23]. Fortunately this is beautifully preserved. Painted for the Archbishop's own town of Kladzko, it breathes pride as well as piety. Not altogether accidentally does it seem to have a faint recollection of Simone Martini's *St Louis*, for here the splendid cut-out figures of Virgin and Child are persuaded by an attendant angel to look down from that fretted heaven of thrones and gold and canopies, to the kneeling donor. He is dressed in blue vestments – the Virgin's colour and a rare, very privileged liturgical one. Having laid aside a mere bishop's crozier, he seems to

21 (*Opposite*) *Nativity* from the Vissí Brod series

22 (*Above*) Tommaso da Modena: *Virgin and Child*

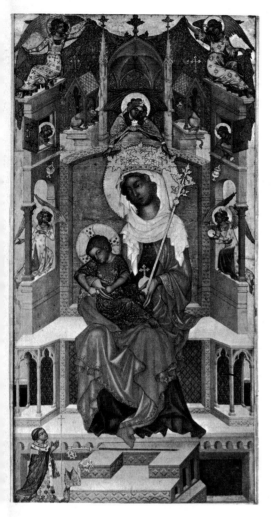

23 *The Glatz Madonna*

welcome not only the celestial vision but the archbishop's cross which stands before him.[22] Dressed in the pallium of archbishop, the first Bohemian raised to this rank, he can afford the familiarity of leaving his gloves to dangle on the step of the throne. Small though the donor is before the huge Queen of Heaven, he is yet distinctly *there* in all his ecclesiastical glory – shown off to his home town to which he donated a complete monastery and a church which once contained this picture.

The picture commemorates too the achievement of the Emperor Charles, who had won in 1346 from his old tutor, Pope Clement VI, that prestigious honour of having an archbishop for Prague, a further 'placing' of his kingdom on the map of Europe. Something of an irony has carried the picture to Berlin, where it stands for the achievement of the Prague school under the impetus of the Emperor and his court in a way that no single painting remaining today in Czechoslovakia can. The Virgin, seated on Solomon's throne, is crowned as queen of angels, and her coronation is witnessed by Ernest of Pardubitz. But it is probably not too far-fetched to see also in the composition an element of heaven present to witness and ratify the achievement of the donor, raised to a uniquely privileged position, himself political functionary as well as a churchman.

Typically enough, we know more about the commissioner of this painting, an enthusiast for national Slavonic church services, diplomat and collector of manuscripts, as well as donor of pictures, than we do about the identity of the artist. Only one painter, and that a very different one, Master Theodoric, exists for us both as an artistic personality, with surviving work and as a painter documented at the time.[23] Although a good deal has been said about medieval traditions of anonymity, this is not altogether a fair argument because other painters are recorded as working in the service of Charles IV. Yet even if we knew much more about any individual painters themselves, I don't think this would greatly alter one's impression of a society where the ideas and 'shaping' had been handed down from the court. Even when a plain burgher commissioned work, it remained aristocratic, featuring the native and royal saints.[24]

In any event, the painters at Prague were in themselves less important than their steady message that heaven stands guard over us: a sentiment well expressed by the words of the mass still said on the royal saint, St Wenceslas's, day: 'O God, who by the palm of martyrdom didst remove blessed Wenceslas from an earthly princedom to the glory of heaven; keep us through his prayers from all harm . . .'[25]

Perhaps the most remarkable of Prague court demands is in the lower half of the votive picture of Jan Očko of Vlasim [plate 24]. He had succeeded Ernest of Pardubitz as Archbishop of Prague in

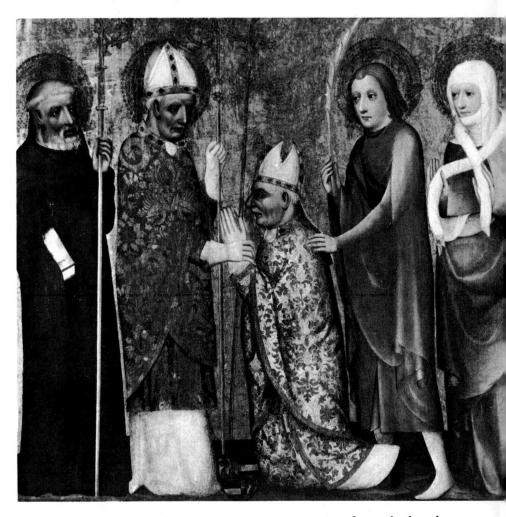

1364 and here he seems to be receiving consecration from the hand, literally, of the very first bishop of Prague, St Adalbert. Other Bohemian saints, Procopius, Vitus and Ludmilla (the latter son and mother) – also closely connected with the history of the country – witness this transference of ecclesiastical authority to the contemporary living archbishop. In its own terms, it is as much a guarantee of a succession assured as is the upper part of the same panel where Emperor and heir kneel with the other leading patron saints of the country.

Altogether, in this unique double composition, a vertical diptych, there is a summing up of the whole empire under Charles IV: the wider politics of ruling in the upper half, where the Emperor and his son flank the Virgin and Child, and in the lower half the ecclesiastical hierarchy of the empire's capital of Prague is confirmed. All the persons, whether living or dead, have passed into a single realm and possess virtually equal importance. In his portion of the panel Jan Očko is the central figure, the hero in fact, around whom the saints obligingly cluster. It is almost a daring *sacra conversazione*,

with the donor the pivot of the scene. He kneels, it is true, but courtesy blends with piety in the action; his memorable profile is stamped like the image on a medal or coin, impressed on the spectator's mind, recording not just the man's rank but his vigorous, unidealized appearance.

In art it all looks very certain, as well as splendid. Yet in the year 1378, a decisive crack appeared in the fabric on which the Christian European world was built. The Italian Pope, Urban VI, was scarcely elected when a group of cardinals declared they had acted under compulsion and elected a rival French candidate, Clement VII. Thus began the Great Schism. This itself was only one sign of other religious disturbances, already apparent in Charles IV's reign but coming to a head at his death. In 1378, a month or two after the Great Schism had declared itself, the Emperor died. England had already been disturbed by the teachings of John Wycliffe, who would give us a different view of those highly placed clerics like Jan of Středa and Ernest of Pardubitz; were not such people too occupied with affairs of state to bother with their religious duty? And other reformers, reading St John's *Revelation* in a fresh way, saw that the 'Great Babylon' was the Church itself, and Anti-Christ was no other than the Pope. More pertinent still, in 1361, in a sermon preached before the Emperor and his court, one Czech ecclesiastic, Milič of Kroměřize, had identified Anti-Christ in someone much closer to Prague: it was the imperial majesty itself which was the incarnate devil – a statement which Charles countered by imprisoning the brave apocalyptic reformer.[26]

Wycliffe's ideas quickly found an echo at Prague – though with

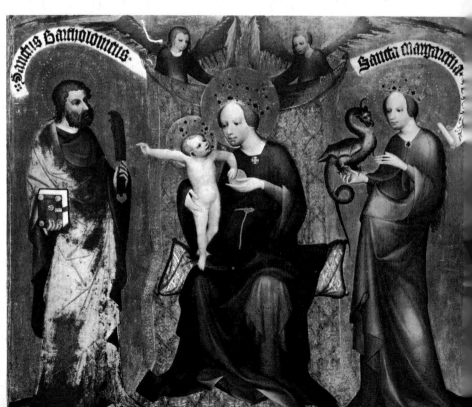

25 *Madonna and Child with St Bartholomew and St Margaret*

John Hus there are distinctly fresh aspects, as well as echoes, in his teaching. In the extremes of religious court art fostered under Charles IV it is easy to see that sensuousness had really triumphed over – not piety, but over everything that might be called utilitarian Christianity. That constant emphasis on an aristocratic Virgin was scarcely based on a strict interpretation of the scriptures; the Vissí Brod *Nativity* was a poor guide to how a humble woman would actually give birth to a child in a stable. The beguiling female saints like gracious princesses, the Virgin sweetly maternal, protective, and yet remote in a glittering heaven of precious stones and gold – these remained for long the stock-in-trade of Bohemian painting. Lively and intensely refined, the *Madonna and Child* [plate 25] of about 1400 could scarcely be more royal amid the embroidered cloths of heaven. By then Charles IV had been succeeded by his amiable but incompetent son Wenceslas. A whole, strongly Puritan sect of Hussites, called the Taborites, would soon specifically reject prayers to the Virgin; yet still there were demands for works of art like this. And the seeds of unreality – distant from the plain ethical truths of Christianity – had been encouraged to grow and bloom most exotically, most flagrantly, under Charles IV's impetus. The ineradicably aristocratic basis of this art, elegant and femininely charming, ever royal, in sculpture [plate 26] as much as in painting, is ultimately a reason for some reformers' rejection of it. Artistically too, Europe was moving against the unreal, delicate, literally jewelled court style, with its international ramifications which culminate in the *Wilton Diptych*, depicting a king who – rather conveniently for linking things artistically – married the Emperor Charles IV's

26 *St Catherine*

daughter. Artistic rejection of the international courtly style became the Renaissance. Religious rejection of the doctrines it had seemed so disarmingly to propagate became the Protestant Reformation.

Yet there was something refined and even worldly about this art, which continued to attract court circles – a spice of the fashionable which would exist even when the idiom had changed and when one could place a monarch in his own court – not in heaven. That shift had not taken place under Charles IV. As documents of what daily life was like in Prague at the end of the fourteenth century, such art is – I'm glad to say – quite valueless. Instead, it offers an insight into the spirit of the period, when art had the freedom to imagine an artistic heaven, without preoccupations about space or volume, or to establish any relationship to the known world. It may seem surprising, but the best defence of the power of art comes from Hus himself, no iconoclast but someone who argued that the people's ignorance, the slowness of the mind, and the sheer memorability of pictures and sculpture, all unite to justify art's use in religion's service.[27] It was comforting to think that, in a coherent, cosmic scheme, out of a heaven of gilt, the Virgin and Child looked down, not only on popes, emperors and kings but on the humblest beggar kneeling in the cathedral of St Vitus. The wrought gold, the embroidered materials and chunks of jewels, now easily regarded as barbaric or childish, were symbols at once of richness and of illumination for the soul. The imagination is encouraged to work, transcending what is seen to reach an inner reality. Art and religion agree in wanting to induce that state in their participants.

We have seen something of the sort of inner reality encouraged by the Emperor Charles IV in the art produced for him and his circle. It had set its sights on the next world, as I have tried to indicate in the title of this chapter. It had made heaven royal, and given something celestial to royalty. It was both mystic and somewhat muddled. Its cosmic theocratic view was justified by the achievements of the ruler who had inspired so much of it and who genuinely had thought in apocalyptic terms.

None of this applies to the courts we next encounter. There the ruler claims plain but intense humanity, set in the ordinary framework of his ordinary life, in small cities, especially in fifteenth-century Italy. The present is reflected, not the future. We are dealing with the illusion of actuality, not timeless mystery. No longer on his knees, man treads firmly the recognizable earth. And it is to exchange the high royal world of *Richard II* for that of *Henry V*, where a ruler himself declares of a king: '… all his senses have but human conditions: … his ceremonies laid by, in his nakedness he appears but a man.'

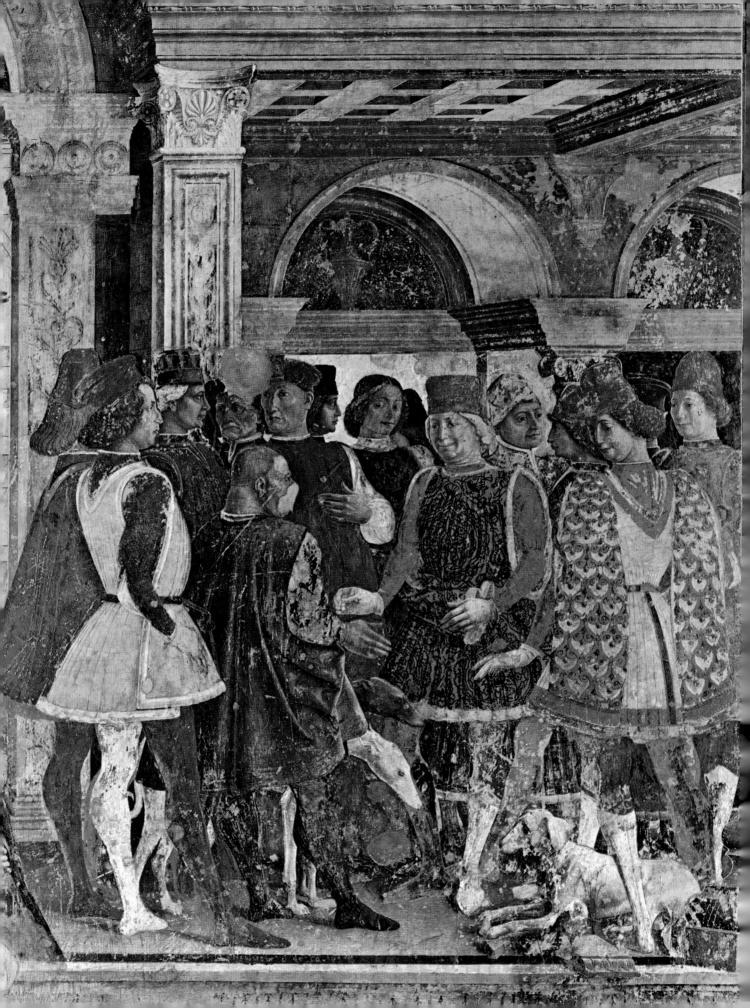

2 COURTS OF EARTH

In the first Chapter, all eyes were directed to the Court of Heaven – and most of the rulers we encountered were depicted getting there on their knees. The tone can be recaptured by a quotation from a thirteenth-century verse history of St Edward the Confessor, when St Peter, the dead king's 'dear friend', opens the gate of Paradise and lets him enter the court of heaven for a new coronation: 'And thus,' we read, 'from an earthly kingdom / He passed to a heavenly kingdom.'[1] This transcendental view of existence had for several reasons been strongly prominent at the Central European court previously discussed: the imperial capital of Prague built up – quite literally – by the great Emperor, Charles IV.

Once that attitude had found expression in art, it was too convenient to be allowed to die out. It became a complete category of picture: the religious composition with a portrait of the donor. On the one hand, the religious context put a ruler, just like his subjects, into the perspective of a spiritual future. And at the same time it gave a divine sanction to the ruler, beneficiary of many a painted vision: on his knees, it is true, but that was a worthwhile position to adopt if it meant a way of consolidating, consecrating, his rule.

It would therefore be wrong to declare a sharp break between the sort of ideals touched on before and those discussed in this chapter. As long as there are monarchs, a tendency exists for them to seek spiritual buttressing; reversing the usual phrase, one might say that the big battalions are on the side of God. As late as Napoleon, this pious fiction remained useful; he did, after all, fetch the Pope to attend his coronation and had the Pope, as painted by David, shown blessing the occasion. There seems nothing apocryphal-sounding about that recorded remark of Napoleon's in explanation: 'I did not bring him all this way to do nothing.'[2]

It is useful to remember that the ruler raised into the Court of Heaven long survived one way or another as a concept. It survived, but it was being weakened by a concentration no less intense on earthly kingdoms. Doubtless we are all going to heaven – but need we go quite so quickly? And then, the increased science and facility of the medium of painting as such, demonstrated so astonishingly by Flemings like Campin or Jan van Eyck, and by Masaccio in Italy, would soon mean that a picture of an earthly court could be painted which would give more accurate sensations of what exterior reality was like. It is true that the King of France's brother, the Duc de Berry, was painted early in the fifteenth century being welcomed

III Cossa: *Duke Borso d'Este rewarding his jester*

45

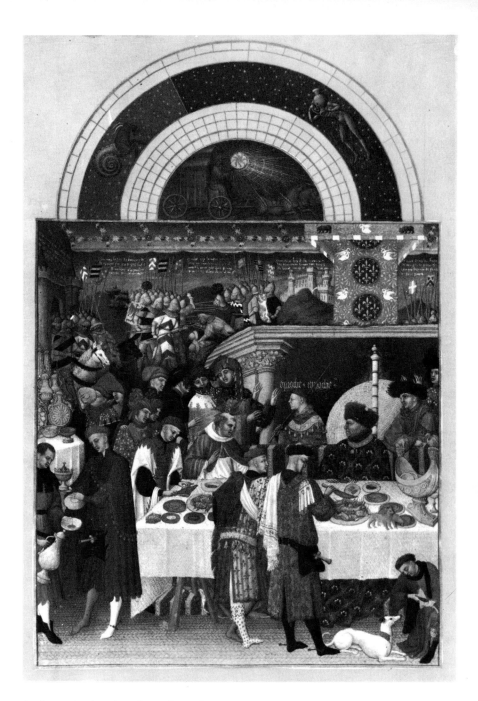

27 Limbourg Brothers: *January* page from the *Très Riches Heures du Duc de Berry*

in heaven by *his* dear friend, again St Peter. But he was also to be painted in a perfectly straightforward *genre* scene, giving a New Year's Day feast, in the *January* page from the calendar of his famous *Book of Hours* [plate 27]: very much at ease, at the fireside, seen in the context of his own private court, not idealized, nor in prayer, but enjoying a grand seigniorial good time on a cold winter's day.[3]

What is more, the emphasis is no longer on just one man and his individual likeness but on the atmosphere of his own court: itself recognized as part of his individuality, reflected not merely by his features but by his chosen – and indeed, with the Duc de Berry, most choice – environment. This is a more complex concept of the

46

human personality than we have encountered before in painting. It is continued, with equal subtlety, in the other calendar pages of the Duc de Berry's *Très Riches Heures*, where he himself is absent from the composition but symbolically present in views of his castles and his domains, usually being actively cultivated in whatever form suits the season. Although the Duc de Berry certainly owned more than enough property to make this point on nearly every one of twelve pages, each for a month, he was not of course the ruler of a kingdom: he was a great patron who happened to be of royal blood, who had wealth without any real political responsibility.

The decoration of the *Très Riches Heures* is indeed a typical private patron's commission: it is not painting as such but the illumination for one person, for his own personal pleasure, and perhaps occasional use, of a uniquely splendid prayerbook. But its theme of monthly country pursuits will have relevance when we turn to other, later fifteenth-century courts where – on a more public scale – ordinary daily life would be depicted. And there the emphasis would be on the monarch amid his courtiers, not exactly ruling or governing but simply living. Nor is this living a matter of splendour but of sobriety.

It is as propaganda for an ideal existence that one can see the pictures painted for, and of, the Duke of Urbino, Federico da Montefeltro, reading in his study, dressed in full armour and with his son beside him, or – again with his son – listening to the discourse of a humanist teacher [plates 28 and 29].[4] Even if this be propaganda of some sort, at least it propagates an admirable concept of the cultivated, literate ruler, willing to be instructed by scholarship, anxious for knowledge as well as power – in other words, something of a rarity among rulers at any period. And it perhaps suggests a new concept of the ruler: as educating himself. In fact, it is not mere propaganda in the case of Federico da Montefeltro, for of him we learn elsewhere that he was genuinely interested in scholarship, was the owner of an extensive library and was a sympathetic, friendly –

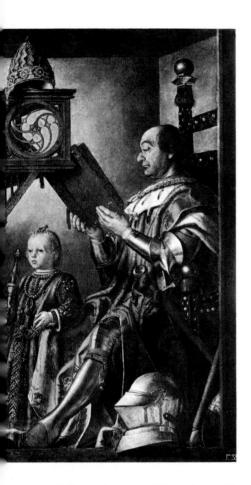

28 (*Above*) Joos van Wassenhove (?): *Federico da Montefeltro and his son*

29 (*Right*) Joos van Wassenhove (?): *Federico da Montefeltro listening to a lecture*

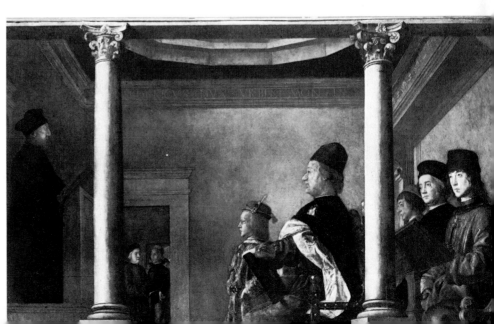

one may say, unassuming – prince in daily life.

The ability of painting to respond in this way – evoking a man and the tenor of his life – meant that there was now an artistic medium which could reflect contemporary events with new truthfulness. And truthfulness itself was to be prized above symbolic overtones. The dignity of a ruler comes from his innate human qualities, not his rank. To rule is something which can be shown historically – in the sense of an actual event narrated, enclosed within a factual context, as we see it in Fouquet's depiction of the formal public scene of Charles VII of France assembled with his councillors [plate 30].[5] This seems compositionally and emotionally to come to a point with the king, fanning out from him through the ranks of councillors and justices to the lowest level of the common people: creating a beautifully coherent view of society, not abstract, not transcendental, but factual and full of lively realism.

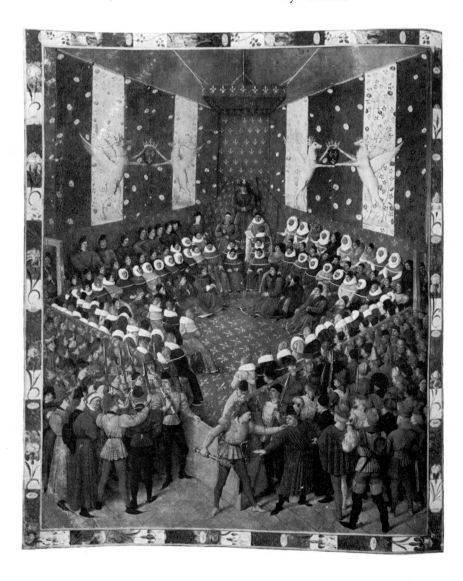

30 Jean Fouquet: *Charles VII of France and his councillors*

At the contemporary court of the Duke of Burgundy, a miniaturist conveys the relaxed and fairly informal atmosphere of life – as opposed to a particularly ceremonial occasion – on an ordinary day there [plate 31]. Even though this scene is of a typical incident, the presenting of a book by its author to the Duke, the general air is intimate and its purport a cultural one.[6] Cultural implications were important in the dissemination of the image of the Burgundian court at the period, under Duke Philip the Good, a great patron, recognized and admired for his opulent court – served by Jan van Eyck and Rogier van der Weyden – famous far beyond France or Flanders. Much more than the Duc de Berry, Philip the Good (who lived until 1464) was probably *the* exemplar of princely patron, inspiring by his example several Italian princes.

Such miniatures of authors presenting copies were common enough from the late fourteenth century to the end of the fifteenth

31 *Philip, Duke of Burgundy receiving a book from Simon Nockart*

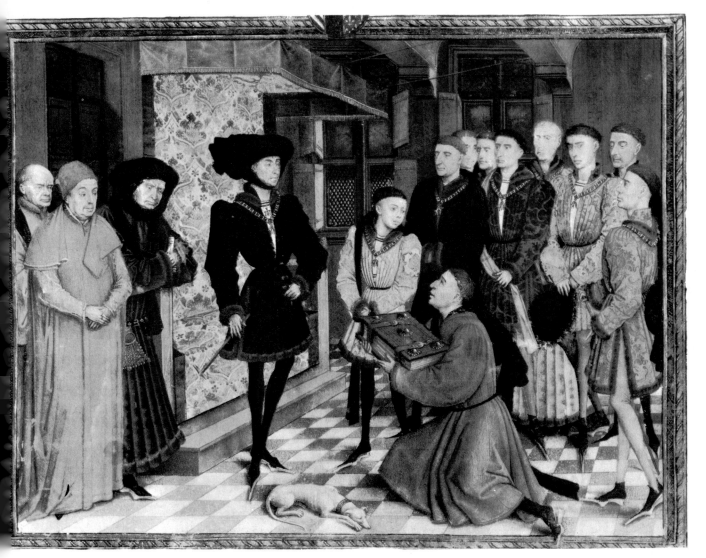

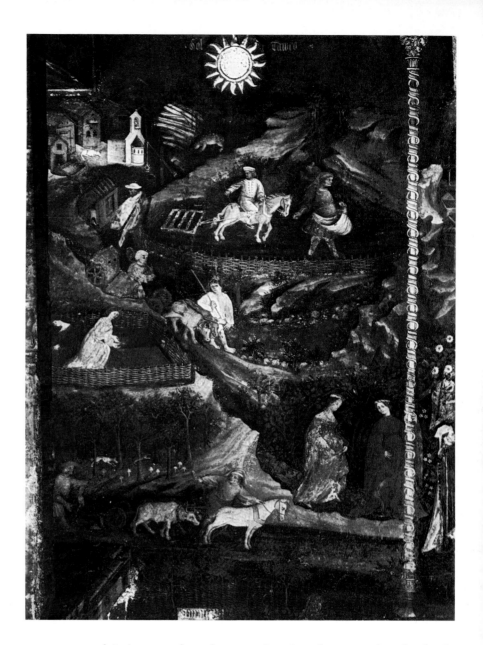

32 *April*: Torre Aquila frescoes

century, and it is true that the occasion is what remains the basic
concern. Although usually depicted, as here, in ordinary costume,
the prince takes on a certain god-like stature. He has become the cult
image before whom an author kneels, seeking patronage and protec-
tion. This in itself gives the prince perhaps a new importance; it is
he around whom cultured people's thoughts revolve; and, since he
can be known, seen, assessed as a human being, his personality and
tastes matter in a new way. The person to whom they mattered
most was, naturally, himself.

 Those who could command their environment were beginning
to take definite steps to create – and then to re-create – it in a particular
way; re-creation of it inevitably required the employment of art.
The word re-creation becomes more relevant when pronounced as
recreation, for it is part of the new mood to depict, sometimes on a

50

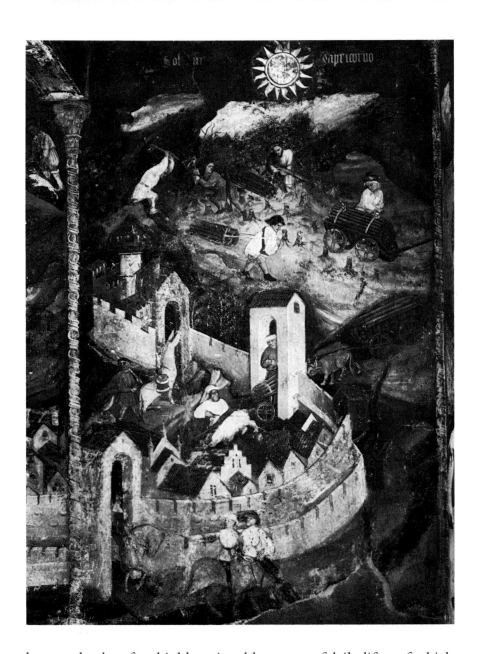

33 *December*: Torre Aquila frescoes

large scale, the often highly enjoyable aspects of daily life – of which painted scenes, on a large scale, of the *Months* are a perfect reflection. What the Duc de Berry saw in the pages of his *Book of Hours* could be seen by a courtly ecclesiastic, the Bishop of Trento, on his own palace walls [plates 32 and 33]: a series of *Months* painted in the Torre Aquila there, possibly by a Bohemian painter, and typical of much other comparable decoration in Northern Italy in the very early fifteenth century. It has some links with the courtly artist Pisanello,[7] and this interest in earthly life – chiefly of pleasure for the upper classes – may well have merged with other interests to create similar fully Renaissance fresco cycles, featuring a prince at their centre.

An early testimony to the presumed power of one's artistic surroundings comes from 1384 when France and England negotiated

a truce and met at a chapel decorated for the occasion with tapestries representing battles from antiquity. These were removed at the command of John of Gaunt, who, as soon as he saw them, said they were an unsuitable setting for men who wished to make peace.[8] In itself that is some indication of the effect art can have by providing a suitable environment. It was a more subtle step when art began to reflect environment positively and realistically, until paintings became like mirrors of earthly existence instead of being windows to heaven.

It is also a shift out of a totally pietistic climate into something more ethical and educative when the prince requires to be surrounded not just by religious pictures but by painted *Liberal Arts*

34 Joos van Wassenhove (?):
Allegory of Music

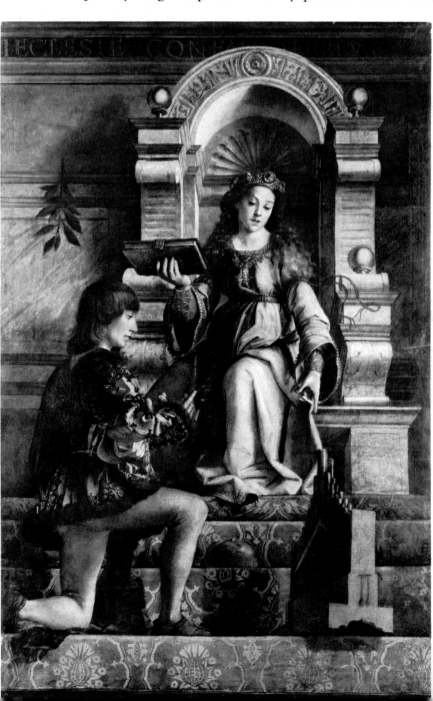

[plates 34 and 35], such as the series originally in one of Federico da Montefeltro's palaces, most probably his studio at Gubbio.[9] They combine allegory and portraiture, but the allegorical personages are no less vivid and realistic-seeming than the figures who kneel in adoration before them. These represent the same kind of homage to learning as is apparent in the picture of the Duke and his son listening to a humanist lecture, painted for another room – probably the library – in the palace. Once again, they speak not to the soul but to the mind.

The sort of enlightened patronage which such scenes suggest is commonly associated with the courts of the Italian states during the fifteenth century: that golden age of patronage and artistic

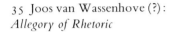

35 Joos van Wassenhove (?):
Allegory of Rhetoric

sensibility which recent closer scrutiny has revealed as sometimes less golden and ubiquitous in reality. Examination of the rôle played at Florence by the Medici, for example, has shown them as not so powerful or direct in instigating art as was once supposed.[10] And indeed we can scarcely call the environment at Florence a court one – any more than that at Venice. Nevertheless, there is one monument in painting to *quattrocento* Medici patronage which can be called courtly, and which is to my mind a glance towards a certain type of profane court art: Gozzoli's fresco cycle, painted for Piero de'Medici, of *The Journey of the Magi towards the stable at Bethlehem*. Gozzoli shows it in such topical fifteenth-century terms that the cycle has come to be seen – not altogether wrongly – as the journey of the Medici, and if not quite as kings, at least in the train of the three Kings. And as a triumph of a ruling house, on the walls of their own private palace chapel, it is quite worthy of royalty. The feathers and diamonds which decorate so many of the personages are the personal devices of the commissioner. He it is who rides prominently on the white horse, whose trappings are decorated with letters making up the Medici motto, *Semper*. The religious *impresa* that blazes down from the ceiling does so within a circle of Piero's feathers, flanked by four rings with his pointed diamond [plate 36].

The result is the most aristocratic and courtly work produced in would-be democratic Florence – but produced, of course, for the very family who were constantly accused of aiming at establishing themselves as rulers over the republic. They were specifically accused of adding their coat of arms to the buildings they had built, in a thirst for glory and self-advertisement.[11]

Gozzoli's frescoes are a little more subtle, but only a little. They are also a private commission in which a family is depicted in its own chapel, riding to worship the newly-born Christ Child. And yet, everyone has always detected their overt note of topical, profane reference, with almost tapestry backgrounds of animals and birds, and that general air which is of hunting and hawking rather than of getting to Bethlehem [plate 37]. Because there is certainly little sense of hastening there. In other portions some of the horses are not even turned in the right direction.

The frescoes are, in fact, neatly balanced between two types of picture. A religious commission, their location a chapel, they do more than merely include donors' portraits amid the scenes. Gozzoli is drawn towards the earthly rather than the spiritual – as much of his other work confirms – and would have been fully capable of reflecting quite accurately the daily life of the Medici family. Far from leading the eye into some fairy-tale world, he brings it back sharply to the known earth, as if gazing into a mirror. As Piero de'

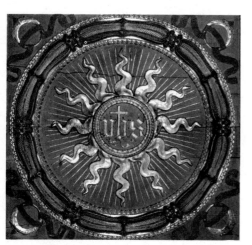

36 Ceiling of the chapel: Palazzo Medici-Riccardi, Florence

37 (*Left*) Gozzoli: *Journey of the Magi*
(detail)

38 (*Below*) Mantegna: Gonzaga
family frescoes (detail)

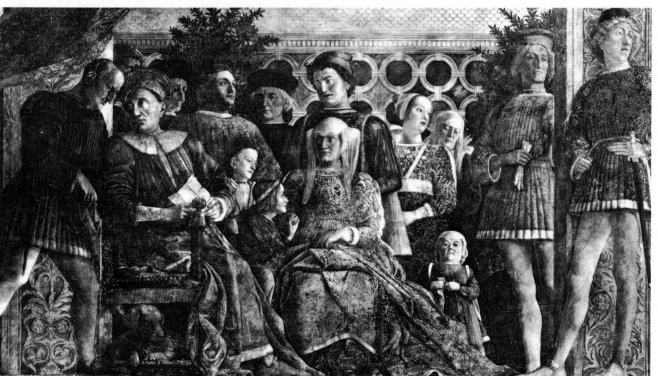

39 (*Below*) Pisanello: *Portrait of Leonello d'Este*

40 (*Bottom*) Pisanello: *Medal of Leonello d'Este*

41 (*Opposite*) Cossa: Palazzo Schifanoia frescoes (*March*)

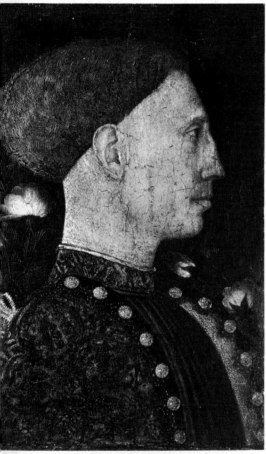

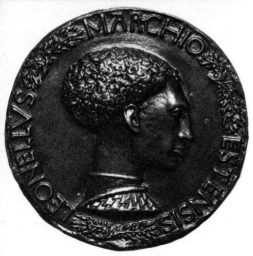

Medici prayed in this small room he could look round and see himself, his family, their friends and dependents (including Gozzoli) travelling through their native land. The next step was to be taken at those Italian courts that really were courts, where the ruler could impress his personality on art, without democratic protest. Only a short step seems to separate Gozzoli's frescoes from those of Mantegna at Mantua [plate 38], painted some thirteen years later. Here the primary purpose is to capture the Gonzaga court for its own sake.

Yet Mantegna's are actually later than the somewhat comparable ones, on a much larger and more elaborate scale, commissioned at the nearby, allied court of the Este family at Ferrara [plate 41]. It was, then, in these basically provincial centres – rather than in Florence – that personal patronage sought what we might call earthly immortality. We can point to nothing so elaborate in other Italian cities as these totally secular fresco cycles which aim to convey what princely life was like in fifteenth-century Mantua and Ferrara – and they have achieved immortality for two noble families. Even if concentrating on the Este court at Ferrara, it is convenient to keep both Ferrara and Mantua in mind, because several things linked them, both artistically and dynastically; nor geographically are they very far apart.

Technically, Ferrara was a democracy, or at least an oligarchy.[12] In fact, it was entirely governed as an autocracy, in which the ruler made no effort – quite the opposite – to dissemble his powers. His personality was important, and often tested. Ferrara was the scene of actual events that are perfect material for a Jacobean tragedy. Niccolò III of Este was himself illegitimate and the father of – traditionally – over a thousand bastards in the area. He murdered his eldest son after that son had committed adultery with his stepmother, and murdered her too. Out of all this – literally – bloody mess, emerged a refined and cultivated ruler, the next senior bastard among the thousand, Leonello d'Este. He was made legitimate, became heir apparent and succeeded his father in 1441.

The father had been a self-taught, religious sensualist, a tough, able ruler, early orphaned, who had fought hard to retain his throne. The son was a new sort of prince, trained in arms but preferring letters: sensitively depicted by Pisanello in paint and metal [plates 39 and 40], one of whose pupils, Matteo de' Pasti, executed a very similar-style medallion of the prince's tutor, the humanist Guarino. Pisanello's image served for other, later likenesses of Leonello d'Este [plate 42], painted portraits which preserve the slight stiffness, the medallion-like profile, and are almost too discreet in giving so little sense of man or ruler.

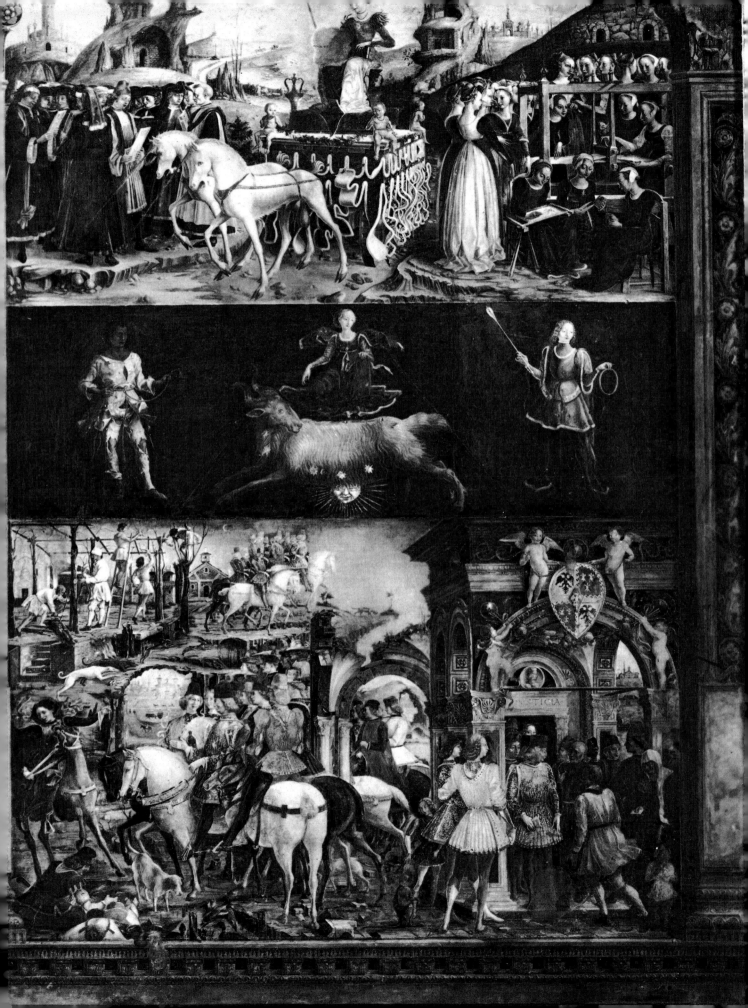

Giovanni da Oriolo's portrait was paid for in 1447 and it shows how Leonello's requirements for a portrait had become virtually schematized – to the point where it remains doubtful whether this is an image from the life. There is something restrictive in the patron's concept of what constitutes a real likeness, a linear response which is content with the incised profile silhouette, probably because of its classical associations; in hands other than Pisanello's, the manner can become somewhat insipid. Pisanello's own links with the Gonzaga court at Mantua are – as it were – echoed by the literal link of Leonello's engagement to the daughter of the Marchese Gonzaga, and she too was portrayed in a medal by Pisanello. It is with such work that Pisanello comes forward as an artist – one proudly signing his work – providing images which subtly evoke suggestions of imperial Roman coinage for the modern ruler. It can scarcely be an accident that Pisanello was caught up in, and perhaps himself encouraged, the humanist ethos of the courts of both Mantua and Ferrara – each of which had its guardian humanist. At Ferrara it was Guarino; at Mantua it was Vittorino da Feltre, one of whose pupils had been Leonello's wife, and another Federico da Montefeltro.

The court of Ferrara under Leonello lives most vividly now not in any painted reflection but in a rare book – *De Politia Litteraria* – by the Milanese humanist Angelo Decembrio, who shows the prince surrounded by a group of like scholarly people, discussing various topics, among them painting.[13] Something of a poet himself, Leonello emerges from Decembrio's work as a sensitive *amateur* of art, fond of engraved gems, coins and tapestries, estimating Jacopo Bellini along with Pisanello as 'the finest painters of our time.'

It is the prince who leads the discussion about art, and interestingly enough in the light of what was to be done at Palazzo Schifanoia [plates 44 and 45] it is he who states that the painter should in effect follow nature; by the standard of truth to nature should the painter be judged. In Guarino's eyes, Leonello d'Este was not only a scholar, a musician, but the 'flower of princes', a phrase which Pisanello's painted portrait accidentally captures: his unostentatiousness is also suggested there, as is the deliberate, almost dandified choiceness of his clothes – controlled by his sense of relationship to his horoscope and the position of the planets. This interest in astrology is mentioned as a trait by Decembrio; and probably it is more than coincidence that astrology plays so large a part in those frescoes to be commissioned for Palazzo Schifanoia by the subsequent ruler, his brother, Borso d'Este.

The two chief palaces used and decorated by Leonello both stood outside Ferrara; neither survives today, but their names – Belriguardo and Belfiore – sufficiently evoke their purpose as places of

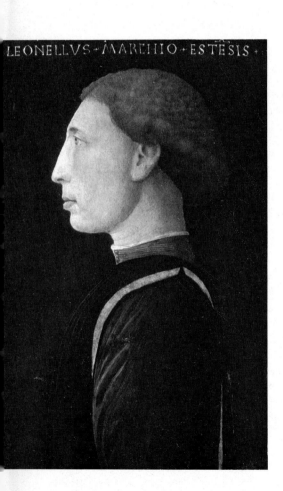

42 Giovanni da Oriolo: *Portrait of Leonello d'Este*

leisure and pleasant relaxation, with an echo of the castles of the French chivalric romances which were then fashionable. Leonello's great hero from antiquity was Julius Caesar; he preferred him to the possibly more admired Scipio. One room at the palace at Ferrara was named after Julius Caesar; a portrait of him (perhaps a modern medal) was sent in 1435 by Pisanello to Leonello. He built little but collected much in the way of art treasures and manuscripts, keeping such things in the pleasure-palace of Belfiore. And though there is no reason to think that Pisanello painted subject pictures for him, the miniaturistic, essentially courtly, even chivalric mood of Pisanello's ostensibly religious pictures is perhaps a clue to the sort of world which Leonello d'Este certainly liked to encounter in books [plate 43], more delicate than the earthy actuality of Schifanoia.

43 Pisanello: *Vision of St Eustace* (?)

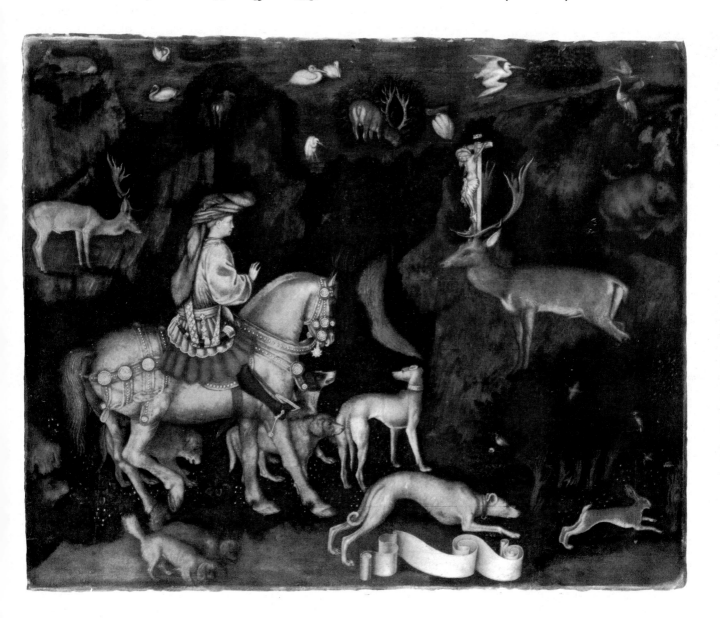

Obscurity to some extent surrounds the court of Leonello d'Este, at least artistically speaking. Partly this is because much has disappeared, but it is also due, I think, to the basically literary caste of much of what was produced for him. Literary association probably mattered more than artistic merit. He was, he remained, the pupil of Guarino: Guarino, who is made in Decembrio's discussion to value paintings very much like literature, finding them similarly instructive, and explaining that the ancients sensibly thus spoke interchangeably of writings or paintings by the term 'scriptas'.

As ruler of Ferrara Leonello had only a short reign of nine years: peaceful years which are interestingly celebrated in the panegyric

44 Palazzo Schifanoia frescoes
(detail of *April*)

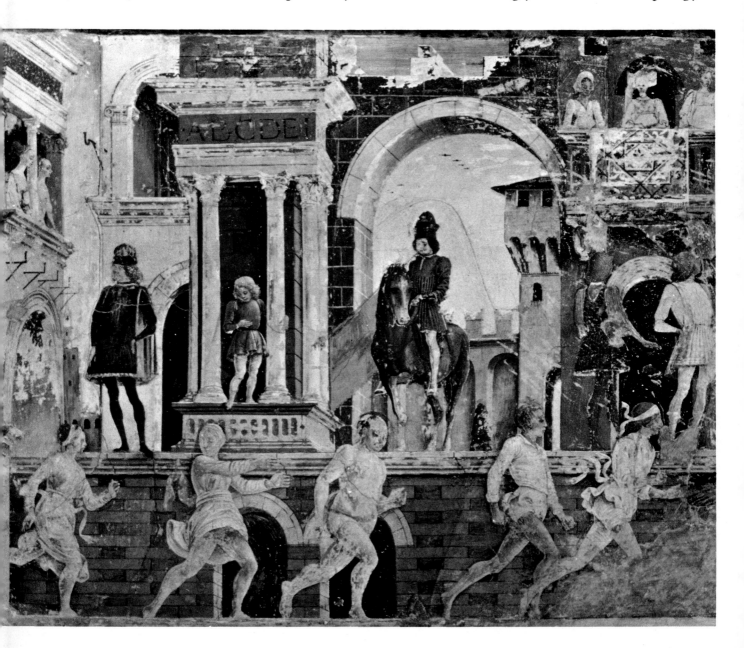

poem of Janus Pannonius, a Hungarian pupil of Guarino's, who addressed to him his praise of Ferrara, 'mother of peace and winged love' (*Pacis et aligeri Ferraria mater Amoris*). In Ferrara there is music and dancing, and within the city 'painted palaces rise' (*picta palatia surgunt*). Perhaps one should not explicitly press poetic licence to make art history, yet it is at least worth pausing over the contrast between these 'painted palaces' said to be within (*intus*) the city and what lies outside, beyond (*foris*) in 'fields that plenty makes rich with laden horn'.[14] It may seem an age-old literary contrast, but it becomes pictorially vivid on the walls of Palazzo Schifanoia [plates 44 and 45], decorated under Leonello's brother and successor, Borso.

45 Palazzo Schifanoia frescoes (detail of *March*)

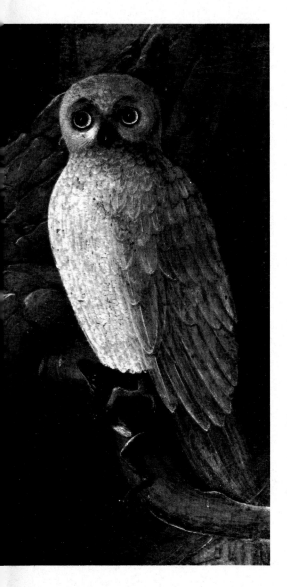

46 Tura: *An owl* (detail of
St Jerome)

Leonello d'Este had created a climate of intellectual splendour.
Borso, whose very name – one might say – suggests something more
earthy, was more fond of actual physical splendour, a positive display
of cheerful magnificence which well suits with the ruler who had
his rank raised by the Emperor to Duke – becoming the first Este
Duke in 1452, two years after Leonello's death. What was reflected
of his court is nothing tremendously subtle or intellectual, but it is
marvellously actual and palpable in the admittedly damaged
frescoes of the *Months* which still decorate the walls of Palazzo
Schifanoia – a name indicative of its use as a carefree refuge – used
by Duke Borso as a summer palace.

Although he did not begin the building, it was only with him that
it came into its own as a residence; Schifanoia, '*gratia quanta Domus*',
is celebrated in a poem by the fashionable young poet at court, Tito
Vespasiano Strozzi, dedicated 'to the Divine Borso'.[15] It was under
Borso that there were employed native Ferrarese painters, who
benefited by the work they had seen by Rogier van der Weyden,
and also by the fact that at Ferrara Piero della Francesca executed –
under Borso – some lost groups of frescoes, of which some echoes
in other pictures possibly still reach us.[16] It was not at Schifanoia but
in the big Este palace, the Corte Vecchia, that Piero decorated several
rooms. His compact, elemental people, inhabiting an almost crystal-
line sphere, are in many ways the progenitors of the strange but
moving, strongly-characterized figures of Ferrarese art, figures
sometimes in the fields and sometimes fitted into highly wrought
architectural settings. Both aspects were encouraged by Este court
requirements.

The painters themselves were certainly much in demand at court.
Of them the eldest and most firmly fixed at Ferrara was Cosimo
Tura. The poet Strozzi himself had some pictures painted by
Tura – a point overlooked by Tura's most recent biographer: not
only a portrait of his mistress but also a portrait of his favourite
hawk, Bargarino, a bird which got a complete poem dedicated to
it and its image – '*tam bene picta*'.[17] That painting is, inevitably I
suppose, lost; but some idea of Tura's response may be gauged from
the vividly-painted bird who sits up on a branch in his picture of
St Jerome [plate 46], and this detail alone is a useful reminder of links
between Pisanello and the Ferrarese painters of the generation after
him. It was a typical commission that Strozzi gave Tura at a court
where hawking and hunting were the most popular recreations –
led by Duke Borso himself.

Tura, we know, was employed on painting portraits of people as
well as birds.[18] But it was in the realm of fantasy and invention that
his art blossomed best. It was fortunate that plenty of opportunities
at court encouraged his ingenuity, giving him commissions to

47 Tura: *Madonna and Child enthroned*
(detail of throne decoration)

decorate rooms, design furniture and also a service of silver plate. Lost though such things are, something of their ingeniousness and elaboration can probably be recovered from Tura's paintings [plate 47] where feigned marble and bronze, and foliage-like carvings, are mingled and twisted into elaborate thrones and canopies, rich for their own sake. This is mannerist architecture long before most art historians would allow the Mannerist style to exist – and fevered mannerism is a weak description of another non-native Ferrarese painter of the period's high court – almost high camp – *Ceres* [plate 48].

The style of such work has passed beyond the comparative naturalism of those *Liberal Arts* portrayed in niches for Federico da Montefeltro at Gubbio and Urbino. What Tura places in a niche is jewelled fantasy, a triumph of spikiness for its own sake – one might think – where the figure preserves a stony, disdainful immobility [plate 49], seated on a throne that writhes with arched, scaly dolphins,

all bristling tails and jagged teeth. The very abstruseness of this allegory or personification – still not convincingly identified[19] – is part of an elaborate court world, comparable to the astrological and allegorical bands in the upper portions of the Schifanoia frescoes. Like those frescoes, this style comprehends both the fantasy element and also a more deliberately earthy and realistic one.

Borso d'Este reigned for nineteen years, remarkably peacefully, and with an outward display of splendour which made Ferrara famous. His reign culminated in his being ratified Duke of Ferrara by the Pope, having ridden in triumph into Rome and returned

65

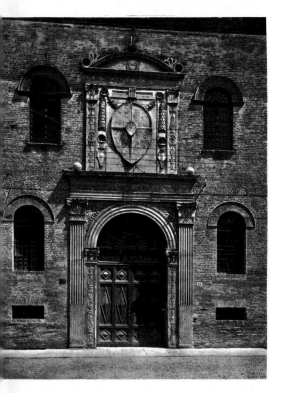

50 (*Above*) Exterior of the Palazzo Schifanoia, Ferrara

51 (*Opp. above*) Palazzo Schifanoia frescoes (detail of *March*)

52 (*Opp. below*) Palazzo Schifanoia frescoes (detail of *April*)

equally triumphantly to Ferrara in 1471, a few months before his death. Of the Este palaces as used and decorated during his reign, only Palazzo Schifanoia survives at all as he knew it [plate 50]. Originally it had served merely as a hunting lodge, but Borso enlarged it into a palace; and it is his own arms that are displayed over the doorway.

Inside, in the Room of the Months, the world that the Limbourg Brothers had created in the pages of Jean de Berry's *Très Riches Heures* takes shape on a large scale on the four walls of a room, in a painted scheme that occupies the whole space between floor and ceiling.[20] There is an echo of the Torre Aquila frescoes, and perhaps it is no accident that Pisanello had created at Pavia a somewhat similar-sounding room, now totally destroyed. At Schifanoia we recognize nowadays that the most distinguished painters involved in the scheme were Cossa and Ercole Roberti. Cossa was dissatisfied with the payment made to him for his portion of the work, and to this dissatisfaction we owe a letter of 1470 from him which indicates that Pellegrino Prisciano, astrologer, poet and ducal librarian, had some hand in the scheme. Indeed, it is reasonable to suppose that this scholar drew up the learned, though not perhaps totally coherent, plan whereby the cosmos would be mirrored: ruled, however, not by God but by the heavens in the sense of the Zodiac signs [plate 41] and the gods of antiquity. On earth, it was naturally Ferrara and its territories which were ruled, in the person of Duke Borso [plate 52] seen in the twin aspects of leisure and duty: being just, charitable and prudent – giving judgment or alms or audience – but also seen out hunting or hawking, under the seasonal influence of each month.

Not all the twelve frescoes survive. We have unfortunately lost almost all of *December* and the whole of *January*, *February* and *November*: months in which it would have been interesting to see if the Duke was shown indoors, feasting and retreating from the weather. In the surviving months, there exists enough for us to comprehend the scheme of Borso, guided perhaps by the relevant sign or governed by the deity for the month. We know how seriously he believed – or professed to believe – in astrology. When Pope Pius II summoned him to Mantua for a meeting, Borso replied that he could not come because his astrologers said he would meet his death if he went. The Pope sent back a strong rebuke, telling him not to heed such 'pagan nonsense'. It is Pius II himself who records this whole incident, adding that Borso d'Este still refused to come and – to compound the insult – was understood to have gone hunting.[21]

Horoscopes themselves were the result of at least pseudo-scientific interest, illustrated by the sort of astrological-cum-geographical treatise which an Italian astrologer presented very early in the

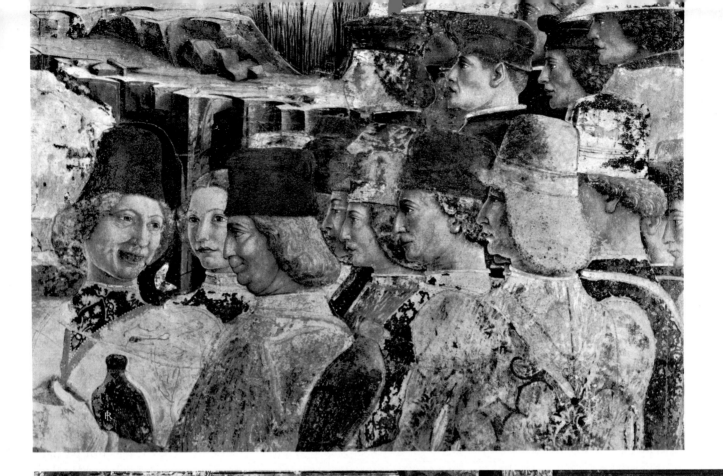

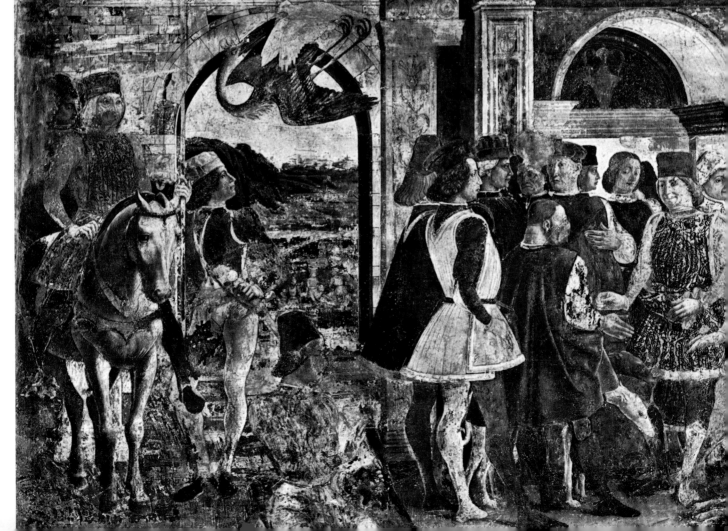

sixteenth century to Henry VII of England, for the benefit of his son, the future Henry VIII.[22] This treatise was a disguised panegyric, with a title page [plate 53] which combines geography, astronomy (of a sort) and astrology: what we see most vividly is a map of the world, surrounded by twelve scenes of human life as it is governed by the stars.

A good deal has been written about medieval and Renaissance ideas of astronomy in connection with the Schifanoia frescoes. Those who have read no further – and they will incidentally have read no one livelier on the subject – than Chaucer will recall how deeply permeated his poems are with the sort of astronomy now called astrology: it provides a celestial machinery which can accompany the lively debates of gods and goddesses, and also play its part – without totally determining – the events of plain but equally lively humanity on earth. This idea was still haunting manuscript illumination at the end of the fifteenth century: what we get at Schifanoia is the same concept now on monumental scale. Chronologically the first surviving fresco is that for *March*, the first on the eastern wall of the room, and the first of the Zodiac signs, the Ram. Although I don't know whether it is more than chance that the winter month frescoes barely survive beyond a few damaged fragments, it may well be that this *March* composition began the series in Renaissance eyes; certainly this wall was always the entrance one, because Cossa – the painter of this fresco – so refers to it in 1470. Several things combine to suggest that the fresco cycle begins here, with the first spring month, presided over by Minerva riding in triumph [plate 54]. To my mind, it is she rather than the Zodiac sign which sets the tone for this month; indeed, this may well have been the original intention of the whole series, assuming that each uppermost band is meant to relate to the lowest scene in each case. For at least some of the later months, it seems impossible to make out such a coherent relationship. But the original programme may have become modified during the work of execution, or was always perhaps somewhat loosely devised. Pellegrino Prisciano seems, in addition, not to have been immune from making one or two classical errors.

Minerva's allegorical triumph is an essentially courtly affair, personally linked with Borso d'Este by the use of unicorns – one of his chosen devices – to draw the chariot. Such elaborate constructions were real enough. A glance shows indeed how practical Cossa's chariot is – really no more than a wagon disguised by rich hangings. Not only are such the typical actual vehicles of any Renaissance pageant, but we fortunately know that when Borso visited Reggio in 1472, after being created Duke, he was greeted at the city gate by a series of triumphal cars, one of them drawn by artificial unicorns.[23]

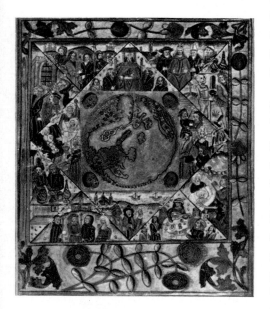

53 Astrological and geographical world miniature for the future Henry VIII

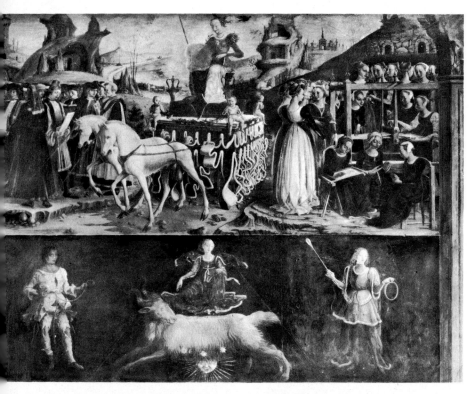

54 (*Left*) *Triumph of Minerva*: Palazzo Schifanoia frescoes (detail of *March*)

55 (*Below, left*) *Group of scholars*: Palazzo Schifanoia frescoes (detail of *March*)

56 (*Below, right*) *Girls weaving*: Palazzo Schifanoia frescoes (detail of *March*)

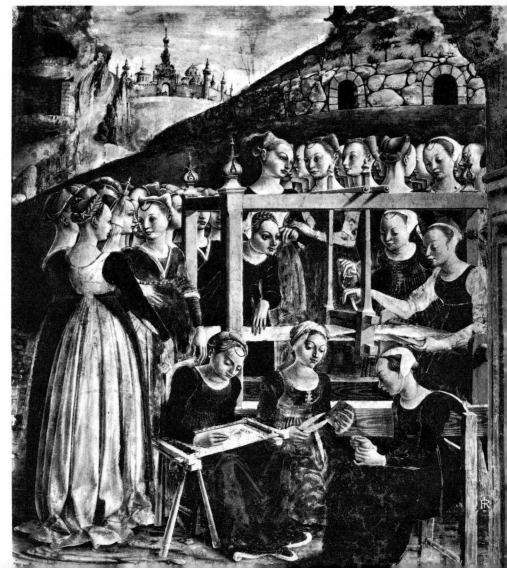

A unicorn also sits above the Este arms on the façade of Schifanoia. Minerva's influence extends around her, not so much in allegory as in the straightforward depictions of learning and industry, manifested in activities traditionally under her patronage [plates 55 and 56]: university scholarship (probably with reference to Borso's reforms of the university at Ferrara), especially jurisprudence; and the domestic activity of girls weaving.

Minerva's position in the upper portion suggests industry and activity, combined with justice. The point is made by the painted building – not totally dissimilar to the doorway of Schifanoia itself – where the Duke is seen hearing a plea [plate 57]. There the doorway behind is positively inscribed with the word *Justicia* (*sic*), as though guaranteeing the right outcome. Perhaps the most remarkable thing about this scene is its sense of informality, along with its verisimili-

57 *Duke Borso hearing a plea*: Palazzo Schifanoia frescoes (detail of *March*)

tude. There is no shift of mood between this side of the fresco and the adjoining portion where the Duke rides out to hunt [plate 58]. Although damage has made this look ghostly, nothing could be less allegorical, and at the same time less ceremonious. We are immediately convinced that this is how life was under Duke Borso in fifteenth-century Ferrara. It has something of Chaucer's economy and directness; and something too of his grasp of humanity under alien customs and clothes:

> '. . . and yet they spake hem so,
> And spedde as wel in love as men now do.'

Although Cossa has to dispose the space arbitrarily, he yet sums up most effectively the climate of a small Renaissance court. It seems perhaps too ideal for factual truth – Burckhardt's dream of the

58 *Duke Borso out hunting*: Palazzo Schifanoia frescoes (detail of *March*)

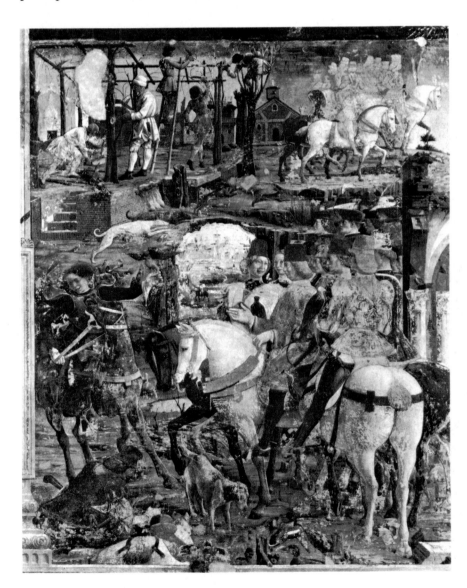

59 A. Lorenzetti: *Outside the city*
(detail of *Good Government*)

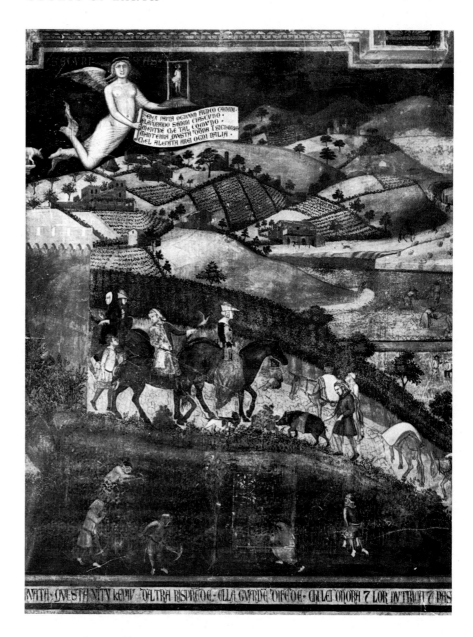

perfect Italian city-state, one might say. And although Burckhardt
rather missed the real significance of the Palazzo Schifanoia frescoes –
'a series of historical representations,' he called them – he certainly
makes Renaissance Ferrara sound attractive enough: '... the first
really modern city in Europe; large and well built quarters sprang up
at the bidding of the ruler ... a true capital ...'[24] The government is
in one man's hands. He dispenses justice. He leads his courtiers out
hawking, more squire than king in many ways, an undisturbing
presence to the peasants who work while he enjoys leisure. Peasants
too have their place in the scheme of things. This is a perfect com-
monwealth: the ruler prudent and wise; his people – among whom
we may reasonably include the groups on either side of Minerva –

literate, domestic or pastoral: all contentedly employed in a prosperous land. Such a vision of good government – of, literally, *Securitas* – had been seen a hundred years and more before on Italian palace walls, in the Lorenzetti frescoes in the Palazzo Pubblico at Siena [plate 59].

But that shows the triumph of the Commune in Siena's own city hall. Schifanoia is the private palace of a reigning Duke; it is his benevolent presence that is the reason for Ferrara's prosperity, admiringly reflected in these frescoes.[25] The heavens above, with the gods and goddesses of antiquity, are possibly less relevant than the personality of the ruler – who appears, usually twice over, in every fresco. Yet even the allegorical and astronomical machinery is, I think, part of a fresh determination to fix mankind in the framework of a real, scientific universe. Though picturesquely shown, the Zodiac signs stand for assumed truths – truths gained not from Christian relevation but from synthesizing knowledge from all sources, including Arab astronomers. And even if contemporaries might have needed guidance over the interpretation of abstruse aspects in the astrological and allegorical zones, they will have needed none over the scenes which record the ruler's daily life. Had the series survived intact (if it was ever completed) we should have had a year in the life of Borso d'Este.

Nor is it always just the ruler's life – as we have seen – which is reflected. While Venus rides over the waves, triumphantly presiding as symbol of April, the month is more topically represented by the scene of the palio help in Ferrara on St George's Day, 23 April [plate 60]; and Venus's influence is reflected in the choice of occupation for the Duke in this month, as well as in the diversions which Venus rules over. The relation of the planets to human occupations is undoubtedly one of the themes at Schifanoia. Venus is protectress not only of singers and musicians but – according to a very popular fourteenth-century astronomical manuscript – of jesters.[26] That it is

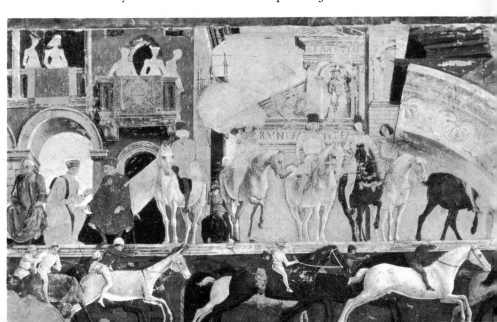

60 Cossa: *Scene of the palio*: Palazzo Schifanoia frescoes (detail of *April*)

in this Venus-dominated composition that Borso rewards his court jester, Scoccola, is surely deliberate [p. 44, plate III]. As an indication of the keen truth to detail, it is worth noticing the Duke's peculiar way of clasping the long sleeves of his tunic across his waist. The painter, here certainly Cossa, gives a witness-like quality to details of this sort; it is by such individual touches that life is breathed into the image of the ruler, man not icon.

I may seem to have spent a long time delaying at Schifanoia. Yet even chronologically, that seems justified. When Cossa wrote to the Duke claiming to be paid more than the inferior painters who had worked in the room with him – that is, in 1470 – the fresco cycle was almost certainly completed. It thus seems to have distinct priority over that other famous cycle showing a comparable ducal court, Mantegna's frescoes of the Gonzaga family in the Camera degli Sposi at Mantua, which is dated 1474.[27] The steady affinities in family and artistic relationship between these two courts are borne out by the fascinating links between the two fresco cycles. More than triumphs of group portraiture, they are triumphs of atmosphere, capturing the tenor of court life in a way that would have been impossible in oligarchic Venice or emotionally democratic Florence. It is an interesting paradox that only in those states where everything revolved around the ruler, technically a tyrant whatever his actual behaviour – only there was art encouraged to show the ruler in domestic rather than in public guise.

No group portrait of the Medici family was painted in the fifteenth century. At Venice, the Doge was painted performing state functions – but never as relaxing with his family in the intimate business-cum-leisure fashion of Mantegna's Marchese Gonzaga, with his wife, his children, his courtiers and a pet dwarf as well as a dog. At Urbino Federico da Montefeltro was depicted sitting reading or listening to a lecture. At Rome the culmination on a large scale of that popular court subject for illuminated miniatures, author confronting patron, came in Melozzo da Forlì's *Platina kneeling before Pope Sixtus* IV [plate 61]. This time the Papal court is shown with factual sobriety: a record of truth rather than a doctrinal statement, in a scene which glorifies the Papal librarian and author, Platina, scarcely less than his patron. Yet this too, like Mantegna's frescoes in the Camera degli Sposi and the group portraits of Federico da Montefeltro, is antedated by the Palazzo Schifanoia frescoes.

Taken together, these works represent the quintessence of a pervasive Renaissance wish to tell the truth about the prince and his place in the scheme of things – not in any shocking sense but in a belief that his place is so sure and dignified that the truth needs no enhancement. At Mantua, the framework of actuality does not have astronomical tendencies but celestially evokes the sky – sky rather

than heaven, with consciously playful effect. Yet there on the ceiling are medallions of other historical rulers, Roman emperors, who thus are brought into a relation with a modern ruling family – a family which does not assume Roman trappings, yet confidently joins in antique associations, suitably in a city which had been Virgil's birthplace. Nor did Borso d'Este – for all his love of splendour – want himself painted in, for example, the full regalia which he had to wear when the Pope ratified him as first Duke of Ferrara. At that time, Borso wrote to a friend describing the crimson and ermine robes he wore, and saying, 'you would have thought you were seeing a Cardinal, and we should have made you laugh in this new costume of ours.'[28]

Too easily, perhaps, do we forget that Renaissance people were actually able to laugh in this sort of way. In Mantegna's frescoes we do see a cardinal, the young Cardinal Francesco Gonzaga, welcomed back from Rome by his family – in a scene where the emphasis is laid first on the solid, bodily reality of these people and then on them as swayed by intimate human affection: the Prince of the

Church becoming a son again at Mantua, drawn back into what is almost literally a circle, as he grasps his younger brother's hand – and in turn that younger brother lets his other hand be grasped by that of the smallest boy, the third generation [plate 63]. This is more than a dynastic statement. It does not tell us so much about the importance of having a cardinal in the family, as about the importance of having a family.

Of course, such humanizing of the ruler and his family did not mean that heaven had ceased to be conjured to play its part. There were still pictures whose ethos, though not their style, was the same as those which had been painted for Charles IV in fourteenth-century Prague. Very late in his life Mantegna painted the smallest Gonzaga boy again – now himself become Marquis of Mantua – kneeling at the Virgin's feet implying a great victory [plate 62], when in fact he had just been virtually defeated – at least eluded – by the French king at the battle of Fornovo, in 1495.(And as a French victory, the battle was painted in the nineteenth century by Féron, shown in the Salon of 1838 [Versailles].) Mantegna implies also the protection which heaven had not, in plain fact, very satisfactorily extended to the Marquis. Yet the picture looks opulent and confident enough. It is usually still called, ·with an irony increasingly obscured, the *Madonna della Vittoria*. Few people who look at it today realize that it commemorates what was at best a dubious victory. Francesco Gonzaga had, by any standards, not emerged well from the battle of Fornovo: even his motives were not above suspicion, because he did not appear totally hostile to the French. Whatever Italy's doubts about him as hero, however, heaven is shown having none. Two warrior saints testify silently to his celestial bravery. At the same time, there remains from the earlier concept of this altarpiece – commissioned before the battle of Fornovo took place – a suggestion of mercy as well as victory. Originally it was planned as a *Madonna della Misericordia* who should protect the Gonzaga family, Francesco's wife, Isabella d'Este, as well as himself. Fornovo changed that; today we see only the Marquis in armour kneeling there.

In such work we encounter also very personal pressure exerted by the patron. The painter at court begins to experience the miseries as well as grandeurs that come from servitude. Mantegna, devoted though he was to the Gonzaga, sometimes displayed what appeared capriciousness, in trying to avoid a commission he did not want. Other painters, like Ercole Roberti, would claim total attachment to their prince but movingly stress their own need to be paid and to live.[29] For those who would serve a court there would always be a variety of tasks, beginning with the provision of an agreeable setting for a princely patron. It would go on being a court requirement, too, to mirror quite soberly – without flattery and, of course, without

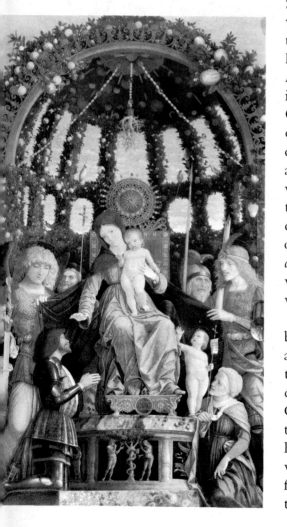

62 Mantegna: *Madonna della Vittoria*

63 Mantegna: *Return of Cardinal Gonzaga* (detail)

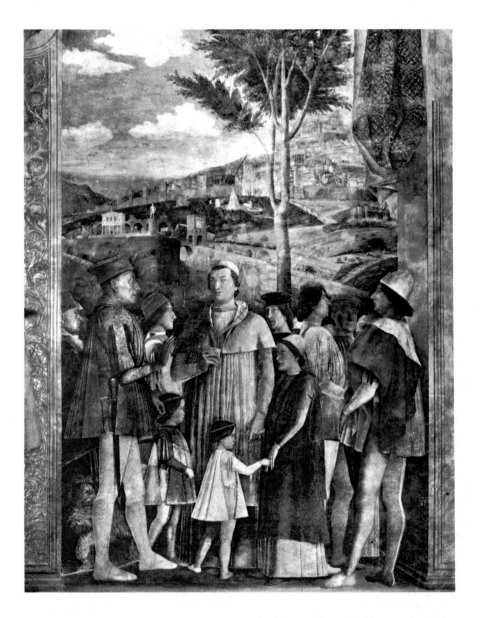

satire – the particular environment of a king. Thus Velázquez's *Boar Hunt* [plate 122] is not only a knowledgeable panorama of life at the court of Philip IV, but a legitimate continuation of the Limbourg Brothers, the Schifanoia frescoes and Mantegna. One can trace the trajectory until eventually it falls with rather a leaden thump into the court of Queen Victoria; there no amount of money would persuade Landseer to paint the marriage of the Prince of Wales.

Meanwhile, more frankly propagandistic ways existed for painters to be used at court, following up with sharper emphasis hints in the *Madonna della Vittoria*. Queen Elizabeth is to be seen on the earth [plate 64], but she straddles it with remarkable effect, claiming a new giant importance for the sovereign as incarnating land and people. This is a triumph of pictorial propaganda. Having conjured

heaven and then enjoyed human dignity, monarchs and rulers would go on to blend the two and aim for new, divine status. Queen Elizabeth was not alone in the claims she is shown making pictorially; nor was she alone in controlling the images of herself disseminated by paintings. Other sixteenth-century rulers proved to have equally sharp eyes for the suitable dynastic impressive image, for the highly personal allegory which would elevate them into spheres beyond the reach of ordinary men.

64 *'Ditchley' portrait of Queen Elizabeth*

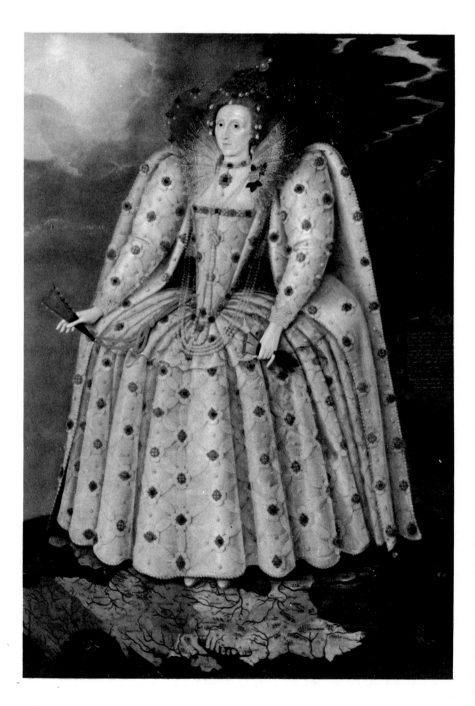

3 PROPAGANDA FOR THE PRINCE

In 1532 there was published at Rome a short book which we now know as *The Prince*. It had not originally been intended for publication. Its author had died five years earlier, a neglected, disappointed figure who in the dedication of his book complained of the long persecution he had suffered from fortune. Machiavelli never knew – and could not possibly guess – the fame that his private treatise would bring: giving him a world-wide name which was, however, to become virtually a synonym for treachery, dissimulation and political double-dealing of every sort. In that sense it had entered the English language by 1579,[1] and ever since it has remained current.

Machiavelli deserves the fame – but not the odium. *The Prince* is a brilliant piece of political history and a superb *exposé* of how to win kingdoms and influence events. It crystallizes lessons in statecraft which had for long been silently put into practice by shrewd rulers. And for our immediate purposes it crystallizes something else: the likely discrepancy between the public show and private behaviour of the prince. It has been estimated that between the years 800 and 1700 some one thousand books were accessible, telling princes how they should best govern.[2] The majority are ethical, even religious, in their emphasis on a practical, limited monarchy, the sort of thing urged by Erasmus in his *Institution of a Christian Prince* (1516). After those, Machiavelli's advice is crisply realistic and politically sharp in its wisdom: 'It is not necessary, however, for a prince to possess all the good qualities I have enumerated, but it is indispensable that he should appear to have them.'

In stating that, with such complete candour, Machiavelli destroys the medieval concept of the ruler who really must *be* virtuous because he is the image of God (who cannot be deceived by show). He also destroys the early Renaissance humanist concept of the ruler who is morally good, as were the good rulers of antiquity, for the sake of fame and out of sheer love of virtue. Erasmus had produced an admirable ethical essay; but it would hardly work as practical policy. Neither the Emperor Charles IV nor Borso d'Este would, we may guess, have seemed to Machiavelli to have much relevance as types of 'the prince'. The prince is concerned with power. The perspective of existence begins and closes therefore with his exercise of power. And the examples quoted by Machiavelli of actual rulers leave no doubt of the importance he attached to the prince's behaviour – not for any religious or ethical reason but out of policy. Cesare Borgia, according to Machiavelli, failed only through bad

IV Vasari: *Apotheosis of Grand Duke Cosimo de' Medici*

luck. As for Pope Alexander VI, he 'proved to the world what a Pope was capable of doing by means of men and money'. Pope Julius II did even better. Such rulers are successful because they understand the art of government: that partly consists of doing one thing and saying another. From that springs the idea of propaganda. And Machiavelli throws in a suggestive remark for any ruler who is thinking of utilizing the visual arts for this purpose: 'All men have eyes, but few have the gift of penetration.'

Appearances are exactly what painting can deal with. It is adept at casting a flattering glow around awkward facts, as is shown in Mantegna's *Madonna della Vittoria* [plate 62]. Machiavelli might have congratulated the prince who ordered that work of art. What is more, of course, painting can immortalize the more desirable qualities of the prince, and inspire them in his subjects. A favourite story among Italian artistic theorists of the sixteenth century concerned those heroes of antiquity who had been excited to virtue and good actions by a sight of statues of other great men.[3] Thus Julius Caesar had been inspired by a statue of Alexander, an instance vaguely cited also by Machiavelli.

In these ideas there is nothing that is truly new – as indeed the examples from classical antiquity show. Nor in the use of painting to convey the ethos of a particular ruler was there anything particularly novel; it had already been done in 1317, in Simone Martini's painting *St Louis of Toulouse* [plate 4]. But there the ruler sought divine sanction. That kings are God's vice regents was an accepted medieval view; it may be most eloquently expressed by Shakespeare's 'such divinity doth hedge a king', but that is the summing up of a long-established belief, not a new doctrine. We shall meet it again in the seventeenth century.

Yet, even while granting the tradition of the doctrine and the occasional appearance of it in pictorial terms, we will see that the Reformation crack across Christian unity, the concurrent rise of nation states, plus the very vividly dominant personalities of several rulers in the early sixteenth century, combined with the appearance of some of the greatest geniuses in Western painting – all gave new impetus to the uses of painting at court.

Glancing rapidly back at the outstanding uses made of painting by rulers, as we have seen them so far in this book, I think it is noticeable that they tend to divide into religious-cum-state examples, like Simone's and Mantegna's, and the unassertively personal. The decoration of private studios and rooms in palaces, as in the case of Federico da Montefeltro, remains largely free of dynastic obsessions or self-glorification. And where the intention is not didactic, it is usually decorative.[4]

65 (*Above*) Pintoricchio: *Worship of the sacred Apis*

66 (*Below*) Pintoricchio: *Apis carried in procession*

It is a different matter when we turn to Pintoricchio's paintings in the Vatican for Alexander VI [plates 65 and 66], celebrating the Borgia family.[5] Although in adjoining rooms to these scenes the Pope kneels before a vision of the Resurrection, and there are depicted the Liberal Arts, striking novelty exists in the concept of adoring the resurrected bull god, Apis, chosen here because the bull is part of the Borgia coat of arms. And such frescoes are no bad pictorial illustration of Machiavelli's remark about what Alexander VI showed the world can be achieved 'by means of men and money'. It certainly shows the prince well aware of what painting can do in this sort of glorifying way. By use of a rather off-beat, unfamiliar image from ancient, pagan religion – not Greek or Roman but Egyptian – it gives a magic aura to the idea of the Borgia family, triumphantly raised up, if not exactly resurrected. In a magnificent way, too, their coat of arms has come alive in a splendid, spangled animal who does indeed sum up the vigorous animal spirits of Alexander VI.

67 Pintoricchio: *Disputation of St Catherine* (detail)

This may be a novel way of celebrating being made Pope. But Alexander had begun the novelty at the very time of his coronation in August, 1492, when the profusion of the display of the Borgia arms with prominent bull had led one Roman satirist to suggest that it was the discovery of sacred Apis which was being celebrated.[6] Under Alexander VI the Papacy was made to reflect the man and the office – the office as great politician rather than priest. And in art too he brought together the state and personal concerns in a whole series of paintings by Pintoricchio of his own life. That series is unfortunately destroyed, but some other work by Pintoricchio suggests their probable flavour [plates 67 and 68]. One is the very worldly, somehow Borgia-infested *Disputation of St Catherine* from the Borgia apartments; the other is from the life of Pius II in the Piccolomini Library at Siena, a series which may well have been suggested by that dealing with the life of Alexander VI, which the Pope had had painted at Castel S. Angelo.[7] In those lost frescoes

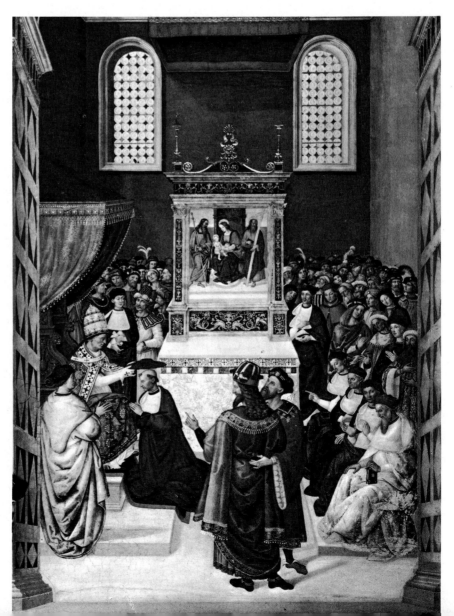

68 Pintoricchio: *Pope Calixtus* III
giving a Cardinal's hat to Æneas Sylvius

mingled portraits of many of the Borgia family, including Cesare Borgia, but the basic theme was the triumph of Alexander VI over Charles VIII of France. Owing to the epigrams originally placed under at least some of these compositions, we know that the king was shown in one prostrating himself before the Pope; in another he declared his loyalty before the whole consistory of cardinals; in a third he accompanied the Papal procession.

The two compositions reproduced give us a good idea of the style of 'history picture' which Pintoricchio would have produced, but with these differences: in one he had an ostensibly religious subject: in the other he was painting the story of a Pope he had never known, dealing with remote events in Italy of fifty years earlier. In the lost Borgia series, he depicted his own living patron and his powerful, ubiquitous children, dealing with a topical and dramatic event of only the year before – modern political history, which openly glorified the abilities of Alexander VI.

We have come a long way – in a very short period of actual time – from the Florence where the Medici were sharply warned against putting their insignia all over buildings they had built. That was not the method of Alexander VI – immortalized between two Borgia bulls in the marble decoration of a room in the Vatican [plate 69]; it might well be called a triple portrait. Only a few years before it was executed, Lorenzo de' Medici had written a letter to his young son Giovanni who was going to live in Rome as a cardinal – the youngest cardinal ever created. His advice was against ostentation: to have only moderate displays of silk or jewels, and to have a well-ordered establishment rather than anything 'ricca et pomposa'.[8]

69 *Decoration with two bulls' heads and head of Pope Alexander* VI

70 Raphael: *Leo* x *with two cardinals*

Not only would such advice have puzzled the Borgia, already famous for his luxury, who ascended the Papal throne in 1492, but it is ironic advice – sober, *quattrocento* advice long gone out of date – if we reflect on it while considering the portrait of himself which this young cardinal was later to commission from his court painter, Raphael [plate 70]. For he too, of course, was to become Pope and make his reign and his court, and his patronage of artists, all famous for sheer magnificence. *Ricca et pomposa* might almost have been his motto. Continual and splendid display was part of his character; perhaps his father had recognized as much when he originally warned him against ostentation.

It is certainly a convenient fact that it was while Leo x was Pope that the Raphael-organized decorations for the Vatican *Stanze* became most illustrative, naturalistic and topical in their references.

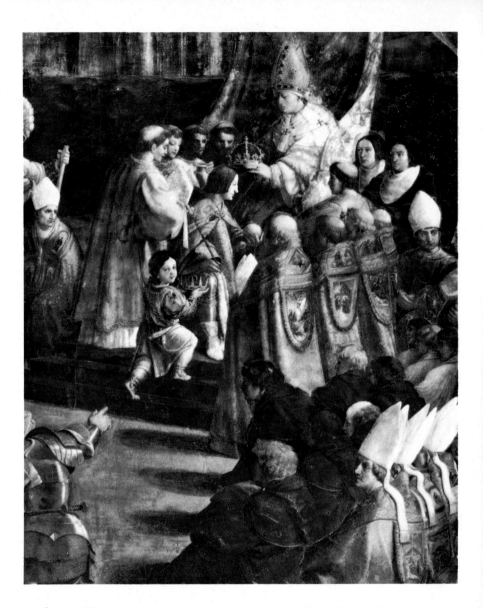

71 Raphael Studio: *Coronation of Charlemagne* (detail)

A fresco like that in the Stanza dell' Incendio of the *Coronation of Charlemagne* [plate 71] is recreating history with the most patent of allusions to – not Pope Leo III but the reigning Leo X, whose portrait is utilized. The scene itself is, as it were, a cornerstone in the construction in the myth of Papal power. Leo III, the Pope who had actually crowned Charlemagne – against the Emperor's will – had commemorated the achievement by a mosaic in the (old) Lateran Palace which showed himself and Charlemagne with St Peter.[9] In the Stanza dell' Incendio there is perhaps a topical reference to the Concordat of 1516, agreed between Leo X and François I, which had been a diplomatic victory for the Pope. Although aesthetically this fresco is probably one of the most despised of those executed by and under Raphael in the Vatican, it interestingly brings to life the court under Leo X – and recalls closely the type of Pintoricchio's frescoes for Alexander VI. The aura of a Papal court, with impressive row of mitred heads is combined with the dominating figure of Leo X

himself, framed by a sweeping curtain patterned with crossed keys and the Medici *palle*. These pretensions with regard to the Papacy probably did not much interest Leo x himself; at least, to catch his personal character something closer to Cossa's scenes of Borso d'Este hunting and hawking would have been more apt.

From Raphael's portrait emerges the personal character of Leo x; its richness is his, with richness of costume, sense of richly-worked *objets d'art* and illustrated book to which the Pope sits up – as if to a meal. Without too insistent a note of ceremonial, it breathes a sense of calm opulence unparalleled in any previous portrait of a Pope: shown here as emancipated from the cares of office – those delegated, as it were, to the attendant cardinals – rich in leisure as well as worldly goods, a connoisseur of art as well as a ruler. This is what the successor of the fisherman, St Peter, had become: it might seem fine to Machiavelli, but not quite so good to Luther. In this portrait we have, in fact, at the very time when kings were beginning to be portrayed with divine symbols and apparatus, the Pope painted without any specific suggestion of power, earthly or spiritual. Images of national rulers were to become increasingly remote and hieratic; Raphael instead provides the closest of close-up views – perhaps the frankest ever painted – of the world's spiritual leader.

One last sixteenth-century Pope did attempt to combine spiritual and temporal leadership: Julius II. Machiavelli, whom we know to be not easily led into attributing virtue to anyone, said of Julius that 'he laboured more for the Church than his own private interest'. Thus it is that he kneels at the *Mass of Bolsena* [plate 72], scarcely humble, no less imperious-looking than he appeared in life, yet personifying faith – for all his splendour – in the central mystery of the Roman Catholic religion.

In an earlier chapter I mentioned the heavenly future which was thought sometimes to be specially reserved for rulers: in a medieval life of the martyred king, St Edward, it was told how his good friend St Peter welcomed him into heaven: the Duc de Berry had been shown in a miniature welcomed into heaven, also by St Peter. A satire on Julius II – a satire probably written by Erasmus – cruelly played on this traditional welcome.[10] Called *Julius Exclusus* and first published in 1517 a year or so after the Pope's death, it is a mordant dialogue between St Peter and the Pope, in which the one-time fisherman quite fails to recognize in the splendidly-clad figure his spiritual successor. The Pope produces some keys; they prove to be those not of the heavenly kingdom but of his cash box. Less lucky than George III in Byron's *Vision of Judgment*, the Pope does not manage to slip into heaven. He is left paying a heavy price for concentrating on temporal earthly power.

72 Raphael: *Julius* II (detail from *Mass of Bolsena*)

73 Holbein: *Henry* VII *and Henry* VIII

The irony of *Julius Exclusus* is, of course, based on the double standard involved in being both temporal and spiritual ruler. In his own particular mirror for a ruler (*The Institution of a Christian Prince*, 1516) – written positively for the future Emperor Charles V – Erasmus counselled moderation: moderation even of the ruler's claim to rule, for that itself is in his eyes a mutual contract: 'it is consent makes the prince.' These Utopian sentiments are possibly a conscious echo of More's work: they are important in a history of European progress, but they turn out to have very little relevance to the world of those princes to whom they were, in effect, addressed. Most of these were busy parcelling out the divine right among themselves, and wrapping up their rule in an autocratic aura. The very person who seemed to Erasmus and More to be a pattern of the Christian monarch was the English king Henry VIII, soon to reveal his dynastic, autocratic character in a sphere where More could no longer obey him.

The claim to unite in themselves spiritual and temporal which had been made by the Popes and Emperors was now to be made by individual rulers, themselves ruling the newly-evolved European powers [plate 73]. In themselves they might be showy and magnificent, like Henry VIII, but each also stood for a concept of national magnificence, a secular mystique which replaced the international piety of medieval Christian Europe. Henry VIII bestrides his kingdom it seems, a not so petty colossus, supported dynastically by the presence of his father – who, however, does not compete for pride of place.[11]

The claims made here for the ruler in strongly realistic terms had already been made in much more purely allegorical ones by Dürer, in one of his panels for the richly intricate, over-elaborate triumphal arch of the Emperor Maximilian [plate 74]. Amid a riot of animal symbols, the Emperor is an almost apocalyptic figure, royal, prudent, courageous, and so on. Dürer's activity on this and closely allied tasks for Maximilian has not, quite naturally, been of great interest to connoisseurs of his art. A good deal of the work is not of the highest standard; much of it is not strictly by Dürer himself. But Maximilian's ideals – as put into a learned though scarcely pictorially rewarding programme by the court mathematician Stabius – are perhaps the most grandiose and typical in their claims for royalty which had until then been made in art. Though they are not expressed by painting but by the fairly humble medium of the woodcut, this is probably in part an accident owing to Maximilian's lack of funds. And even if the medium is humble, the scale of the *Triumphal Arch* is certainly vast enough for a whole fresco series, measuring over a hundred square feet when assembled. The comparison made by Stabius with the Triumphal Arches of ancient Rome is hopelessly

74 Dürer: *Symbolic portrait of Emperor Maximilian* I

inapt for such a proliferating Gothic folly, but it tells us something about the mood in which Maximilian erected this paper monument to the glory of himself and the house of Habsburg.[12] It comes halfway between the durable stone of Roman triumphal arches and those ephemeral festival decorations put up so often in Renaissance times to celebrate royal occasions.

Chivalric, generous, attractive as a personality, Maximilian had not in fact proved a triumphant ruler – as indeed was clear at the time when this propaganda programme was undertaken. Political realities had defeated the man celebrated here through the designs for triumphal cars. He was happiest in a mythical land of cloudy chivalry where it was romantic to be royal. The individual panels of alliances and events from Maximilian's life do not for a moment purport to record actual scenes [plate 75]. The assembly of princes at Vienna is – even in the restricted black and white medium – a rich, shimmering surface of pattern where the figures are as stiffly heraldic as the very shields. From this single composition – one of many on the façade of the Arch – the spectator gets an impression of Byzantine splendour, with scarcely human figures encased in the armour of heavy embroidered clothes, fringed with ermine and hung with jewelled chains.

Shakespeare – of course – has caught the mood perfectly in *Henry V*, where 'The sword, the mace, the crown imperial / The intertissued robe of gold and pearl' are part of 'the tide of pomp / That beats upon the high shore of this world.' These Habsburgs, clad

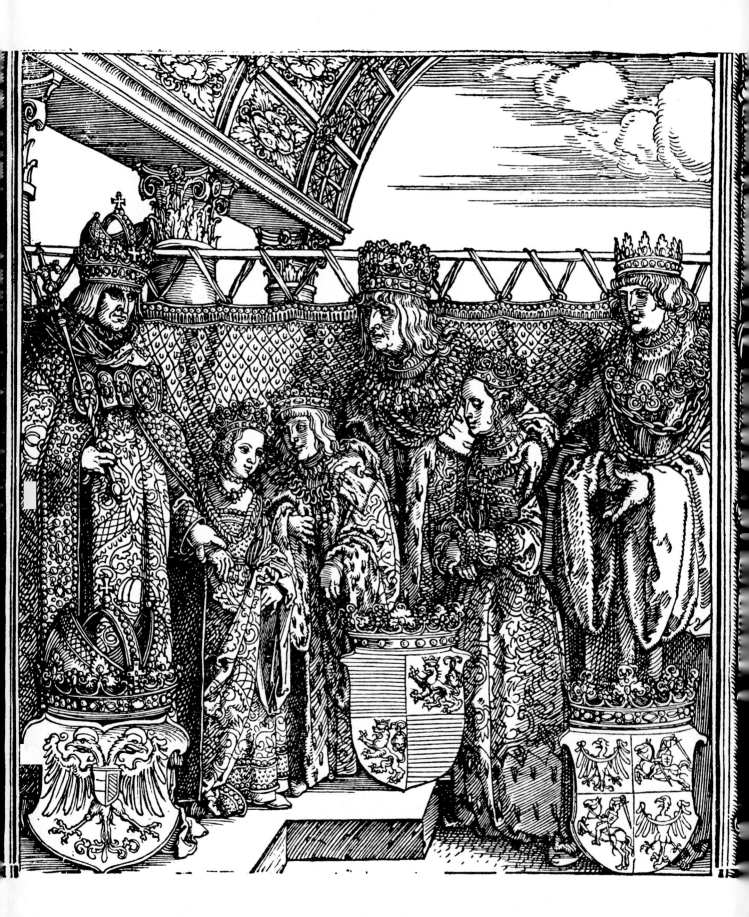

75 Dürer: *Assembly of the Princes at Vienna*

in intertissued robes, are secular saints. Indeed, this is a holy family, as depicted by Dürer, but its holiness is a matter of elevated rank: holy in the literal definition of kept apart, inviolate. To see how far we have removed from earth – not into heaven but into a sphere of pure royalty and princely magnificence – it may be useful to glance back at Mantegna's view of a princely family [plate 63], of some forty years earlier.

Just as Pope Alexander VI evoked the mythical Egyptian past when the bull-god Apis was worshipped, so Maximilian was evoking a hopelessly chivalric and aristocratic past. Elsewhere he mingled his real family with figures from mythology as well as history, culminating in the rows of lifesize statues for his own tomb at Innsbruck: a strangely moving bronze pageant-procession which seems intended to defy death and claim an eternity of fame for the subject. And in another, more simply effective triumphal arch than that of Maximilian, the one put up by the German merchants in London for the coronation of Anne Boleyn in 1533 [plate 76], Holbein seems instinctively to pick on the divine subject of Apollo as harpist.[13] Not only does this seem a patent allusion to Henry's fondness for the instrument, but perhaps – in Apollo's pose – there is some hint of the king's typical posture.

76 Holbein: *Decorative arch for the coronation of Anne Boleyn*

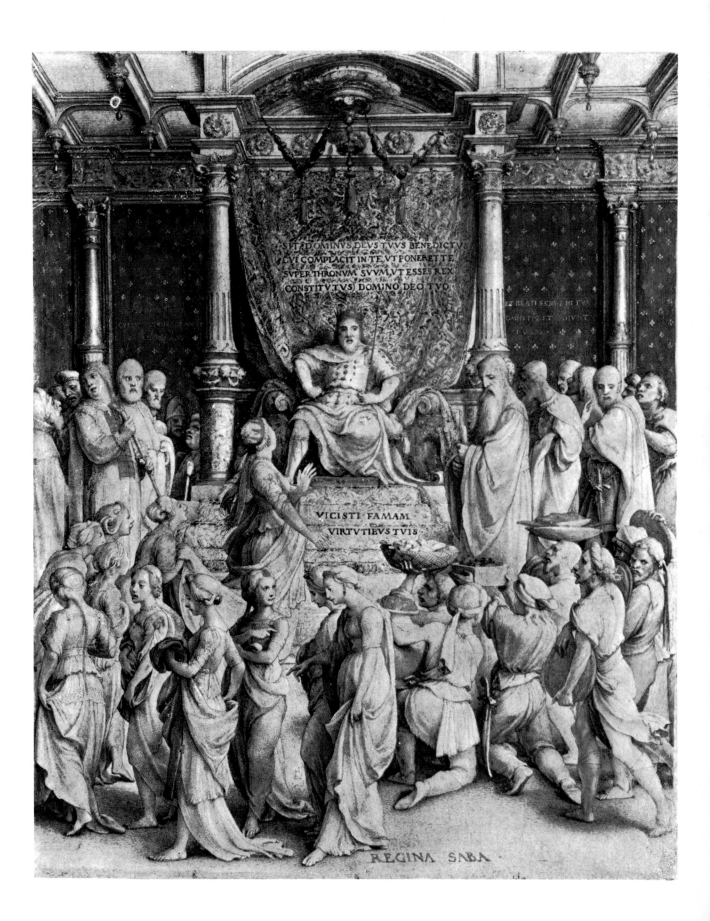

77 Holbein: *The Queen of Sheba before Solomon*

It seems more patent still in a Holbein miniature, which openly claims a sort of sub-divine status for Henry VIII [plate 77].[14] Here the king has assumed the role of Solomon, not in judgment, nor in any action, but in order to receive the homage of the Queen of Sheba – a mere lay-figure, conveniently turned towards the king so that nothing interferes with the impact of his full-face, frontal pose: the hero seated at the centre of homage from all sides, in an obviously Tudor setting. And across the curtain above him are the Queen of Sheba's words on meeting Solomon: 'Blessed be the Lord thy God, which delighted in thee to set thee on his throne, to be king for the Lord thy God.'

Analysed in the context, the text seems to compliment God for having had the sense to choose Henry VIII to be king. That certainly reflects well enough the policy which was encouraged for the English crown when Thomas Cromwell became chief minister – at a moment when it was essential to bolster the throne after religious dissension. Cromwell had definitely, and usefully, read Machiavelli's *Prince*. It was a brilliant political move which made Henry VIII, by the Act of Supremacy of 1534, head of the Church of England. With that realization we should look at Holbein's majestic composition – no more than a miniature, yet worthy to fill a whole wall. The subject of the Queen of Sheba's visit to Solomon was an old-established religious motif (occurring, for example, at Amiens, Chartres and Rheims); in medieval analogy, it symbolized the Church coming to hear Christ's words, or the adoration by the Magi of the divine wisdom. Thanks to Cromwell, Henry VIII and Holbein (himself of rather vague religious allegiance, a suitable sounding-board for not too complicated theology), the *Visit of the Queen of Sheba* has taken on a personal application to one monarch, himself a Solomon, hailed by a Queen of Sheba standing perhaps for the English nation. Nor, surely, is it any accident that the very setting has affinities with that of Holbein's woodcut of the king in council.[15]

Such specific Tudor uses for painting, to unite the nation under the monarchy, are particularly associated with the style required to do justice, a few years later, to Henry VIII's daughter, Elizabeth [plate 64] which may seem to mark the extreme of royal idolatry, encouraged by, and in turn no doubt inspiring, the flattery of the poetry of the period.[16] The extraordinary icons of her that were evolved are in fact part of a whole European movement: in all rulers was to be seen what George Puttenham in his *Art of Poesie* (1589) saw specifically in Queen Elizabeth: 'the very image of majesty and magnificence.' And the Queen is recorded to have ordered to be burnt at one period all portraits of her done by unskilful 'common painters' – those probably who forgot to show her either as majestic or as an

ageless beauty. 'Times young houres attend her still,' rhapsodized a prudent poet, clearly taking the right propaganda line. Her lovers might grow old – but not she. It is no wonder that in one of the most extraordinary of all royal allegorical pictures, the new-style Judgment of Paris [plate 79] she is shown (herself the judge and the victor of the contest) putting to shame Juno's power, Minerva's intellect and Venus's beauty. If her father could be Solomon, she could be Paris. Indeed, when she visited Oxford and Cambridge both universities said there could be no doubt she was Paris, complimenting her in that way on – above all – her judgment, a year or two before this picture was painted. It was equally as a marvel of prudent good government that François 1 had appeared. Just as Queen Elizabeth had undergone a sort of sex change, he also underwent one, emerging as in part a male Minerva [plate 78], depicted somewhat earlier by Niccolò da Modena.[17]

Even if we leave the Emperor Maximilian aside as a very special case, there is still no doubt that the allegorized portrait of the ruler and a tendency to reflect his abilities in pageant-like allegorical pictures – such as these – are two of the most typical achievements of sixteenth-century court art. In the right atmosphere it could even be useful for glorification of one's ancestors; thus Vasari produced exactly the sort of portrait of *Lorenzo il Magnifico* [plate 80] that the fifteenth century had failed to, making him in retrospect an almost literal vessel of prudence and statecraft. This was, significantly, produced when the Medici were re-established in Florence: just as François 1 was re-established, after defeat, when he began Fontainebleau. A few years after Vasari produced this deliberate piece of history re-written, glorifying the Medici rulers in the person of their ancestor, it was the turn of Popes Leo x and Clement viii – the family's two Popes – to be celebrated. The sculptor Bandinelli devised a scheme in which Saints Peter and Paul were subordinated to the two Medici Popes – an excessive piece of flattery which went too far even for Florentine court circles. Vasari, someone not easily shocked, as we know, by this style of propaganda, permitted himself an epigram. Bandinelli's scheme in fact pleased nobody; and in it, according to Vasari, he 'showed either too little religion or too much adulation, or both together.'[18]

Vasari's *Lorenzo de' Medici* provides a convenient prologue to what is probably the most fascinating of all sixteenth century courts for its blend of patronage and propaganda in the art commissioned there: the court of Duke Cosimo 1 de' Medici at Florence.[19] The very circumstances of Cosimo's election as ruler, his dynastic concerns and ambitions, not only give this art its particular flavour, but mark off this court in a special way that does not apply elsewhere in Europe. The Valois, the Habsburgs, even the Tudors, were established royal

78 (*Below*) Niccolò da Modena (after): *François 1 as Mars-Mercury-Minerva*

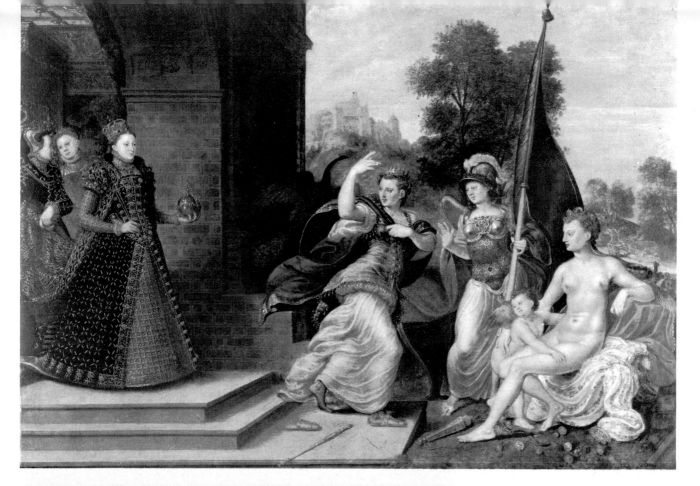

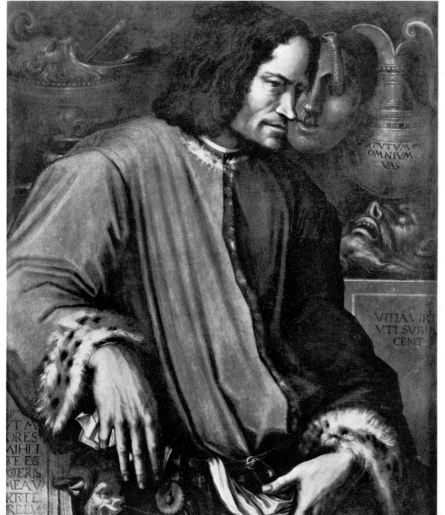

79 (*Above*) Eworth: *Queen Elizabeth and three Goddesses*

80 (*Left*) Vasari: *Lorenzo il Magnifico*

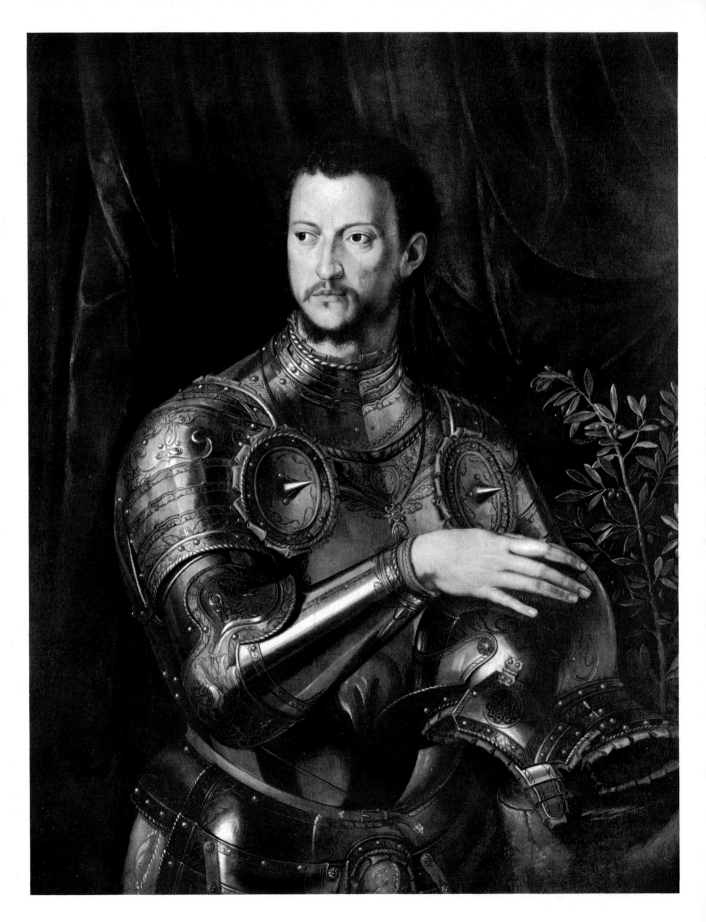

81 Bronzino: *Duke Cosimo I de' Medici*

houses. The Popes might or might not come from distinguished families, but their throne itself had been firmly enough established by Christ in person.

None of the rulers with whom we have been dealing had quite the same urgent need of what we may call 'putting himself across' as had the young, almost forgotten, member of the Medici family who suddenly became Duke of Florence in 1537 [plate 81]. Elected after the dramatic murder of his cousin, Alessandro, Cosimo was probably chosen for his name, his inexperience and his obscurity. He must have seemed a promising figurehead who would give no trouble while others ruled. Bronzino's portrait clearly tells us what an error that assumption was. And, oddly enough, at least one exiled Florentine recognized the inherent danger. The assassin of Alessandro had been his cousin, Lorenzino, who was hailed enthusiastically as a second Brutus. Yes – pertinently pointed out the exiled leader, Filippo Strozzi – but the analogy could prove too apt: once again assassination might turn out to be an ineffectual deed, 'Augustus succeeding to Caesar.'

This proved remarkably prophetic. Cosimo not merely built up a sort of pseudo-Augustan age, but he achieved a uniquely new

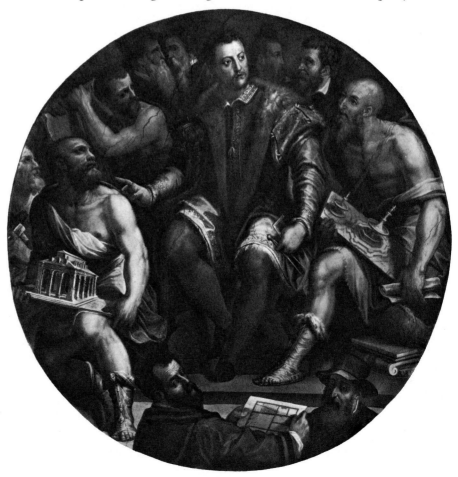

82 Vasari: *Duke Cosimo I and his artists*

rank, higher than that of any Medici previously, becoming first Duke, and eventually Grand Duke, of Tuscany. The dynasty he established lasted until the eighteenth century; his kingdom lasted until the nineteenth century. Perhaps it is there only potentially in Bronzino's painting, but it is already very much *there*: the coldly armoured face, as well as the actual armour, the ruler who has no doubts of his ability to rule. After the average moody-style portrait of sixteenth-century Florence, this positively clangs with certainty.

But it is only a beginning. It speaks of one who is prepared, yet scarcely prepares us for the thoroughgoing and tight grasp which Cosimo increasingly took on his state. He dominated: dominating the arts as we see in Vasari's painting in the Palazzo Vecchio [plate 82], where the Duke is the largest, central figure, inspirer like the sun of the planets orbiting about him. He himself becomes an artist – holding dividers and set-square – yet splendidly dressed in rich, contemporary costume, in contrast to his classically draped servants. He is the instigator and inspirer of artistic activity, of new buildings in Florence, and of all the arts (for painting and sculpture have their representatives here too) which circle about the princely commander.

And, we may ask, when was he not shown commanding? As sculpted by Cellini he was a heroic, frowning, imperial figure, an Augustus to overawe any republican tendencies in his citizens. It is right that Cosimo should look really terrifying in that bust, because Cellini – not someone easily overawed – has left testimony in his autobiography to the Duke's imperious temper which would suddenly burst out; yet it is pleasing to note that Cellini also tells how the Duke complained of his, Cellini's, *terribilità*. When it was necessary to show the Duke in action, positively engaged in bringing benefits to the city of Pisa [plate 83] there was a natural tendency to exalt him into this commanding sort of role, allegorically supported – as it were ordering the city like some god from classical literature, to enjoy the benefits of his rule.[20] Nevertheless, all the evidence we have suggests that allegorical homage was not particularly to Cosimo's taste when it came to political realities.

Something more explicit was needed, to show first Florence, then Italy – and finally all Europe – who was ruling in Tuscany. It was all very well for Pierino da Vinci to sculpt Cosimo surrounded by Neptune and Minerva, as well as by his own Virtues (as Vasari tells us). The Duke did not wish to be indebted to Neptune and Minerva; if he was sagacious or prudent, it was thanks to his own solid actual self. Perhaps, rather like Henry VIII, he wanted it to be seen that he was not so much a type of Solomon but a modern Solomon himself. When Vasari designed a composition of Cosimo in council with his ministers, planning war against Siena, the Duke swiftly criticized the composition, pointing out coldly that no

83 (*Above*) Pierino da Vinci: *Cosimo I bringing benefits to Pisa*

84 (*Below*) Vasari: *Cosimo I plotting war*

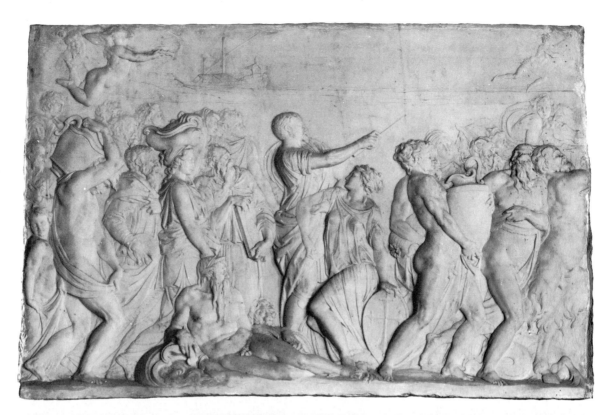

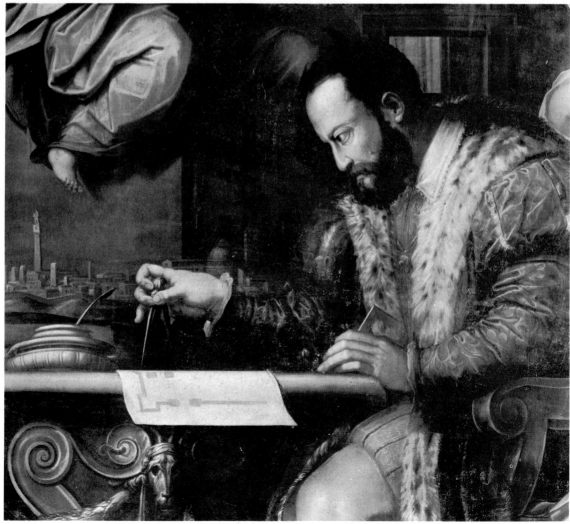

ministers were required. 'We were alone (*Noi fummo solo*),' he wrote back to Vasari.[21] It is true that in this instance he went on to say that he would permit the presence of some suitable allegorical figure, who might be shown beside him. But his choice is significant too; it should be a figure of Silence. It seems legitimate to reproduce a detail of the resulting picture which concentrates on the active wily ruler himself [plate 84] – alone apart from the allegories. In more ways than one, we may detect anticipations of Napoleon's demands from art.

The birth of an heir did not prompt Cosimo to the style of picture which Philip II of Spain commissioned from Titian [plate 85], celebrating at once the battle of Lepanto and the birth of a son to the king which followed within two months of the victory. That extraordinary composition once again states, in full High Renaissance style, the old, well-established belief in heaven's concern with reigning monarchs, and its interest in seeing their prosperity guaran-

85 Titian: *Allegory of the birth of
an heir to Philip* II

teed. Indeed, Philip – who was almost certainly adviser of the subject-matter here – has produced a sort of personal interpretation of the sacrament of Baptism; the heir to the throne receives a palm of victory and promise of greater benefits on the way (tagged with the cool phrase – greater things for you: *Maiora tibi*). For the baptism of his heir in 1542, Cosimo took equivalent pains with different results, celebrating the occasion by having the interior of the Baptistery at Florence completely modernized and decorated by Tribolo.[22] When there were only six days left before the ceremony Cosimo discovered it lacked a large painting and he ordered one. Alone among Florentine painters Vasari hastily obliged, thus conferring – so he tells us – grace on the whole decorative scheme.[23]

No doubt he did. But more important to Cosimo was the sheer fact of possessing an heir – not under divine sanction but to be seen simply, without allegorical properties, with his mother [plate 86]. For the small boy in this superb double portrait several identifications

86 Bronzino: *Eleonora di Toledo and her son*

have been proposed, and it must be admitted that the children of Cosimo and Eleonora di Toledo all looked remarkably alike. All the same, I think there are sufficient clues for us to be reasonably sure that what we see in this picture is Eleonora di Toledo with her eldest son, Don Francesco de' Medici, the second Grand Duke. It may be enough to say first that such a double portrait of this height, by Bronzino, is recorded in a Medici inventory well within his life-time.[24] And then, the dynastic reasons for such a picture being executed are obvious enough. Further, the Duchess looks very young in this portrait, which could therefore fit in very well with her age about the time her eldest son was four, that is around 1545; the boy here looks approximately that age.

87 Bronzino: *Giovanni de' Medici with a goldfinch*

At that period Cosimo had plenty of orders for Bronzino. In April of that year[25] he was given the quite difficult task of painting the most recently born Medici boy, Giovanni [plate 87], not yet aged two. We have an almost embarrassing amount of personal detail about these Medici children and thus are in a position to know that the fat lively boy was not merely very precocious but had already been spoken of in 1544 for his progress in teething.[26] Two lower teeth are carefully made visible in his portrait. When it was executed Bronzino and the boy were both in Florence, while the ducal family were staying outside the city at Poggio a Caiano. A letter to the duke from his majordomo tells us that Bronzino has perfectly portrayed Don Giovanni 'et è veramente vivo' – which is true enough. The letter goes on to ask if Bronzino should come out to Poggio to do the portraits of the other children. Though the answer appears to have been 'no' in May, by August Bronzino was there, reporting back to the Medici majordomo in Florence, writing letters which capture the tone of this close but power-obsessed court. A portrait which Bronzino calls simply Il Ritratto, had been executed. It would be very tempting to think that the reference is to the double portrait, for we even have a very unusual open-air setting – certainly never occurring in such a positively countrified form elsewhere among Bronzino's portraits. For a picture done in the country villa setting of Poggio, it would, however, make considerable sense. And it would then be the earliest version of a composition repeated later, almost certainly of Francesco de' Medici and his mother, and near to Bronzino in style.[27]

How closely Bronzino had been drawn into this world is shown by the courtier-style language he used to express the health of the ducal children: 'Our angels,' he writes, 'are all very well and are adored.' As for the death of the ducal jester, which had just taken place, Bronzino expresses sorrow on several counts: for he was an amusing and agreeable man, honourable and 'the most faithful servant of the heavenly house of Medici'.

That last phrase might serve for Bronzino's own epitaph. And when some years later the Grand Duke, as he had become, cut off Bronzino's salary, the letter the painter wrote is desperate under its fulsomely humble terms: he hopes that his imperial highness will see an occasion to use Bronzino for the little he is worth and will reopen the door of his most holy home (sua santissima casa).[28] It was one thing for the Duke to dispense with excess fulsomeness or formality; his employees were well advised to retain both when approaching him. And that is, in general, a trait which has always typified the uneasy relationship between the governed and their governors.

88 Bronzino: *Eleonora di Toledo*

Behind the door in the Grand Duke's holy house there dwelt the power of the state, enshrined in that nearly always armoured figure. The inner ring of this court was strangely isolated and lonely. There were those children whom Bronzino portrayed singly, with a poignancy combined with discretion not met again until – significantly – Velázquez. There was the ailing, prematurely ageing Duchess, who perhaps posed to Bronzino only twice: once for the type of portrait, often duplicated, of her in youth; and once again later in life, for a portrait which may no longer exist in an autograph version but which anyway marks the almost shocking change of her appearance [plate 88]. In his art Bronzino was no courtier in the conventional sense. The very 'realism' and steely directness of his

89 Bronzino (after): *Eleonora di Toledo*

portrayals are at once devastating and yet exactly what made him the ideal delineator – firm, bold, clear-cut and elegant – to serve the purposes of Cosimo de' Medici.

And to these artistic qualities must always be added Bronzino's literary ones. Himself from youth onwards part of a sophisticated, literate and poetic circle in Florence, he was not merely the painter of the Duchess and her sons but the poet who mourned them when she and two of them were carried off by fever in 1562.[29] 'Then are the stars mortal?' is the opening of one of his sonnets which bewails this monstrous calamity; another speaks of 'the chaste Juno that was Leonora'. Stars, goddesses – commonplaces of rhetoric, one will be told – and yet I think these people had been transmuted pictorially

by Bronzino into a comparable, inaccessible perfection, so wrought and congealed that there is nothing of living tissue left in them. Their hands have turned to ivory, and their eyes to pieces of beautifully cut, faceted jet. Thus, as I read it, Eleonora di Toledo was brought back in perfection after death [plate 89]. The Wallace Collection portrait is consciously posthumous – and the empty vase perhaps symbolizes death. More patent is the inscription with its threnody-like words: 'Favour is deceitful and beauty is vain' – a quotation from *Proverbs*, used in the mass for a holy woman.[30]

As for the Duke, depicted by many of his artists, he is recognizably the person to whom Vasari dedicated the *Lives* of the painters, hailing the Duke and the whole Medici house in the first edition for their great patronage of the arts, but going yet further in the second edition of 1568 where, of course, are included the lives of the painters still living and practising in Florence. How then, Vasari asks, could the *Lives* be dedicated other than to Cosimo?

For not only was it with your help and favour that they first came to the light, as now they do again, but you are, in imitation of your ancestors, sole father, lord, and unique protector of these our arts. Hence it is very right and reasonable that by these there should be made, in your service and to your eternal and perpetual memory, so many most noble pictures and statues and so many marvellous buildings in every manner.[31]

That quotation says enough, before we reach the passage where Vasari invokes the Duke to look into his soul 'like Almighty God', having previously compared unfavourably his own small knowledge to the Duke's greatness of mind and truly royal magnificence.

Enough is heard in these sentiments to crystallize the myth (which, by the way, does not necessarily imply that everything in it is false) not only of Medici patronage down the centuries but of the prince-instigator, to whose 'eternal and perpetual memory' it is now thought 'very right and reasonable' that so many works of art should be devoted. In many of these [plate 90], at least as executed under Cosimo's rule, we may feel that the dynastic references are more effective than any aesthetic merit. This *Holy Family*, by an unknown Florentine painter in the 1570s, completely fuses portraiture and religious picture in a composition where the Madonna is clearly Eleonora di Toledo and the saints are the Grand Duke at the extreme left, with several of his children as the other saints – a triumph of the 'holy house of Medici' indeed.

But the allusions were everywhere in the Duke's Florence: even in a painting of a foundry for the Palazzo Vecchio, we find Cosimo the centre of it (though rather difficult to detect), ordering and organizing [plate 91]. His arms appear prominently on the cannon in the foreground. While such an idea of the living active prince is one aspect of Vasari's panegyric, there is also the important, ever to

90 Sixteenth-century Florentine
Holy Family

be stressed fact that this ruler is linked to the *de facto* rulers of fifteenth-century Florence in the persons of his own ancestors; as Duke Cosimo appears patron and father of all artistic activity in the present, so his great-great-grandfather, Cosimo il Vecchio, takes his place at the centre of a circle of the famous men of his day [plate 92]. He is brought back to existence by Vasari, frescoed to be part of a complete room whose theme is the life of Cosimo. On the one hand, we have the 'imitation of your ancestors' as Vasari called it; on the other, this highly glorified depiction of one of the ancestors – the first to be commemorated in the whole suite of Medici rooms, each

devoted to a different but always successful member of the family.[32] The whole scheme was in Vasari's hands: it begins with plain, semi-republican old Cosimo and ends with the extraordinary apotheosis of Grand-Ducal Cosimo [p. 80, plate IV].

Only the high points of the family's fortunes over one hundred years are touched on by Vasari, whose fluent pictures resemble a eulogistic speech. Indeed, Vasari wrote the requisite eulogy – of himself and of the Medici – in the fascinating document of the *Ragionamenti*.[33] In those significant dialogues the painter takes the lead, while his – as we might say – stooge is the young Francesco de'

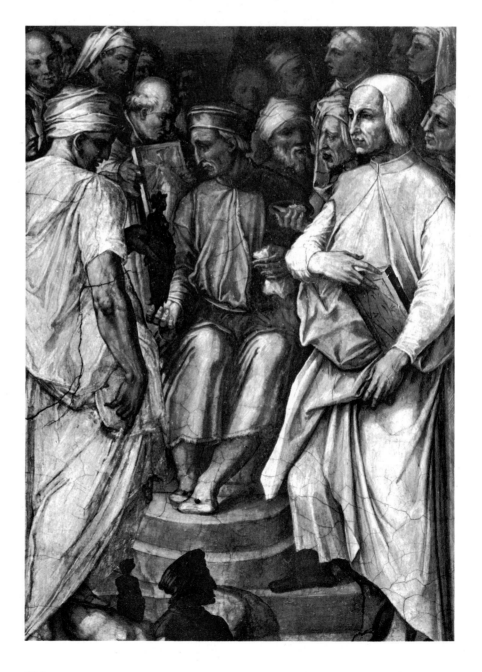

91 (*Opposite*) Poppi: *A Foundry*

92 (*Right*) Vasari: *Cosimo il Vecchio and philosophers of his day*

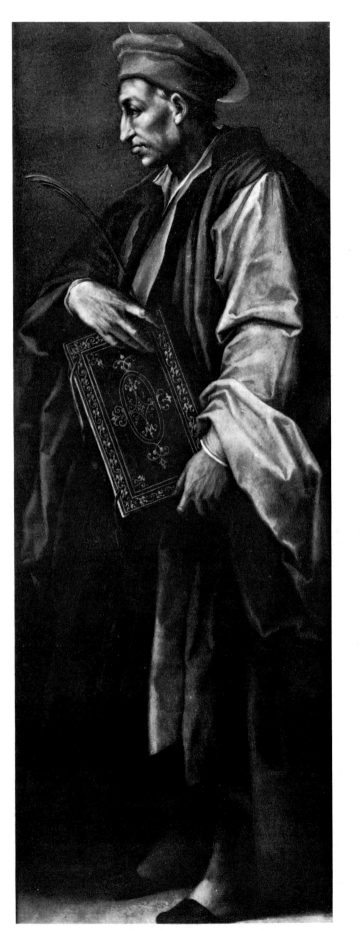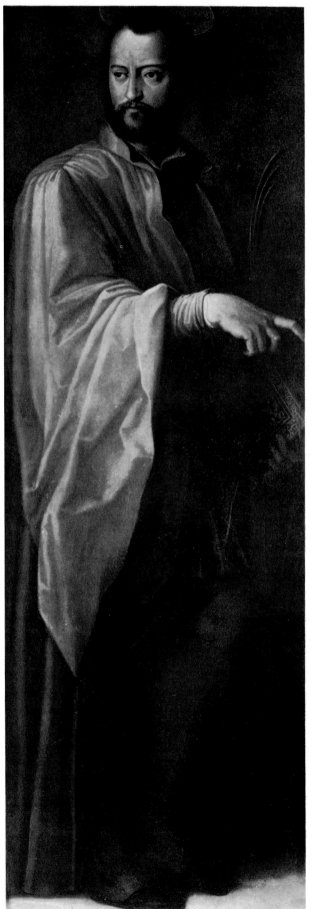

93 (Opp. left) Vasari: St Cosmas

94 (Opp. right) Vasari: St Damian

Medici, heir to the dukedom. Vasari sets the stage very well: it's a hot day and the young prince can find no coolness or repose in his own rooms so he has come to visit Giorgio. Together they tour Vasari's frescoes, giving the painter-author many a good opportunity for self-praise when the prince asks a question and the artist explains. And there is at least one moment of real drama when they have passed through the rooms of past history to enter the room 'dedicated to the exploits of the Duke, your father ...' Under that luminous shadow, heir and painter pause. Well may the family afford the luxury of having the earlier Cosimo's exile depicted – something that the Florentines had, in many ways, lived to regret. That, one might say, is how a republic treated its greatest man. And plate IV shows how an autocrat has come to view himself. To his people he is indeed, as the period believed a ruler should be, the 'light of all their doings ...'.[34]

It was probably always on his namesake, Cosimo il Vecchio, that his great-great-great-grandson wished to lay emphasis. The founder of the family fortunes was in effect his patron saint, and it was remarkably perceptive – or perhaps remarkably docile – of Vasari that he should also have painted these two men – the founder of the family's fortune and the supreme consolidator of its European prestige – as Saints Cosmas and Damian [plates 93 and 94], the patron saints of the Medici family. These two pictures hung in the chapel of the Palazzo Vecchio. In the assumption of saintly roles by the two actual Medici there is more than the usual portrayal of a real person in the character of his namesake saint. There is a profound truth under the allusiveness, under the flattery, and even under the myth of Medici patronage in a golden age of art and government. Duke Cosimo I had certainly done much for the arts in sixteenth-century Florence; Cellini, Bronzino, Pierino da Vinci and Vasari are merely some of the artists he had patronized, whose work has been mentioned here. He had very much wished to tempt Michelangelo back to Florence from Rome. He had failed, but the sole meeting between the two men – a meeting of two princes each with a sphere of greatness – was thought worthy to be commemorated in the funeral ceremonies at Florence on Michelangelo's death [plate 95].[35]

It is true that this may be read – the actual painting has long ago disappeared and we are dependent on the drawing – as part of the myth of Medicean patronage, casting a further aura around the prince who deigns to treat an artist in this friendly way. But such a dialogue between prince and artist is itself of some significance; it may be read in another way, as more propaganda for the rise in status of the artist. Although there are sad letters about the lot of the painter at court, there are also by the sixteenth century too many

95 *Meeting of Duke Cosimo and Michelangelo*

testimonies for it to be other than true that in becoming something of a courtier the artist had advanced in status. In addition to the very famous instances, we hear Hilliard (in his *Arte of Limning*) chatting away with Queen Elizabeth – in a manner one doubts Holbein ever did with Henry VIII. Whether proud like Michelangelo, tame yet confident like Raphael, or something of a lackey like Vasari, the painter had approached within the aura of the prince and proved himself more than just a craftsman. And in praising princes one raised the profession.

Even Titian found it as well to address his patrons with a nod towards their important role: 'I am the more convinced,' he wrote to Alfonso d'Este, 'that the greatness of art amongst the ancients was due to the assistance they received from great princes ...'[36] Modern painters came to be admitted to great familiarity with princes. They are part of a new atmosphere at court. Which, one might ask, looking at the encounter between Michelangelo and Duke Cosimo, is the artist and which the prince?

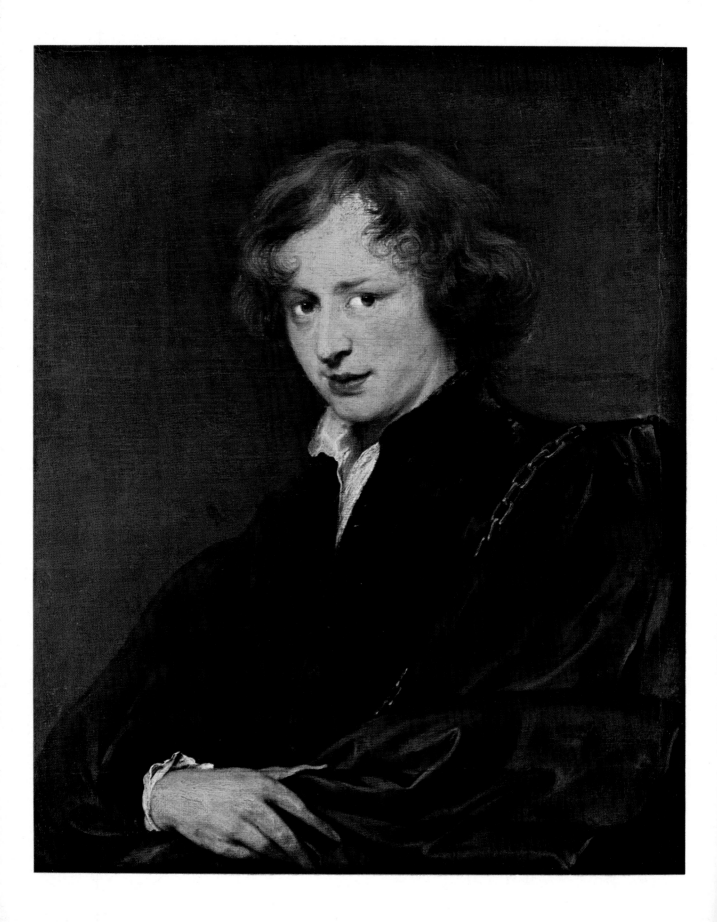

4 THE COURTIER-ARTIST

The status of the painter over the period dealt with so far here is something which may seem to have been neglected. Just because he was employed at court, it did not follow that the painter had become a courtier. On the whole topic generalizations indeed are difficult; but the middle point of this book may be a good moment to consider the question. It also happens to coincide with the seventeenth century, when not only the artist's status but also the particular question of service with a prince or great patron could be a literally vital issue.

The issue was connected not so much with art as with behaviour.[1] No longer was it a matter of the extravagant character of the great artist: that had represented perhaps a first breakthrough after the medieval craftsman who could seldom afford to show temperament. The aristocratic capriciousness of Michelangelo – experienced so painfully by several Popes and other rulers – had made it patent that the man of genius could be exceptionally tiresome as well as exceptionally gifted. Leo X looked on Michelangelo as a brother, recalled their upbringing together – and admitted he still felt afraid of him.[2] As for Leonardo, he had managed to exasperate more than frighten the good-tempered Pope by his dilatoriness and delight in dabbling, always failing to complete a task. But, though their lives were certainly spent at court and in the service of a variety of great, princely patrons, neither Leonardo nor Michelangelo could possibly come into the category of 'courtier-artists' – any more than, for different reasons, could such *quattrocento* figures as Cossa and Mantegna.

The type of courtier-artist was supremely established by Raphael, uniting Michelangelo's energy with Leonardo's gracefulness, socially no less than artistically. Vasari, if he does not quite say it in those words, does undoubtedly make the emphasis quite clear – and we may listen the more attentively since the words come from the pen of one who had no greater god than Michelangelo: 'Thus Nature created Michelangelo Buonarotti to excel and conquer in art, but Raphael to excel in art and in manners also.' Vasari explains that Raphael was able to charm a sternly-grand Pope like Julius II as much as the generous, open Leo X, so that both could treat him with familiarity. What they found in him was a character uniting the arts and the virtues. Such familiarity is different in kind from the private friendliness shown by, say, the Gonzaga family to Mantegna; it is the difference between the attitude to a courtier and that to a servant.

v Van Dyck: *Self portrait*

117

Indeed, courtier is too weak a word for the status of Raphael: 'he never went to court,' Vasari says, 'without having fifty painters following to do him honour … In short,' he goes on, '*non visse da pittore, ma da principe*'.[3]

Even if there is some element of exaggeration in this, it remains a memorable, effective image: the painter-prince. By the time Vasari set it down in print it might serve to inspire any artist to improve his own status. But it is also connected with another change: public recognition of the importance of genius, as itself possessing something of divine right and royal status. Earlier periods might have accorded this to the saint. Now it was the artist who had taken on something of the same power. Ruler and painter were both monarchs, each able to help the other; and the Emperor Maximilian is shown advising in the painter's studio, in one of Burgkmair's illustrations [plate 96] to the Emperor's *Weisskönig* romance. An antique parallel existed for this sort of easy relationship in Alexander and his court painter, Apelles. Not only had Alexander traditionally expressed his attachment to Apelles' work by deciding to be painted by no other painter, but their relationship had been of such friendly equality that Alexander had passed over to Apelles one of his own mistresses, Campaspe.[4] This generosity was not to be emulated by any Renaissance patron; all Cardinal Bibbiena offered Raphael was one of his nieces. The fame of Apelles made him, of course, one of the great prototypes – along with Zeuxis – with whom any 'modern' painter might be compared. We find that even the feeble Piero del Pollaiuolo was described by a Tuscan humanist, in surely a

96 Burgkmair: *The Emperor Maximilian I in the painter's studio*

thoughtless moment, as '*alterum Prasitelem*'.[5] But by the time this kind of comparison is used about Titian, the emphasis has changed from being merely a way of paying a compliment, to hinting at new status for the artist.

Even *where* it occurs in this case is significant enough: in the patent by which in 1533 Charles V created Titian a Count Palatine and a Knight of the Golden Spur.[6] There it is said that Titian deserves the name of Apelles, and the Emperor is only following the example of his predecessors: Alexander the Great being specifically cited as having sat to none but Apelles. And it is not simply Titian but his whole family which is honoured: his children are raised to the rank of Nobles of the Empire 'with all the honours appertaining to families with four generations of ancestors'. This represents a clear rise in social status; equally clearly, it is credited in the imperial patent as due to 'Titian's felicity in art, and the skill he has displayed.'

My subject is not simply that of which painters have been ennobled by royal patrons; for, if it were, one would have to go back into the fifteenth century, when Gentile Bellini was knighted by the Emperor Frederick III, and Crivelli was knighted by Ferdinand, King of Naples. Both painters were proud enough of the distinction to incorporate it into their signatures. Yet, at least in Crivelli's case, these honours are rather different from those given to High Renaissance artists like Raphael and Titian. As far as one can judge, Crivelli's patent was issued by King Ferdinand not as a personal testimony to a favourite painter but as an expression of his appreciation of the loyalty of the citizens of the small town of Ascoli Piceno, where Crivelli worked. Indeed, in what survives of the actual citation, no mention at all is made of Crivelli's art.[7]

Very different in every way is Titian's case, beginning with the Emperor's admiration for his work before he had met the painter. And then there are the first meetings between the two men when they discussed works of art in general, as well as the actual works of art made by Titian in the shape of the Emperor's portrait. That was fairly quickly followed by the issue of the patent ennobling the painter. Titian, further, seems to have achieved some familiarity with Charles V, and certainly had the entrée to court.

This argues a certain standard not only of talent but of behaviour. Seldom is Titian thought of as a paragon of good manners – though I don't know any anecdotes which positively contradict that idea. But it should be remembered that he certainly had courtly good manners at least in his letters – thanks to his friend Aretino. Aretino was able to provide the perfect literary tone. He could write for Titian, expressing exactly the right mixture of flattery with occasional sharp jabs about money and/or recognition. It is thanks to one of Aretino's letters, written to Charles V's wife, that we know

97 Rubens: *Philip* IV

how struck the Emperor was on first seeing a portrait by Titian; it was that which led him to request his own.[8]

During the sixteenth century there had emerged clearly the concept of the courtier-artist: a figure whose manners would be as requisite as his talents. Something of a dialogue was established between the prince and the painter: just as Michelangelo had been shown conversing with Duke Cosimo de' Medici [plate 95]. In Hilliard's case it turned out that 'her Majesty's curious demand hath greatly bettered' Hilliard's judgment: and doubtless improved his art. Of Cosimo I, Vasari had said much the same, at greater length. And Hilliard threw in a very plain claim for his art: '... I wish it weare so that none should medle with limning but gentelmen alone ...'[9]

The tradition established by the sixteenth century meant that many a budding Apelles might now look to find an Alexander, if only a miniature one. Royal patronage was a fact worth recalling: the patronage extended, for example, to Jan Bruegel by the Emperor Rudolph II was carefully recorded on the painter's tomb[10] – and a greater example of this will be encountered. It is probably not forcing too strict a graph to trace a rise from the fifteenth-century compliment that any good painter is another Apelles, through the styling by a sovereign that a painter favoured by him is the Apelles of the century, to the culmination of such comparisons, in Gevartius' epitaph for Rubens: 'the Apelles of all time.'

This is less friendly hyperbole than a scholar's choice of epithet, justified by the words which follow and which are still strangely moving when read on the floor of the Rubens funerary chapel at St Jacques in Antwerp,[11] incised a few paces from one of the last and most triumphant, and most gloriously coloured, of Rubens's own paintings: 'And he made himself a pathway of friendship to kings and princes.' That sentence is important enough to need expansion, for the man celebrated is not so much an artist as a courtier-diplomat: someone who late in life depicted himself with proud restraint [plate 98] in much the same pose as that which had ten years before served for him to depict the young King of Spain [plate 97].

In the same mood Gevartius's epitaph continues, evoking the world of great events and great personalities in which Rubens had moved – not as a prince but, more usefully, as a statesman: 'By Philip IV, King of Spain and the Indies, he was adopted as Secretary to the Sacred Council, and as ambassador in the year 1629 to Charles, King of Great Britain, soon happily established a basis of peace between those Princes.' And so the painter of the vivid allegory of European peace and felicity [plate 99], a picture that he presented to one of the principal figures involved, namely Charles I, is also claimed as architect of the actual facts underlying the allegory – a

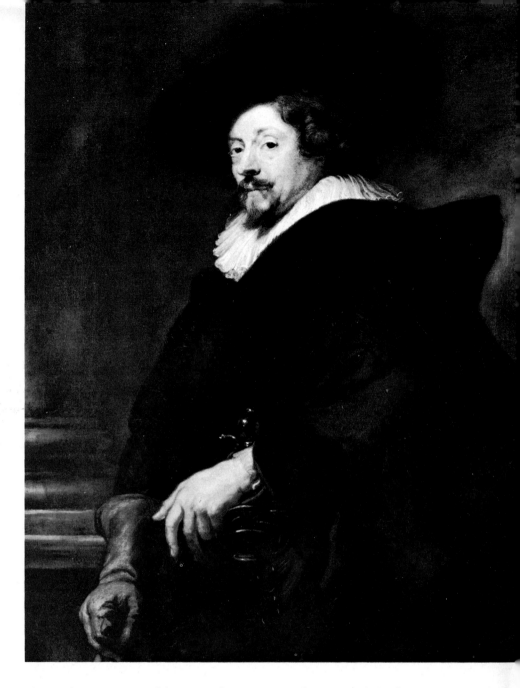

claim that is reasonable enough. He was, after some initial reserve, highly regarded by the Spanish court; and he knew Philip IV, not only as someone to serve and portray but as the one person at the Spanish court whom he completely liked.

Bronzino had not explored below the surface of Cosimo I; Titian and Aretino hailed in Charles V a perceptive patron and connoisseur. But Rubens was actively concerned with Philip IV's character as a ruler. He saw and wrote of the king as 'obviously very fond of painting', yet he also discussed him in a shrewd political way, which was sympathetic and wise, but quite unblinded by flattery. Scrutinizing kings like that would have seemed most injudicious to Aretino, and would frankly not have interested Titian. Writing to a friend, Rubens thus describes his feeling for the Spanish king:

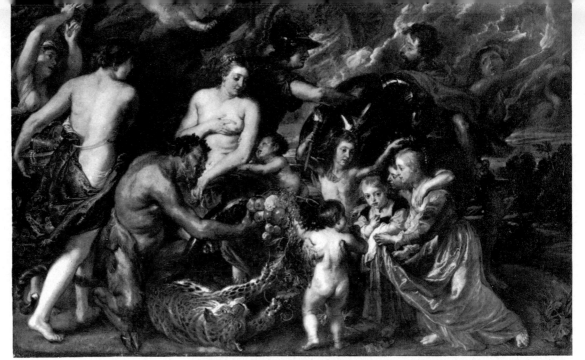

99 Rubens: *Peace and War*

100 Velázquez: *Philip* IV

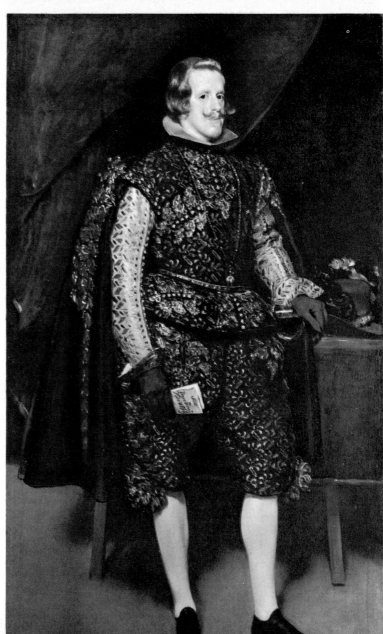

[He] alone arouses my sympathy. He is endowed by nature with all the gifts of the body and spirit, for in my daily conversation with him I have learnt to know him thoroughly. And he would surely be capable of governing under any conditions, were it not that he mistrusts himself and defers too much to others. But now he has to pay for his own credulity and others' folly, and feels the hatred that is not meant for him.[12]

The king portrayed by Rubens in paint, as well as words, has been rather overshadowed, even criticized, as insufficiently the man we know from the source of another painter-courtier, at the heart of Philip IV's court [plate 100]. Actually it is not necessary to claim a profound insight in Rubens's depiction, but there is something of a different yet valid aspect, the result of the impression made on a robust yet sympathetic mind by the never quite certain king, who 'mistrusts himself'. In Rubens's sketch there is something more tentative about the king's glance, it is not too subjective to say, than appears in Velázquez's portraits of the king.

If Philip IV, who had appointed him ambassador, represents one pole, the English court under Charles I represents the other. Here there was no initial reserve to be overcome; here Rubens was warmly welcomed as artist and as diplomatist. 'I am universally honoured,' he wrote of his English stay; and his success began with the king. The knighthood given him by Charles I was indeed the most permanent result of his mission. The shifting sands of European politics resulted in the long-term in the failure of his diplomacy. He was, it has been suggested, too honest for the task. He really wanted war to be banished and plenty to return; he made them realities – not just topics to discuss. Gevartius was understandably warm in his friend's praise, claiming a little more permanence for his statesmanship than was strictly true, but the knighthood and the friendship with two great European sovereigns were glorious truths in themselves – public declarations of what a mere painter could achieve, which eclipse the social prestige even of Raphael.

Nobody, in fact, was to achieve again the double rôle and double fame of Rubens. Even his tombstone did not have space to describe the other courts he had served, as painter if not as diplomat; and it was silent where the man himself might have been most eloquent, over his place at the court of the widowed Infanta Isabella-Clara-Eugenia, the Regent of the Netherlands: a place that was intimate enough to cause a good deal of hostility and jealousy. Two of her names, Isabella and Clara, were given to two of Rubens's daughters by his second marriage. The widowed ruler, last of a remarkable line of Habsburg women who had ruled the Netherlands, was to be painted several times by Rubens. Once painted splendidly dressed, she changed in widowhood, taking the habit of the Poor Clares [plates 101 and 102], assuming the rôle of sanctity in place of royalty,

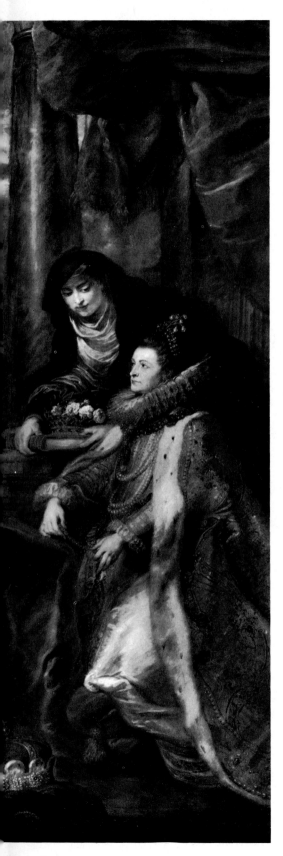

and becoming like her own patron saint. To Rubens her reward was – it is worth remarking – once again a social one: he was *de facto* court painter, but under her he was to become also 'gentleman of the household of Her Most Serene Highness'. If Raphael is the supreme type of sixteenth-century socially successful painter, Rubens is that of the next century. The Venetian ambassador in 1629 recorded the impressions of a widely-travelled English ambassador, Sir Thomas Roe, that Rubens appeared everywhere 'not like a painter but a great cavalier with a very stately train of servants . . .'.[13]

It becomes a type: even down to the knighthood which Charles I would give Van Dyck. Pope Urban VIII made Bernini *Cavaliere*. Philip IV of Spain, apparently consciously echoing what his ancestor Charles V had done for Titian, made Velázquez a Knight of Santiago – a rare honour, for only one other Spanish painter – Ribera – was recorded as knighted in recent times. These are the most glittering examples, but the social success of other painters at the period is indubitable.[14] Pope Innocent X was said to have handed a canvas to Pier Francesco Mola; Pope Alexander VII made him be seated; Queen Christina took him for drives in her carriage: and all these actions were said to echo the treatment once received by Titian and Michelangelo.

And painters' images of themselves were coloured by such social success. Carlo Maratti, himself also a *Cavaliere*, painted his own self-portrait, admittedly as painter, but still one splendidly-dressed and calmly at ease with a patron beside him. Maratti is a good example of the completely competent, as well as confident, artist. He lived well, charged high prices for his paintings, and it was virtually as an equal that he faced even the most highly-placed patrons.

The *beau idéal* of 'the painter' is described negatively by Passeri who criticizes those painters who have had a poor education, 'who have' – he goes on – 'some ability in their art, but who outside the practice of painting are dull, raw and uncivilized.'[15] Against such people we may put the painter who arrives on the scene already a courtier before he has chosen, or been chosen for, a court. The very youthful Van Dyck, who already had painted himself with sensitive, suave elegance [p. 116, plate v], deep in self-love, appeared at Rome in the early 1620s, trailing clouds of finery and giving himself such airs that he became very unpopular with other northern artists. He imitated, Bellori tells us, 'the pomp of Zeuxis'; and the whole style of Van Dyck's life and circumstances were clearly meant to mark him out – although he was only twenty – as the genius-cum-gentleman. 'His behaviour,' Bellori continues, 'was that of a nobleman rather than an ordinary person; and he shone in rich garments; since he was accustomed in the circle of Rubens to noblemen, and being

101 (*Opposite*) Rubens: *Infanta Isabella* (wing of the Ildefonso altarpiece)

102 (*Right*) Rubens (after): *Infanta Isabella* (engraving by Pontius)

naturally of elevated mind, and anxious to make himself distinguished, he therefore wore – as well as silks – a hat with feathers and brooches, gold chains across his chest, and was accompanied by servants.'[16] The later self-portrait with a sunflower [plate 103] is recognizably of this noble, graceful and yet faintly contrived personality whom Bellori describes.

Such a person was obviously destined for the life of a courtier. Nothing about him revealed the painter, still less the mere craftsman. But what was conveyed was personality – dress, as Castiglione had remarked, being 'no slight indication of the wearer's fancy.'[17] Van Dyck's Wagnerian love of thin, flowing silks, for his sitters as well as for himself, is one expression of refinement – a refinement which, as Bellori pointed out, should have made his fellow-artists pleased for the sake of their profession. Rome and Antwerp proved too

103 (*Above*) Van Dyck: *Self portrait with a sunflower*

104 (*Opposite*) Van Dyck: '*Le roi à la ciasse*'

coarse for Van Dyck. For a ten-year period he visited a variety of courts, a fact too remarkable for it to be coincidence: in none did he settle long, but they left their imprint on him. The sunflower he holds is like a symbol of court favour shining on him; it stands perhaps not only for royal esteem but for art. The portrait seems consciously ambiguous, because Van Dyck is possibly the light to which the flower turns. Achievement, status even, strong pride are all apparent, notwithstanding the gracefulness.[17A]

It is ultimately with the court in England that Van Dyck is associated. He had glimpsed it, and been rewarded, under James I, but it was of course under Charles I that he came to know it. And there he behaved, and was treated, in a way which no other painter in England has ever equalled. His manners, his style of living, his attractive appearance all suited the king and London society.

Looking at his portraits of himself, we may echo Cowley's lines *On the Death of Sir Anthony Vandike*: 'Nor was his Life less perfect than his Art. Most other men set next to him in view, / Appear'd more shadows than th' Men he drew.' Van Dyck was well lodged at Blackfriars – where a special causeway was built to receive the king on visits to him – and he was also given a summer residence in Kent. How he in turn rewarded Charles I is summed up in a quite new type of royal portrait, which has few real predecessors either as composition or for its attitude to the subject of a monarch: the *Roi à la ciasse* [plate 104].[18]

Other portraits of the king are more completely formal, or alternatively show him virtually relaxed in a domestic context. This picture aims to capture the atmosphere, as it were, around the king, retaining his regalness in an open-air countrified setting. In painting the king, Van Dyck has virtually mirrored himself. Not since Titian had a painter been able to draw so close to a monarch, and – without either flattering or falling into mere prosaic record – throw an aura of glamorous instinctive nobility around a royal person.[19] Van Dyck had long before revealed this ability, postulating a spell which actually came more from rank than from personality. The point can most effectively be made by comparing this dream of being royal, strolling under heavy-foliaged trees in summer, with a perfectly competent full-length portrait of Charles I by Van Dyck's predecessor at the English court, Daniel Mytens [plate 105]. Where James I had spared a hundred pounds for the young Van Dyck, he had been content to give Mytens a gift of only twenty-five, and a pension of fifty (that is: a quarter of what Charles I paid – or owed – Van Dyck). As one scholar has recently underlined, there is no evidence that Charles ever kept any of Mytens's portraits of himself and his queen.[20] Although this particular one is now in the English royal collection, it entered it only seven years ago. And it shows that competence was not enough, even though Mytens has proudly signed it as *Pictor Regius*.

The new-style *pictor regius* – and Van Dyck never bothered to sign in that form – is conscious of giving as well as receiving. The real triumph of the *Roi à la ciasse* is that Charles I is given a totally natural look of instinctive sovereignty, in a deliberately informal setting where he strolls so negligently that he seems at first glance nature's gentleman rather than England's king. Without falsifying, Van Dyck is able to follow the precepts of Lomazzo, the theorist most likely to have influenced monarch as well as painter, because Lomazzo's *Trattato* had been translated into English in 1598. Lomazzo had strongly recommended giving to a Pope or Emperor or King 'the dignity which he ought to have'. He makes his point even more firmly in stating that 'the defect of nature should be skil-

105 Mytens: *Charles I*

128

fully covered with the veil of art'.[21] The chief defect of Charles I was one shared – as a matter of fact – by Van Dyck: small stature. Yet in both cases, nature had made up in other ways for this defect, not least in the dignity and elegance both men possessed. And throughout this painting Van Dyck keeps oscillating between what we see and what we sense: the king who has dismounted, and thus apparently forgone an obvious advantage of command, is yet the more commanding for being disengaged, posing idly while those who are his servants tend to the horse and carry his cloak. This is one romantic aspect of royalty – being as naturally royal as an oak tree. But Van Dyck was excited also by the full panoply of being a

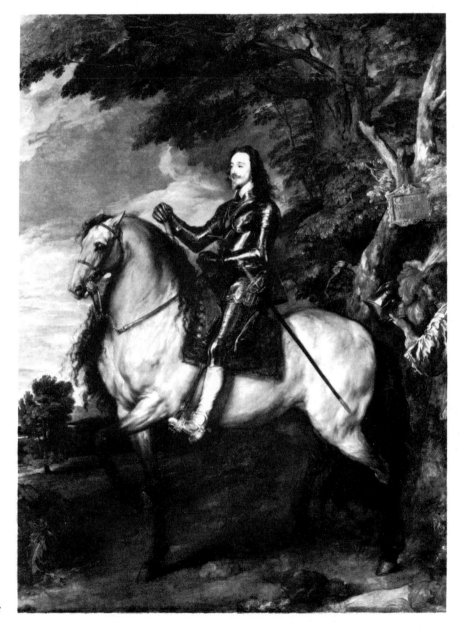

106 Van Dyck: *Charles I on horseback*

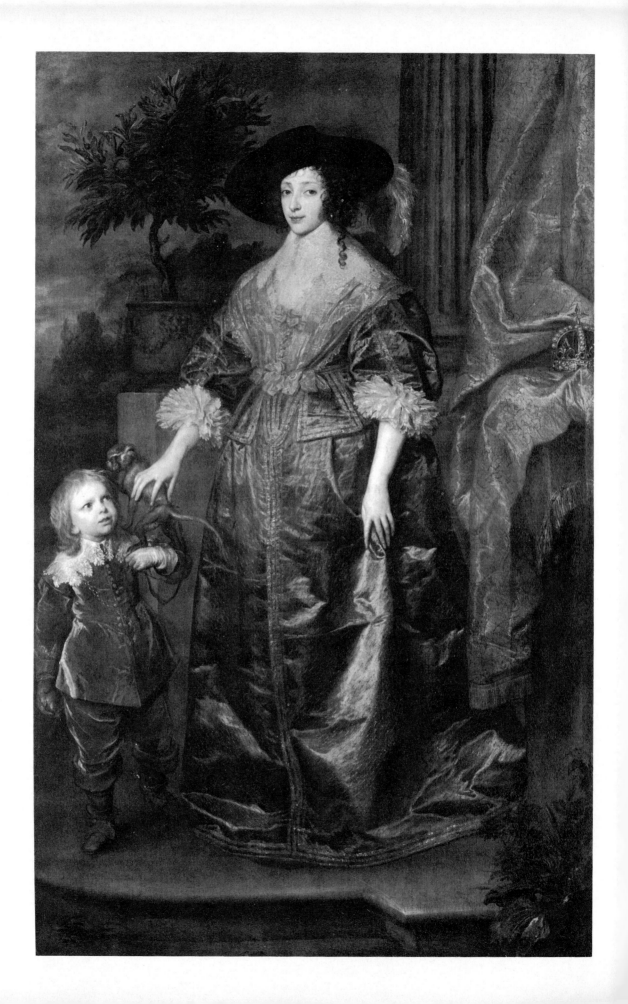

107 Van Dyck: *Henrietta Maria with her dwarf*

king, romantically picturing him riding out [plate 106] in what is the official answer to the negligent gentleman of the *Roi à la ciasse*, general now as well as king, leading into some as-yet-distant battle non-existent troops.

The same sympathetic response to great position is evident in Van Dyck's portraits of Henrietta Maria. Something of a pendant to the *Roi à la ciasse* is produced by the wonderful full-length [plate 107], echo of Van Dyck's Genoese portraiture, with its combination of dignity and liveliness. The dignity is the Queen's, with a reminder of royal status not in her dress but in the crown at the extreme right, and the liveliness in the court dwarf, Jeffrey Hudson. And what is perhaps no more than intimation here is confirmed by Van Dyck's interpretation of the royal couple's children [plate 108].

This familiar group is at once beautiful and yet difficult to appreciate as the novelty it is, especially in its combination of dignity and intimacy, revealing the circumstances of princely upbringing. Along with the fall of curtain and expanse of patterned carpet, there is the more relaxed, welcome breath of flowers and fresh air at the right. There is certainly an informality which Van Dyck's later pictures

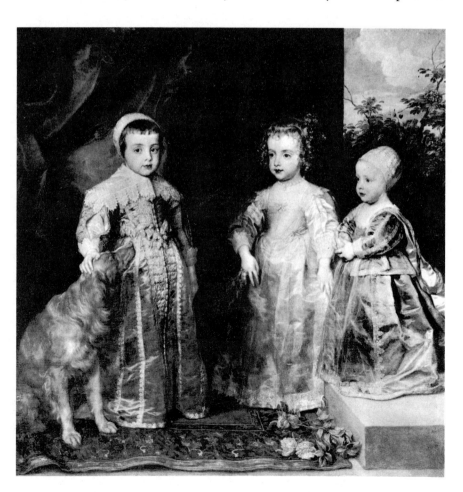

108 Van Dyck: *The three eldest children of Charles* I

of the royal children never caught again. Indeed, in painting the heir to the throne in babyish cap and long-skirted childish coat, Van Dyck appears to have annoyed the king by his truth to nature in an official portrait.[22] Such scenes of domestic court life are not unique, only because at almost the same moment as Van Dyck's came the equally moving – and more penetrating – depictions of Velázquez [plate 124]. They serve to trace the life – such as it was – of the heir to the Spanish throne.

Before turning to that court, served by the greatest of courtier-artists, we must consider the situation of Van Dyck, an Apelles who had for so long been aspiring to court life, now that he was at last placed at the court of an Alexander who prized him. Rubens had never given up his independence, for all that he served so many sovereigns – and went on serving them up to the end of his life. In

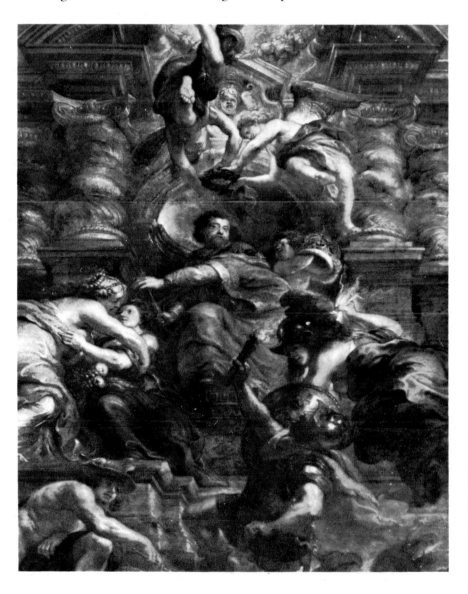

109 Rubens: *The Felicity of the reign of James* I (detail)

110 Van Dyck: *Sketch for a Garter procession* (detail)

1635, when Van Dyck was at the peak of his career in England, Rubens was happily at home in Antwerp, occupied with immortalizing the reign of James I [plate 109] for the ceiling of Charles I's banqueting house at Whitehall. Yet Rubens did not stir to see the canvases placed in position: 'Inasmuch as I have a horror of courts,' he wrote privately to a friend, 'I sent my work to England in the hands of someone else.'[23] An agreeable irony resides in this clear verdict by a painter who had seen so many courts, and been so well received at them, who gave this judgment on completing his deliberately glamorized account of the blessed reign of King James I: better to paint it than to partake of it, seems Rubens's sober view.

Van Dyck was less fortunate. He had not preserved his independence, and indeed was not even kept supplied with the money due to him. The courtier-artist was to find court life disillusioning, at least in England. He was condemned – the word is scarcely too strong – to painting portraits,[24] even while he dreamt of following up Rubens's Whitehall ceiling decorations by his own designs for the walls [plate 110]. Faint though these figures seem, enough is visible of a Garter procession, led by the king. It is a chivalric pageant which, if it did not come near to Rubens's effortless allegorizing of great royal occasions, suited Van Dyck's slimmer, more earthbound talents.

Of course, Rubens could do better. Not since Dürer's day, had an artist designed anything so elaborate, fulsome and yet so completely energetic for a prince as the *Pompa Introitus*[25] which Rubens produced for the city of Antwerp when the Cardinal-Infante Ferdinand of Spain, Philip IV's brother, entered as ruler on the death of Infanta Isabella [plate 111]. The drama of personifications with threat of war and promise of peace – is still wonderfully

111 Rubens: *Triumphal Arch for the Cardinal-Infante Ferdinand*

animated by Rubens. Though times were bad, and the Antwerp councillors restrictive, Rubens exuberantly responded – as this design alone shows – to the project of decorating his city to welcome its ruler who rides here in peaceful triumph. His own personal world still placed emotional emphasis on these people – fallible though they might prove to be. A new ruler promised new possibilities to someone of his temperament – and the artistic tribute Rubens paid was indeed enough to encourage any prince.

And Rubens was back at court. The Cardinal-Infante made him his court painter. From Madrid Philip IV constantly pressed the

ageing artist for further designs for his hunting lodge, the Torre della Parada. There already hung Velázquez's portraits of the royal brothers as huntsmen. While Spain employed these great painters, Charles I was forced to reject Van Dyck's scheme for Whitehall Palace: it was too costly, and the period was scarcely propitious for evoking the splendours of Garter festivals.

When Rubens grew ill – was indeed dying – the courts of Europe received bulletins about his health. And yet Rubens stands for a definite ambiguity about court life, coming finally perhaps to prefer – like Poussin, whose phrase in a letter this is – some obscure corner,

observing without being involved: '*quelque petits coings pour pouvoir voir la Comédie à son aise.*'[26] Van Dyck, exhausted by the unending English court demand for portraiture, tried to escape by turning to another court, that of France, and hoped to receive the commission to decorate the *Grande Galerie* of the Louvre. Peripatetic, even feverish, in what proved to be the penultimate year of his life, Van Dyck was still fluttering around foreign courts – returning to England only to die. The true courtier-artist, one may feel, should be attached to his native court – as Van Dyck was not; he should serve there for a lifetime, as courtier as well as painter, in a way that Rubens could not bring himself to do.

It is Velázquez who is the supreme courtier-painter of the seventeenth century. He has anticipated all explanations and himself summed up his own existence at the centre of the Spanish court in *Las Meninas* [plate 124] which is – as well as being so many other things – the most fascinating of all painters' self-portraits simply because it extends from that to show us so vividly the painter's environment. Even if he were not shown painting, Velázquez would have his place in this picture, for he was an official of the royal palace, palace marshal to the king, and soon to be required to put forward proof not only of his nobility (he was knighted by Philip IV at last in 1659) but of his court service.[27]

When in 1660 he acted at the festivities for the marriage of the Spanish Infanta and Louis XIV, Velázquez shone as the personification of courtier-artist: 'His art and his courtly refinement were shown in the arrangement of the numerous diamonds and gems,' says Palomino. He wore the red cross of Santiago, a sword, cloak, and the order itself around his neck.[28] Yet he returned to Madrid weary, and a few weeks later was dead.

Out of an almost obsessive court existence, whose very disenchantment is evoked in a phrase of Calderon's, '*desengaños de palacio*', had come much of Velázquez's finest art. And his choice of becoming court painter was something which, it is worth making clear, was a deliberate act. It was under the patronage of the first minister, Olivares, that he first came to the king's attention; and perhaps of all his portraits, those of Olivares [plate 112] are most powerfully weighted by the artist's sense of the sitter's importance.

Even the angle of the view seems to increase this sense of power; and something comes too from the dark bulk of the sitter's body, topped by small head. In such portraits, Olivares seems to impose himself, to dominate the whole picture area. What is not occupied by physical bulk is occupied by the visual bulk of images of his power: his wand of office, the sweep of thick gold chain. Against the solidity of the paint in such portraits, even the most showy and glittering pictures of the king may look full of visual uncertainties.

113 Velázquez: *Infante Felipe Prosper*

It is more than subjective perhaps to find the king not firm enough, not standing on the floor with the authority of Olivares. And by the time of Velázquez's later portraits, uncertainty has touched the heir to the throne: a sickly ghost in a high, half-shadowy room [plate 113], appealing through his very frailty and illness – a child more tragic even than a dwarf, and doomed to an even briefer existence.

More than thirty years at court had brought Velázquez this vision. He had wished to serve his sovereign; and the wish was granted. We can mark off the steps by which he rose, from being merely one of the royal painters in 1623, when he was carelessly called in a document 'Diego Vazquez',[29] to the more noble-sounding 'Diego de Silva Velázquez', occupying his own rooms at the Alcazar in 1647. By then other royal painters, like Carducho, were dead. For none had the king personally done more than for

114 Velázquez: *Philip* IV

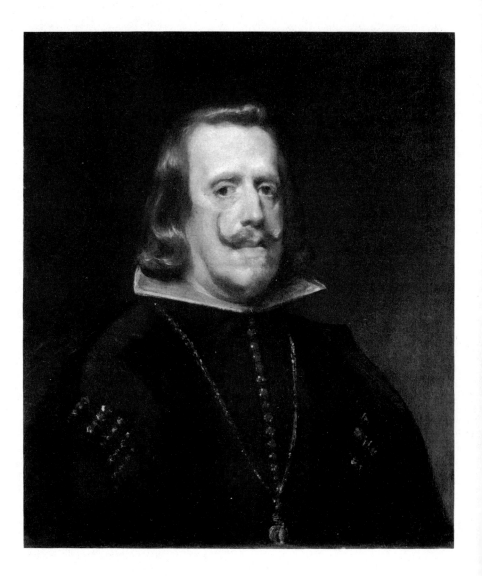

Velázquez. And the later portraits the painter does seem literally to approach the king more closely [plate 114] and to emphasize man rather than monarch. Velázquez had entered court under the patronage of Olivares, whose disgrace he easily survived. To the ageing king the painter must have come finally to stand as the solitary survivor of a family and a court that could be evoked only in the two men's memories, and in Velázquez's paintings. Before making too cruel a judgment on the face of Philip IV in old age we must remember that this is the face of a man who had personally lost by death his son and heir, his two brothers and his first wife. And, politically, Spain under him had lost those North Nether-landish provinces which form Holland. Philip's despondency – a documented fact – on the death of his court painter is therefore understandable enough from many points of view. Probably no great painter, in fact, has ever been as close to his sovereign – and

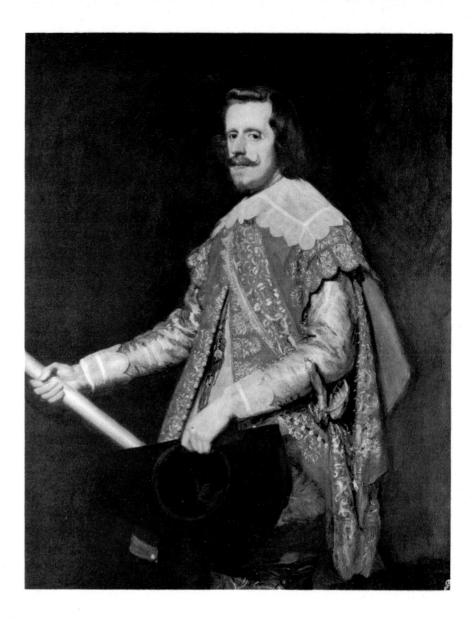

over such a long period – as Velázquez to Philip IV.

One final piece of evidence of affinity sometimes gets ignored, and that is that Philip himself, and his brothers, painted pictures. The fact was first published by Carducho in his *Dialogos de la Pintura* in 1633 – a book dedicated to the king and concerned with – among other things – elevating the art of painting.[30] What could be grander or more honourable – asks Carducho – than thus to see this most noble art holding its place as pastime among 'crowns and sceptres'? The Emperor Charles v and Charles i were connoisseurs; and now we encounter a court where the artist may claim he shares his profession with the king.

In many ways it is probably easier to discern Philip iv's attitude to the painter than the painter's attitude to not only the king but the whole court life. Granted his remarkable daily familiarity with its inmost circle, what did he make of it? He saw the king in the quite

exceptional splendour of the costume he wore at Fraga to lead his soldiers [plate 115]. Yet there is a distinct reserve about this most beautifully painted picture. Whether or not Velázquez codified the rules which seem to govern the answers in his work, he can scarcely have fretted against them. On this admittedly subjective point, my impressions are that he did in fact codify the rules himself. He created the images – or, at least, the most memorable of them – whereby the court of Madrid in the seventeenth century survives for us. And not only the images but whole concepts. The powerfulness of them is testified to by the fact that they were to be taken as the norm for royal portraiture by the Spanish Bourbons painted in the following century by Goya.

Certainly the rules had changed when compared with those not only of other seventeenth-century European courts but even from the prestigious examples of sixteenth-century manners, when Leo x could be portrayed with a relaxed intimacy which Velázquez never attempted with his king. Philip IV was usually shown standing. Once, exceptionally, in a non-autograph work, he appears on his knees praying [plate 117] but was never portrayed seated – except on horseback. Indeed, although chairs do appear in Velázquez's pictures, one gets a sense of a palace rather short of chairs, even if protocol had allowed sitting in them. Many contemporary testimonies speak of Philip's phlegmatic, unmoving features, in public moulded into a mask of dignity which would have won the approval of Machiavelli and Lomazzo. In Velázquez's pictures, the king – like an Edwardian lady in bed – does not move. The unmoving, consciously statuesque air of Philip IV can best be appreciated by comparing one of Velázquez's most typical depictions of him [plate 100] with the contemporary *Charles I* of Van Dyck [plate 104]. Applying the test of sixteenth-century theorists to these two likenesses, one could award Philip the prize for majesty but Charles that for suavity.

Yet it is part of Velázquez's unique power to take us deeper and deeper into the heart of a court he really knew, into rooms which he may well have furnished, and certainly through doors which he – as palace usher as well as painter – could open. Increasingly, he seems to have turned from the baroque convention of a piece of curtain emptily looped up, preferring to realize a setting in which some object makes it localized, even personal, with unexpected intimacy. And, once, the effect of opening a door or drawing aside some screen, brings us to confront the images of king and queen – reflected in a mirror – in the most elaborate of all such interiors [frontispiece]. *Las Meninas* is a picture which cannot be looked at too often, a door to which the last key has not yet been applied – a glass door, if you like, through which everything looks so transparently simple, but which yet mysteriously remains closed against

116 (*Opposite*) Velázquez: *Baltasar Carlos in the riding school*

117 (*Below*) Velázquez (studio): *Philip IV kneeling*

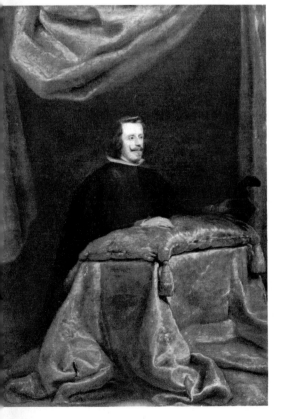

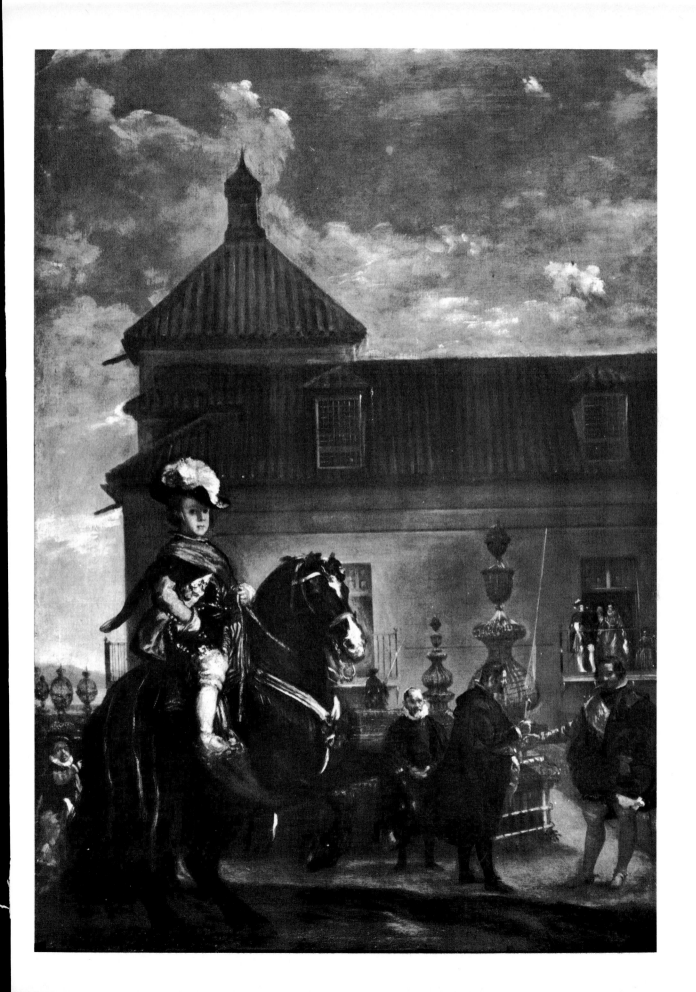

us. Nobody else made such a statement as this: a group portrait which does not look like a portrait, a combination of formality and informality which gives an air of spontaneity to something totally contrived.

The nearest comparable statement which had been made was twenty years earlier and, significantly, by Velázquez himself [plate 116].[31] This composition could well be entitled 'The Education of the Prince', for through the metaphor of managing a horse, it suggests the management of self and kingdom which the heir to a throne must learn. 'If princes were as industrious to know the capacities of men for the different trusts they put in them, as good horsemen are to employ each horse in that which nature design'd him for ...,' so meditates philosophically the seventeenth-century Duke of Newcastle in his *A General System of Horsemanship*.[32] And Velázquez's picture is touched with political meaning under the apparent *genre* scene. Although it is usually said to be a scene in the royal mews, that is not so, and the setting has its relevant part to play: it is the grounds of the Buen Retiro, the palace built by Olivares as a gift to the king. An engraving of a few years later [plate 118] shows Buen Retiro when Tacca's equestrian statue of Philip IV had been set up quite close to where the young Infante Baltasar Carlos puts his horse through somewhat similar paces. What might at first seem a piece of ordinary daily life is much more complex: not only is Olivares present, organizer and almost conductor to the prince, but in the background is a sort of miniature group portrait of the king and queen with – probably – the king's sister, who was a nun, assembled on a balcony of their new palace to watch the prince.

Three planes of existence are present, beginning with the prominent foreground occupied by the equestrian prince – seen earlier by Velázquez when no more than a baby as already apeing his father in heroic pose [plate 119]. Now, as heir to the throne and the picture's ostensible 'subject', he alone occupies the foreground, while in the background are the group of royal parents and family. Summary as the figures there are, two of them are immediately recognizable by pose as the king and queen so often painted by Velázquez. And as a bridge between these two planes is the middle distance occupied by Olivares, himself being respectfully served by the Master of Horse, even while he half bows – with hat off – to the youthful prince whom he is instructing. Can we doubt that this is how Olivares saw himself: between present and future king, the prime minister, the king's ruler and the prince's mentor. There is irony not only in the fact that life did not turn out that way, but that the queen on the balcony was coming to hate Olivares. This picture is, however, an apt illustration of the English ambassador's description in July 1634 of the court installed at Buen Retiro: 'much to

118 Meunier: *Palacio del Buen Retiro* (detail)

119 (*Above*) Velázquez: *Equestrian portrait of Baltasar Carlos*

120 (*Below*) Jordaens: *A Prince on horseback*

their Majesties' contentment, wherein the Count of Olivares took great pains, all things being ordered by himself.'[33]

With this straightforwardly realistic, yet subtle, education of a prince, we can compare another seventeenth-century composition, Jordaens's allegorical treatment of a similar theme [plate 120], executed with emphasis entirely on the decorative, and yet didactic. Youthful management of the animal in a palatial setting, with admiring parent-like figures in the background – the elements of both pictures are remarkably similar. Jordaens's painting was intended positively as decoration, connected with a tapestry series of horsemanship;[34] Velázquez's picture has more particular application and was almost certainly painted for Olivares or for some member of his family.

It was for the royal collection – and probably personally for the king himself – that Velázquez produced what might be called his most cosmic view of Spanish society, with royalty at its centre, and from around the same date: in the so-called *Boar Hunt* [plate 121]. This picture, or another version, was certainly hanging at the royal palace, the Alcazar, at Madrid in the late seventeenth century. It is indeed a boar hunt, and yet so much more than a mere hunting picture. While in one way presenting us with a panorama or landscape as well as society, Velázquez also manages to present numerous individual portraits,[35] including the king's brother on a white horse and the queen watching from a coach [plate 122]. For the first time, almost, these rare creatures are seen in the context of daily life outside palace rooms, separated only by canvas walls from the humanity less absorbed by them than by the need to have a drink on a hot day [plate 123].

This is Velázquez's *le Roi à la ciasse* but now placed in the context of his subjects, humble as well as noble. And it is to be noticed that it is this outer ring of humanity which not only surrounds the royal personages but takes on greater vividness and actuality. The court is not a mere abstract expression or made up of faceless servants, but peopled by solidly painted lively figures, talking, drinking, or holding dogs on a leash. They actually have greater weight in the composition than the royal figures who become almost actors engaged before an audience, rather than rulers of subjects.

Yet, of course, it was this view which was the result of a royal commission: the requirement to see oneself mirrored in the ordinary known context of daily life which is so literally carried out in *Las Meninas*. There it is by standing in the king's position that the painter has come to compose his picture: as if he looked on at himself, but reflected at the composition's centre the images of king and queen [plate 124]. For what is painted to seem only a fleeting moment, he saw the court as they saw it – ranged around the girl who at that date

121 (*Opp. above*) Velázquez: *Boar Hunt*

122 (*Opp. below*) Velázquez: *Boar Hunt*

123 (*Below*) Velázquez: *Boar Hunt* (detail)

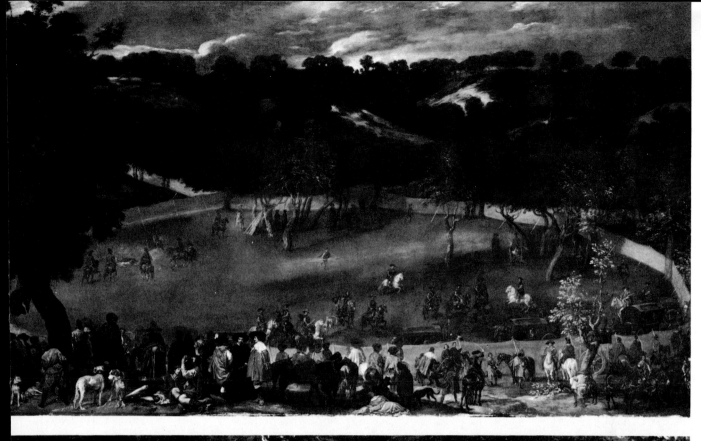

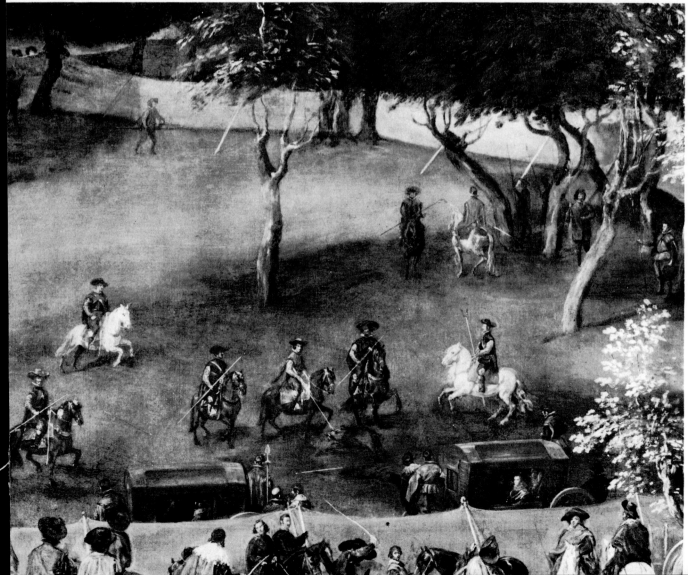

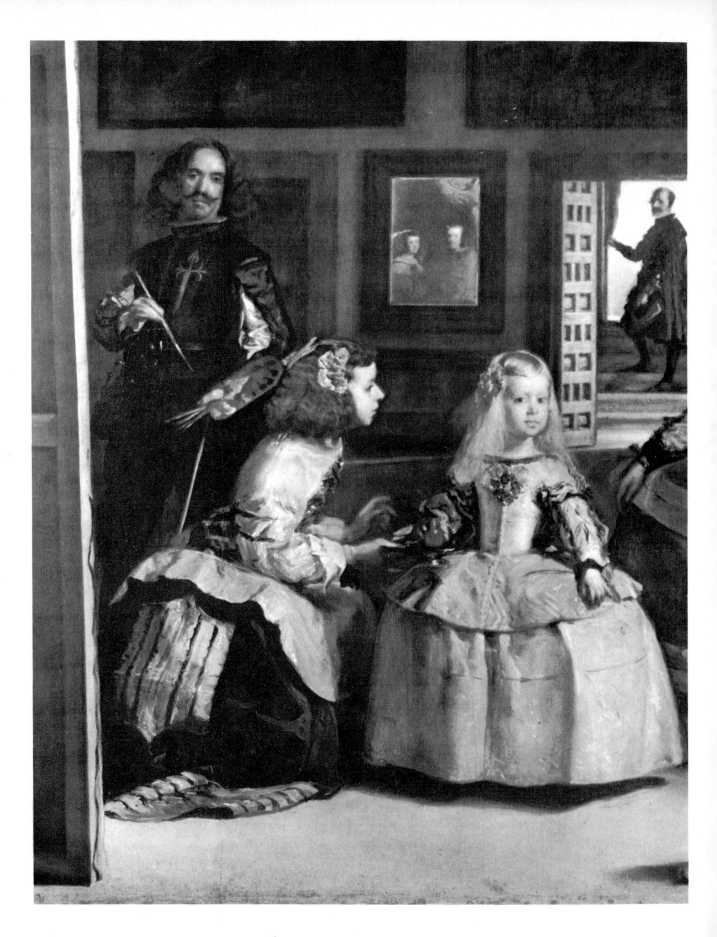

was their sole surviving child. Again and again, incidentally, it is on these hopes for the future – brief sparks of vitality amid age and gloom – that Velázquez lays emphasis. The earliest mentions of this picture do not call it *Las Meninas* but simply and more truly *La Familia*, and it is in this sense that we must read it.

The family here is not just king, queen and daughter, but that larger family which belongs to every monarch: his subjects. The group made up of ladies-in-waiting, a nun, dwarfs, the palace marshal – and the royal painter – symbolizes the range of the king's people; they are his concern and come, whether actually or metaphorically, under his eye. But this group is in a special way part of his family, true to the derivation of the word, for it is his household; each of them is indeed a *famulus*, occupying a particular position and painted with as much individuality as the Infanta herself. Like Queen Victoria, Philip IV might well have referred to such a group

124 (*Opposite*) Velázquez: *Las Meninas* (detail)

125 (*Right*) Mazo: *Queen Mariana in mourning*

126 Velázquez: *Baltasar Carlos and a dwarf*

as 'our people'. So it is a court assembled to make full sense only when it is surveyed by the king and queen. Their presence completes it; their presence is implied by the central mirror reflection and confirmed by the faces gazing out of the composition. What is shown is their own familiar, personal vision and it closes at the end of the room with the image of themselves.

When the king was dead, the queen was to preserve something of the effect and reverse Velázquez's composition in portraits by Mazo [plate 125] where she occupies the foreground in widow's clothes and her last, epileptic son, Charles II, is seen amid servants in the background. It is to this that *La Familia* has diminished.

In retrospect, it is noticeable how little emphasis Velázquez laid on the royalty of his sitters in terms of asserting rank. We never see – as we do with Van Dyck – a crown or sceptre. The royal family are never shown amid a flutter of allegorical virtues – not even juxta-posed to images of the saints. Dwarf or king, and once dwarf *and* king's son together [plate 126] they share in common earthy, earthly humanity; they inhabit shadowy, bare rooms with not much more furniture than a prison cell. And more than once there are the silent shapes of clocks, simple or elaborate, visual metaphors or plain facts: no one better than Velázquez could appreciate the passage of time, marked on the faces of the children who grew and parents who aged even while the rooms they inhabited did not. The

children bring, as it were, more setting with them. A pony, a dog, a vase of flowers – they are at least juxtaposed to such things, even if not quite possessors of them. There is no direct comment, but infinite pathos in the frail Felipe Prosper who gazes out with features which seem almost consciously echoed by those of his pet dog [plates 127 and 128].

In a century which saw such painterly glorification of princes – from Rubens's triumphs for King James I to Pietro da Cortona's for the Barberini family – and in a century which is often art-historically explained as 'baroque', Velázquez in many ways failed to glorify his prince, and certainly failed to be stylistically baroque. (That Velázquez had been told to try to get Pietro da Cortona to come to Spain is additional irony.) There is nothing about his art which would foster a belief that rulers are types of Solomon. The 'state of monarchy is the supremest thing on Earth,' James I had once told an astounded and incredulous House of Commons; and Rubens responded to that statement.[36] The deathbed of Philip IV saw another monarch, in different mood, blessing his five-year-old son and saying sadly, 'God make you happier than he has made me.' [37] Perhaps it is not too much to sum up by feeling that instinctively Velázquez had responded to the truth underlying the Spanish king's remark. Perhaps only a painter who had profoundly experienced court life, and seen daily the people he painted, could have reached such truths. Few painters were ever again to be invited to step so close to their monarch. Besides, a soberly truthful, intimate vision would not always be in demand at court.

Something more dynamic may be needed to require people's homage, and bring them to kneel before the spectacle of a Louis XIV – or a ruler yet more demanding. 'A true prince is the artist of artists … The prince performs in an infinitely manifold spectacle where the scene and the public, the actors and spectators are one and the same, and where he himself is the author, the dramaturge and the hero of the play.' It is surprising that Napoleon did not say that. Novalis said it,[38] but Napoleon certainly believed it. We are, in a way, returning to the world of propaganda when we consider him. After equestrian portraits by Van Dyck or Velázquez, that by David of Napoleon seems the more strikingly superhuman and heroic – and certainly more outrageously 'baroque'. A new standard for portraiture is raised. Exactness in recording the features will not be necessary. Napoleon told David as much, and clinched his dubious argument by invoking, for his own purposes, that long-established comparison: '*Certainement Alexandre n'a jamais posé devant Apelles.*'[39]

127 & 128 Velázquez: *Felipe Prosper* (details)

5 A HERO TO HIS PAINTERS

From what has already emerged, it is clear that once various themes are launched by court requirements they are to be found appearing every so often: divine sanction for the ruler, ideas of personal propaganda and such like, become stock themes which – in one way or another – can be found lurking at various periods at various courts. Strictly speaking, a ruler is always a hero to his painters, so it might seem wrong to try to emphasize that aspect in this chapter.

Much depends, however, on how the word 'hero' is interpreted. 'A man of distinguished valor or performance, admired for his noble qualities' is the opening definition given by the *American College Dictionary*. This clue leads one to consult the entry for 'valor' and I am pleased to see that, along with 'boldness and firmness in braving danger', it mentions, 'especially in battle'. Because the type of hero I have in mind definitely goes into battle; and, from their studios usually, painters follow him. The two heroes we shall be concerned with are Napoleon and, to a lesser extent, Louis XIV, as something of an artistic and political forerunner. But between those two heroes intervenes the eighteenth century. It is worth pausing there to show how generally unheroic its courts seem, compared with the martial glory of Louis XIV that had preceded it and the subsequent romantic revival of heroic associations required by Napoleon at his court.

There are other distinctions to be made as well, not irrelevant perhaps to Napoleon and his ideals. A distinction exists between the ruler who – whatever his personal ambition – remains within the framework of a Christian cosmos, and the ruler who claims to be outside any framework, and virtually to be divine. A good example of the brave ruler declining to pose as more than God's instrument before his people is early provided by an anecdote recorded of King Henry V of England. After he had won the battle of Agincourt in 1415, he was hailed by a choir singing his praises but he snubbed them because of the implied blasphemy; for his victory 'thankes must whollie be given to God.'[1] We have already encountered several examples of great royal patrons who did not demand the art at their court to make them either supremely royal or particularly heroic. Philip IV seems one of the most remarkable of these men. He seems truly to have preferred Velázquez to tell the truth about him and his physical appearance, setting the monarch and his immediate circle in the ordinary context of their daily lives. The king was not painted brooding on the fortunes of Spain, nor involved in any

VI David: *Napoleon at the* Sacre (detail)

153

particular government action – nor even as being divinely inspired, though he was the Most Catholic King. Indeed, so impassive is Velázquez's art that it is hard to tell whether Philip IV appeared to him another Alexander or simply a well-meaning man, with a real response to painting, but basically quite unfitted to rule a kingdom.

In many ways this 'realistic' attitude of Velázquez, whereby we perceive more of the man than of the monarch, is remarkably prophetic of the vision to be encouraged at most courts in the eighteenth century. While the glamour of the past may conveniently be evoked in dealing with ancestors and stirring events in history – when kings really were heroes – for oneself, and one's family, a fairly simple, even bourgeois, depiction is enough. Thus in France and in England, the court encouraged at the end of the eighteenth century an almost deliberately bifocal vision. The past consisted of brave, stirring, heroic deeds, often performed by the monarch's ancestors, as in Benjamin West's painting for George III of *Edward III crossing the Somme* [plate 129], part of a series at Windsor Castle planned to glorify Edward III.[2]

Sometimes a historical composition could be convincingly factual yet evocative of a great ruler. Royalty and chivalric past glamour combine in Moreau's *Institution of the Order of the Golden Fleece*

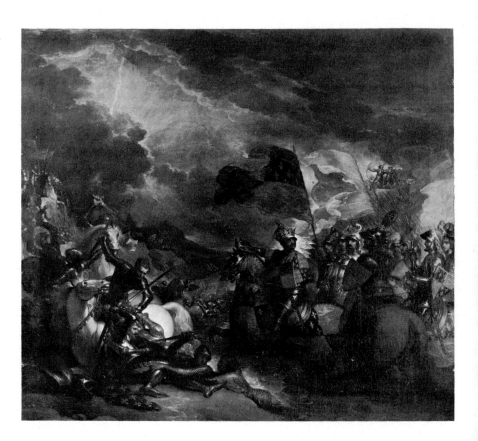

129 West: *Edward III crossing the Somme*

[plate 130] an engraving which, though it might strictly be concerned with fifteenth-century Burgundian history, served as frontispiece to a '*Voyage Pittoresque de la France*', and was exhibited at the Salon in 1781.[3] In the same Salon Moreau also exhibited a drawing of the Sacre *of Louis XVI*, but for the privacy of their own homes the French and English royal families seldom wished to appear amid ermine and with trains of attendants. Zoffany shows Queen Charlotte seated at her dressing table, with her two sons amusing themselves [plate 131] in a depiction which is at once convincing, charming and homely.[4] And Marie-Antoinette appeared walking in the Trianon gardens with her children [plate 132]: this may seem a stiffer and more official affair, yet not only was it intended to look relaxed and personal but it was actually to be criticized for this very informality. It appeared at the Salon of 1785, and attracted much adverse comment; the most pertinent criticism from our point of view was the judgment: 'Royalty should always be royal, even in a painting.'[5]

Wertmüller's picture was not the first occasion on which portraits of Marie-Antoinette had been criticized – a hint that in France the concept of being royal was best interpreted with a dignity and aloofness that went against the grain of a basically humane and

130 Moreau le jeune: *Institution of the order of the Golden Fleece*

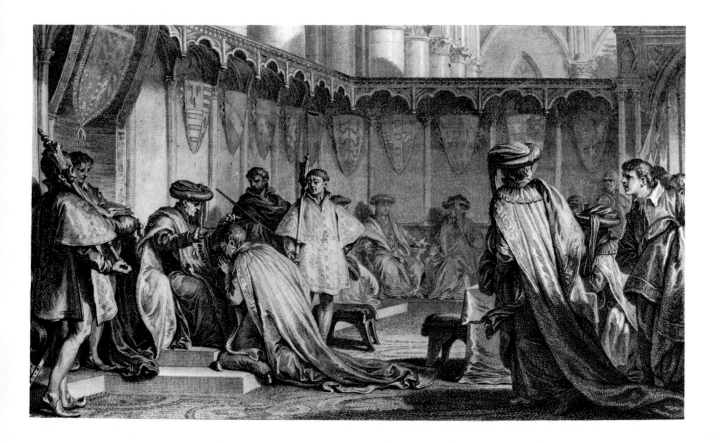

131 Zoffany: *Queen Charlotte with
her two eldest sons*

132 Wertmüller: *Marie-Antoinette
with her children*

rational century. Yet Nattier had earlier managed to combine ease with dignity, without criticism, in his portrait of the Queen of France, Marie Leczinska, and Boucher had painted at least one royal child with greater intimacy even than the royal children of Van Dyck or Velázquez.[6] The Spanish court at the end of the eighteenth century was itself probably much more relaxed than the French one. We know from memoirs how very informally and plainly-dressed, for example, was Charles III on all possible occasions.[7] Goya's royal portraits – still so misunderstood – reveal how sheerly human were the personalities at court [133]. And even the most cursory examination of Goya's career shows that he was a success at court from the first. It was the old Charles III who made him *Pintor del Rey*. Such a king has his feet on earth, walks through the world of real Spanish landscape, and thus is not in conflict with the sort of rustic pictures which Goya was called on to produce for palace rooms.

It is customary to smile at the uncouth and uninspiring figures of such eighteenth-century monarchs as Charles III of Spain, Louis XVI of France and George III of England – rustic hunters, workmen or farmers, if only nature's original intentions had not been interfered with by dynastic accidents. But theirs was not actually a century suited to heroics. When these sovereigns did play at being heroes they were seldom very successful. When, if at all, any of them were to be praised, it was scarcely for their heroic virtue or bravery on the battlefield; it was for family feelings, or charity and straightforward kindness. The case of Louis XVI is peculiar, for he alone of this trio actually died for the monarchy. But he lived again briefly in art on the restoration of the Bourbons, and can be seen not ruling, merely being benevolent, in Hersent's painting of him distributing alms during the severe winter of 1788 [plate 135], a sovereign among his people – seen from the viewpoint of 1816, sentimentalized rather than glorified. And, it is fair to say, this picture could well have been painted in *ancien régime* days, for it accords with the increasingly popular theme of personal royal benevolence.[8]

This is, of course, typical Enlightenment concept. When the artist had to deal with the not always attractive subject of monarchy, he often turned deliberately away from the previous conventions which had governed such treatments. An emphasis on domestic happiness is one solution. And where the occasion is too public and official for that to be possible, there were other solutions to be found. Pigalle, and after him Falconet and Houdon, deliberately chose to emphasize the humanitarian, not bellicose or pompously glorious, aspects of the subjects they commemorated in monuments of, respectively, a French king, a Russian emperor and an American general. Pigalle specifically wrote to Voltaire to say that he had

133 Goya: *Charles III of Spain in hunting costume*

been struck by Voltaire's criticism of placing chained captives at the foot of monuments to kings. For his monument to Louis xv at Rheims he therefore sculpted instead a happy citizen to symbolize the people's felicity, and a woman holding a lion to symbolize the ease of government. Above stood the king [plate 134], with hand extended, '*pour prendre le peuple sous sa protection*'.[9]

It is only in scale that this is heroic. Otherwise it is very different from the sort of statue, usually equestrian, which had previously glorified monarchs and, by the use of armour, had given them a heroic status as saviours of their people. That had, of course, been a type of painting fostered, though not invented, by the seventeenth century. Van Dyck had imagined Charles I riding out in heroic pose [plate 106] though probably with no very coherent idea of *where* he was going, or exactly why. In the same way, Velázquez had once conceived Philip IV involved with a background of battle – though the king had never seen a battle when the picture was painted – and the whole concept remains alien to the painter, if not the sitter.

But the ideal it suggests is not one that is usually quite alien to kings and rulers at any period, because the combination of horse and rider easily stands as a symbol of domination. Wherever this particular note is to be struck, that is the image which returns to currency; in artistic terms it appears to derive, at whatever remove, from the most famous surviving antique example, the *Marcus Aurelius* at Rome. That too had once included a captive as part of it.[10] Pigalle's standing *Louis XV* stressed another aspect, but plenty of statues were put up to Louis XV as a triumphant hero, usually a military one, the leader of his people in warlike mood, or at least as armed against any threat of attack; and these were, traditionally, equestrian monuments.

It was only at certain courts that there had appeared a tendency to require consistently portraits of the ruler as symbol of the state, usually at courts where the dynasty seemed to require particular bolstering. The Tudor and Medici courts produced very special types of picture, adulating in different ways the sovereign and giving him or her a sort of semi-divine, heroic status. The divine right of kings in England had finally been enshrined in the wisdom of James I, as seen by Rubens on the Whitehall ceiling [plate 109], and in Rome the wisdom of Divine Wisdom was contemporaneously seen to be enshrined by Sacchi in the Barberini family on their own palace ceiling. All this is allusive, allegorical flattery, insufficiently direct, not frankly aggressive enough, when compared with the heroic demands to be made in the same century by Louis XIV; and his demands are a mere prologue to the free-ranging megalomania of Napoleon.

All the same, it must be agreed that there is more diversity to the

134 Pigalle (after): *Louis* xv *statue at Rheims* (engraving by Cochin)

135 Hersent (after): *Louis* XVI
distributing alms

demands of Louis XIV than the most famous monuments to his
myth and his patronage at first suggest. Over the course of his long
reign he did not in fact manage to give complete coherence to the
art produced at his court; indeed, the style probably mattered much
less than the ideas enshrined by the paintings which he inspired.
And although he is thought of as virtually a synonym for self-
idolatry and excessive praise of autocratic monarchy, he personally
remained within the framework of a Christian king, being one of
the very last sovereigns to appear in votive pictures [plates 136 and
137] in his own person, introduced by St Louis and accompanied by
Colbert, adoring the risen Christ, in Lebrun's altarpiece of 1674, and
nearly thirty years later on the ceiling of the dome of the Invalides,
where Lafosse merges the royal saint and modern king, giving his
features to St Louis presenting his sword to Christ. This admittedly
marks a sense of triumph, an extreme of mood which was increasingly

159

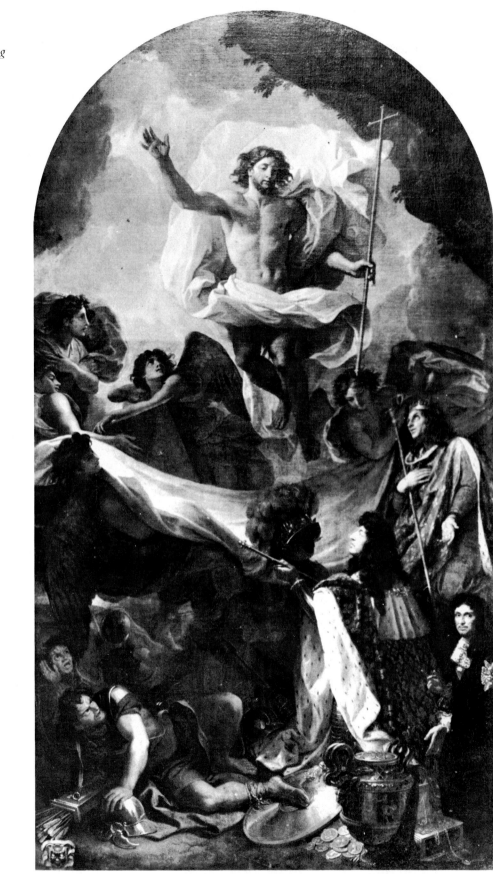

136 Lebrun: *Louis* XIV *adoring*
the risen Christ

137 Lafosse (after): *Dome of the Invalides*

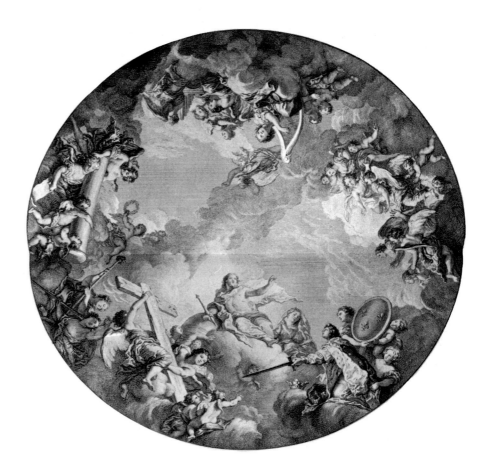

true in the realm only of imagination.

The novelty of Louis XIV's patronage lies probably less in what was produced than in its original intentions and, of course, in its huge scale. It drew together threads which had appeared in other kingdoms, under other rulers, but wove them into not one but a whole series of vast tapestries proclaiming not merely the prince, but 'the state', in the sense of a complicated organism which must constantly ascend until it really was like the sun risen above earth. It was called France but it aimed to spread over Europe: it was absorbing, pushing, expanding in a way that had scarcely been seen before.

To express this with artistic novelty was not easy, and there remains often something rather insipid in the results, so often allegorically dissipating the message. Even when the king is seen charging triumphantly across the heavens amid a whirl of personifi-cations [plate 138], some sense of weariness remains. The appeal is not to reason but to emotion. We are meant to be excited by the bravura of it all, located in a sphere inaccessible to mortals, and driving forward with such impetus that one is not meant to stop and raise moral, legal or rational quibbles. It is enough that France

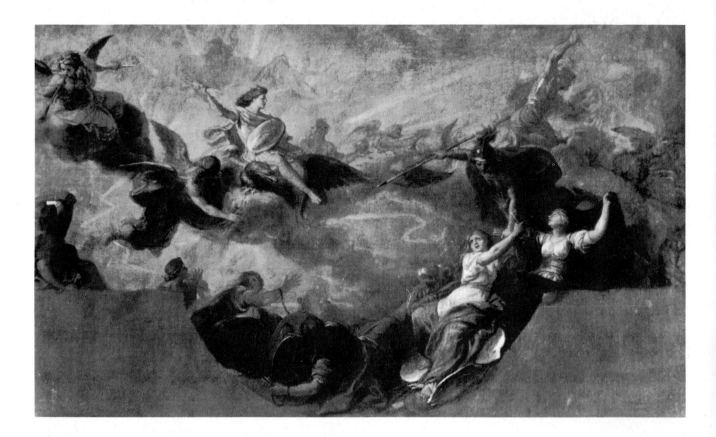

triumphs; her enemies are dispersed; the king bursts across the sky like the sun, and is no more to be held to account by human standards. At Versailles nothing succeeds like excess.[11] 'The prince performs in an infinitely manifold spectacle ...,' I quoted in the last chapter. Such a performance was well understood long before these words of Novalis were written. Versailles was the carefully-designed theatre in which Louis XIV moved in painted semblance, regardless of whether he actually appeared in the flesh, in a way that must engage the emotions.

When a guide at Versailles asked the English poet Prior if the king of England's actions were as lavishly recorded as were Louis XIV's, the poet replied: 'The monuments of my Master's actions are to be seen everywhere but in his own house.'[12] It's an admirable answer; but it is too optimistic and too reasonable if you want to make a hero of your master. It was the reverse of the policy always pursued by the Church; and Versailles is meant to be at least a temple, if not positively a church, dedicated to the glories of the French nation: focused on one person to symbolize them all, Louis XIV [plate 139]. He must exceed nature, triumphing over that as he had over Flanders or Spain, or the Franche-Comté, the Protestants, or the Pope. Such is the message of Rigaud's state portrait which is consciously excessive, deliberately formal and utterly majestic.

138 (*Above*) Lebrun: *Louis* XIV *scattering his enemies*

139 (*Opposite*) Rigaud: *Louis* XIV

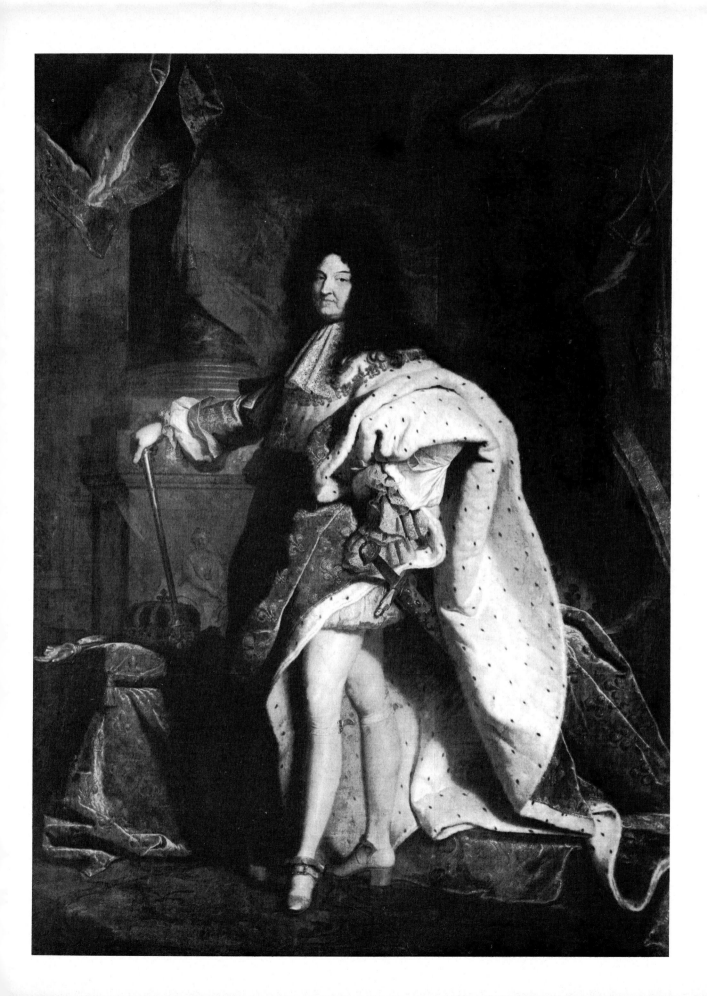

Let Velázquez show Philip IV as only too human – a dangerous way of risking disillusion in a monarch and in the audience around him. Of course, this does not mean that there was any disrespect in Velázquez's attitude – any more than in Goya's attitude to the Spanish royal family. But there was greater respect for nature and for things seen rather than symbols. Rigaud encourages the illusion that there is scarcely any humanity – certainly no clay – in an idol who here stands incarnating France. The royal crown, the sceptre with the hand of justice which is Charlemagne's, the sword which is St Louis's, as well as the proliferation of fleur-de-lis, drive home the historical message for anyone careless enough to have missed it at first glance. This is, in effect, a coronation portrait – painted years after the actual coronation of Louis XIV – which has become almost a canonization portrait. The descendant of St Louis, who in simple clothes had dispensed justice sitting under a tree, has become this imperious, aloof figure, himself as firm and unchanging as the pillar behind him. The descendants of Louis XIV conformed to this pose for their official *sacre* portraits, softening the mood with smiles of vague benevolence or sheer self-consciousness.

A deliberate and quite unsmiling echo of Rigaud's portrait, re-sounding with every form of certainty, is given off by a truly heroic composition which appeared at the Salon of 1806: Lefèvre's portrait of the new ruler, a new-style monarch who may be the successor of Charlemagne but is *not* the son of St Louis [plate 140].[13] Rigaud's *Louis XIV* has been transformed and even magnified into this most imperial portrait of Napoleon. David had depicted him crossing the Alps with the name of his famous predecessors engraved on the stone in the foreground [plate 141]. It is their statues that are visible down the long gallery where Lefèvre has posed the Emperor: they are the prologue from a heroic past – Charlemagne, Alexander – to lead into the heroism – or rather, the hero, of the present.

Nor is the echo of France's greatness under Louis XIV irrelevant. This was the particular note to be sounded in Napoleon's France when it came to considering the position of the arts. In Lebreton's report on the fine arts, read at a session of the Conseil d'Etat on 5 March 1808, it was said that 'Louis XIV and Colbert had raised the arts to their proper height, their thought was continually occupied with that ... it is to this principle of administration even more than to the monarch's taste that the brilliance of the fine arts at that epoch should be attributed. The success of the arts,' Lebreton goes on with yet greater firmness, 'is a benefit [derived] from the laws.'[14]

This moral belief is a legacy from the eighteenth century. And it is also true that Colbert's policy was more pertinent and effective than the somewhat fluctuating taste of Louis XIV. But if in Rigaud's portrait, painted long after the death of the great minister, one

140 Lefèvre (after): *Napoleon as Emperor*

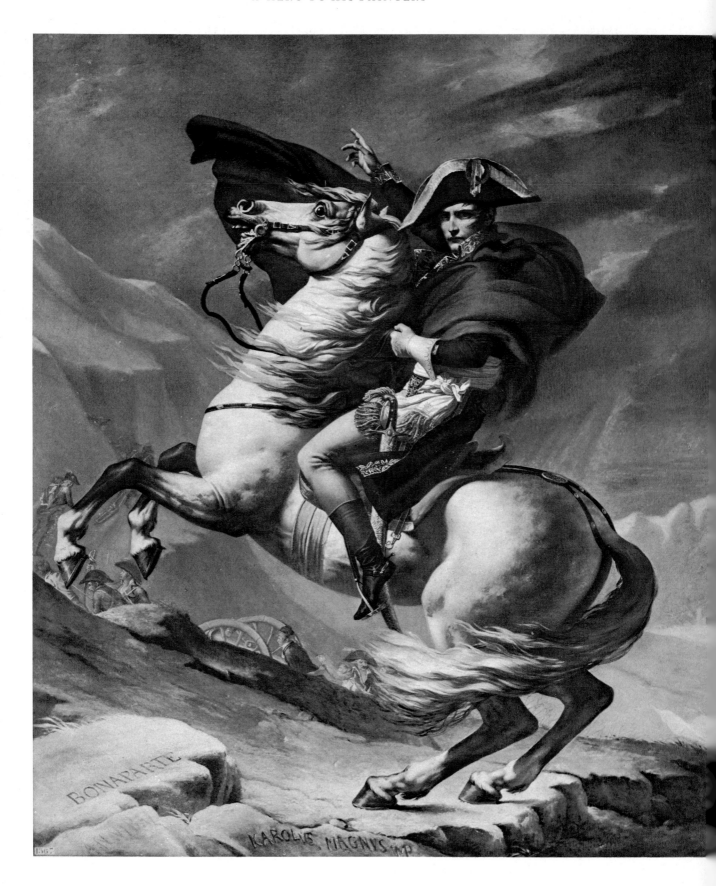

141 (*Opposite*) David: *Bonaparte crossing the Alps*

142 (*Right*) Drawing for *The distribution of the Eagles*

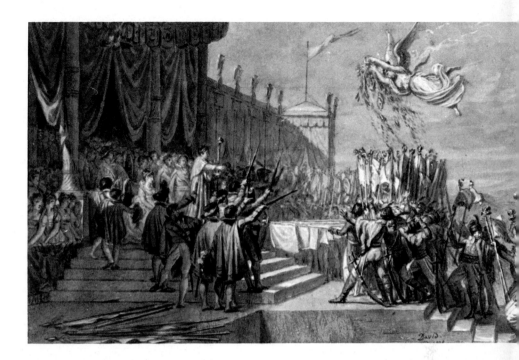

detects the culmination of his policy, in Lefèvre's we see the glorification of minister and monarch in one man, Napoleon himself. The arts at his court did not just revolve round him; they were fixed in a single beam or spotlight on him alone – a sun king who brooked no planets. He detected even in allegories possible rivals for the spectator's attention. It is well known – and it is highly significant – that David's preliminary drawing for the *Distribution of the Eagles* [plate 142] contained a Renown scattering flowers who had to be suppressed in the final painting.

The flattering advice of Vivant Denon, virtual Minister of Fine Arts under Napoleon, is less well known but points the way to a monopoly – not to say monotony – of subject matter which rivals anything a Tudor, Medici, or Bourbon ruler had imposed. 'The only monuments you will accept, sire,' Denon wrote to Napoleon, 'are those of a kind which, in consecrating your glory, will give the measure of it and will render foreign nations tributaries of your magnificence. Further, an image of them copied by engraving and by descriptions will amaze in the same way as the events which have prompted them.'[15]

Napoleon's own advice to David was that he should move away from historical pictures to scenes of heroic modern life. Whatever David might or might not do, once Napoleon was established as Emperor, the commands for pictures showed a marked shift towards 'modern life' as interpreted by the Emperor. Denon presented him in 1806 with a project for eighteen paintings, to be executed by a variety of painters, among whom Gros is now the best known. It

would be tedious to list all these subjects, but only one of the eighteen does not deal with Napoleon's career or campaigns. What is more, Napoleon carefully read through the lists presented by Denon. Not all the subjects were acceptable to him – least of all, one might guess, the brave proposal to paint '*The Death of Admiral Nelson*', an event of the preceding year. This proposal was accompanied by a pleading note that it might be interesting to transmit to posterity the generous devotion of the captain of the *Formidable*, although, the note admitted, 'the sequel to the battle of Trafalgar was disastrous.' Napoleon confirmed that view by deleting the whole subject.[16]

Where Napoleon was particularly fortunate was in the variety of painters available to be patronized. To each he became heroic. To catch the heat, martial brilliance and panache of his achievements we turn to Gros [plate 143]. To catch the more decorative, ephemeral to some extent, and more graceful aspects, connected with his wives rather than himself, we must not forget Prudhon, who saw Josephine as a romantic heroine. As for the man, David did superb justice to the man of state, working late into the night, guiding the destiny of France [plate 144].

144 David: *Napoleon in his study*

168

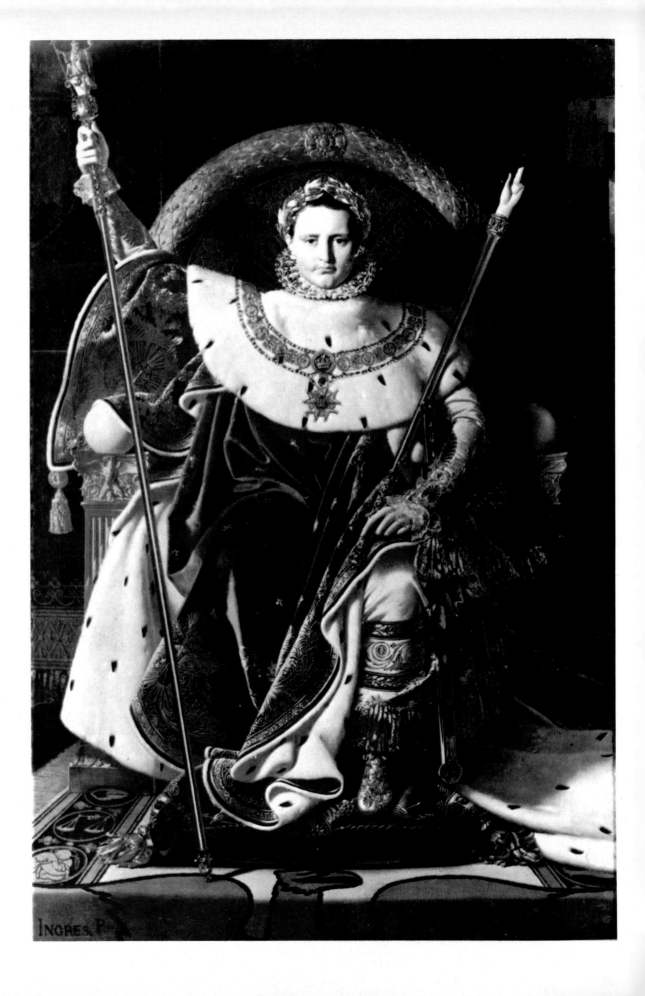

Yet the highest consecration of the imperial myth, not dependent on Rigaud but going back further into the past to evoke Jupiter or Jehovah, is in the icy, Byzantine image dreamt up by Ingres [plate 145]. How reasonable and plausible is David's depiction compared with this: David taking the eighteenth-century side of the Emperor, pausing preoccupied in his study amid a litter of papers, his sword unbuckled, his pen only just laid down.[17] One candle has guttered; the other burns low. And the prominent clock points to almost 4.15 in the morning. This is the benevolent, wise and sleepless monarch – his sword laid aside and the *Code Napoléon* visible among the scrolls of paper. It is the sort of portrait Reynolds or Goya would have produced of a minister or government official – the sort of portrait any eighteenth-century statesman might have commissioned. Perhaps there is even some significance in the fact that, though Napoleon warmly approved of the resulting work, it had in fact been commissioned by a British admirer, the Marquis of Douglas, and is a masterpiece of an unofficial kind, never intended for public exhibition in France.

But Ingres's moonlit, and indeed slightly mad, painting is an important, official portrait. It shows us no monarch of this world, but some cast-iron cut-out, his foot barely denting the cushion on which it rests, and the white leather-gloved hands no warmer nor more flexible than the ivory hand that tops the sceptre. Augustus, Alexander, Justinian, Charlemagne: all these emperors are evoked, yet none can rival this absolute image of imperial isolation.[18] It is indeed the portrait of one who, in Madame de Staël's apt words, wanted 'to put his giant self in the place of mankind'.

It is an image evolved for worship. In the year that it was exhibited at the Salon there was published the final form of the catechism approved by the Emperor for use throughout his Empire. A change had been made in the old traditional wording which under Louis XIV had been drawn up by Bossuet. A change? Several. Louis XIV had been content with a catechism that commanded in general terms respect for all superiors, pastors, kings, etc., in that order. Bossuet's catechism, after being doctored by Napoleon, partly read thus:

Christians owe to the princes who rule them, and we in particular owe to Napoleon I, our Emperor, love, respect, obedience, loyalty, military service, the dues laid down for the conservation and the defence of the empire and of his throne; we also owe him fervent prayers for his safety and for the temporal and spiritual prosperity of the State.
Why do we owe all these duties towards our Emperor?
First, because God ..., plentifully bestowing gifts upon our Emperor, whether for peace or for war, has made him the minister of his power and his image upon earth. [19]

146 (Opposite) Saint Napoleon

If that was not strong enough, a subsequent sentence tells every French Christian that since the Pope consecrated Napoleon, the Emperor has 'become the anointed of the Lord'. Nor is it just my own fancy to attach sanctity to images of Napoleon, whether by Ingres or by such anonymous engravers as produced compositions of *Saint Napoleon* [plate 146] – of, that is, a hastily excavated saint, given the Emperor's own features.[20] And these easily-disseminated prints probably played their part in fostering devotion for the Emperor just as effectively as English propaganda on the other side had engaged in making sharp, satirical fun: aiming to destroy that image of power and invincibility which, however, was not so easily destroyed.

Ingres represents it at its firmest and at its furthest removal from reality. To such an extent is this so, that the contemporary criticisms missed the point by stigmatizing his portrait as a poor likeness. But, to adopt the sitter's own words to David, who asks if the portraits of great men are good likenesses? It must remain an open question if the new Alexander would have been able to appreciate and encourage the creator of this marvellous image, despite the criticisms made of it, had Ingres remained in Paris. Even if so, Ingres would perhaps merely have had to endure – or reject – the crippling duty which fell on Girodet, commissioned in 1812 to paint thirty-six full-length portraits: thirty-six full-lengths of Napoleon in coronation robes.[20A]

Nothing suggests that Napoleon was particularly drawn to Ingres. And Napoleon's patronage was also – as the Girodet commission suggests – voracious in its somewhat monotonous demands. Nevertheless, it is particularly interesting for a number of reasons, not least the fact that it so perfectly enshrines the romantic concept of the ruler, hymned in advance by Novalis, making welcome the dynamism of a ruler who really does rule – whatever crimes he commits in so doing. Of all the captains and kings who have crossed our path here, Napoleon is probably the one, among those at any rate who have figured prominently, with the least interest in art other than as a vehicle for propaganda or as providing alternatively a softly suitable setting for women – of whom he did not have a high opinion.

Yet it was through a woman that he was to have two striking examples of what painting could do for what we may without incongruity call, in our own jargon, his 'image'. The famous portrait of *Bonaparte at Arcole* [plate 143] is due to Josephine, as well as to the painter Gros whom she had introduced to Napoleon. This may be better understood as the portrait of the new-style hero when compared with a contemporary Italian effort, Appiani's allegorical tribute to General Bonaparte, victor of the battle of Lodi [plate 147]. The

147 Appiani: *Napoleon as the victor of Lodi*

Sᵗ **NAPOLÉON,**
Patron des Guerriers.

conventional praise of Appiani, neo-classic in the manner almost of
Batoni, is obliterated by the actuality and pressure of Gros's concept
of a hero actually involved in battle – not just standing there, but
really doing something. He calmly leads his men forward across the
bridge, holding in his hand the flag of the Republic and looking
back to the unseen soldiers – necessary supernumeraries in battle
but who do not compete in the portrait for our attention. Not only
did this imaginary picture – for Gros had not been present at Arcole –
give the French public of 1800 (when it was exhibited at the Salon)
the clearest idea of their new hero, but it remains the most vivid,
stirring, and convincing of all portraits of Napoleon. Almost with-
out one's realizing it, it disposes of the conventional posed portrait
of the eighteenth century: dispensing with rhetoric, it yet refuses to
be modest. One final reason for the convincingness of this portrait
comes, I think, from the fact that it was painted without premonition
of the future. Imaginary reconstruction though it was, it does not
suffer from the self-consciousness of later depictions of scenes from
the emperor's early achievements.

Whatever artistic judgment we now make, however, it is very
likely that Napoleon would have preferred some of the later paint-
ings by inferior men. He might feel that Gros had shown him too
engaged, merely an excited fighting soldier, whereas his require-
ments from art were to be more elaborately ambitious when he
came to organize this aspect of his own empire. Indeed, it was
perhaps with this very portrait in mind (a portrait which, by the
way, he never owned) that Napoleon forbade David to paint him
on the battlefield of Marengo, with sword in hand. To be 'calm on a
mettlesome horse' was his own memorable phrase for his require-
ments, the programme beautifully executed by David in *Bonaparte
crossing the Alps* [plate 141]. That is more than the portrait of a
victorious general, or even of the successor to Hannibal or Charle-
magne. It is nature that Napoleon conquers: taming without effort
his fiery horse and also the icy nature of the Alps. He is above
climate, as he is above doubt; and – as commander-in-chief – he is
above any sense of battle. At the same time, he remains a modern
hero in a modern, would-be realistic framework. It is easy to see that
Napoleon realized how much more effectively is revealed his super-
natural superiority when set within the natural world.

Equally shrewd was Napoleon's preference for *ancien régime* style
costumes for his court, in preference to David's proposal of classical
antique dress. It is to the *ancien régime* that one must turn back, I think,
to understand what Napoleon tried to do, if not with all the arts, at
least with painting. The bifocal vision of the eighteenth century,
excited by great rulers of the past but so sober about the rulers of its
own day, must become focused in one form of programme where

the two are blended. It will no longer be necessary to show a St Louis or an Edward III to stir patriotic associations. The modern monarch, Napoleon, will conquer or be magnanimous, as the subject requires. Both portraits and subject pictures will thus revolve round the same subject: himself. By 1806 this belief had been effortlessly absorbed from politics into aesthetics when Chaussard's *Pausanias Français* began its publication with a general account of the contemporary artistic scene, in France of course. 'The opening of the nineteenth century,' it said, 'will always be memorable.' Some previous centuries have been lit by the torch of the arts, like that of Louis XIV. But when the torch of Art is joined to the torch of Glory, what brilliance may be expected. Splendidly reckless in its prophecy, the *Pausanias Français* sets out to fulfil the task of chronicling art 'for the century of Napoleon I'.

If it was to be Napoleon's century, as he certainly intended it should be, it was necessary that he should appear in roles other than that of military conqueror, and it is remarkable – or perhaps, on reflection, it is only typical – how quickly he realized that he must incarnate statesmanship, government, wisdom and foresight. Those are qualities which he needed to prove his possession of, while the world could see for themselves his victories in battle. Thus it was as statesman not general that he was painted when First Consul by Greuze and Ingres and Gros [plate 148]. Gros shows him with one hand on papers which list his treaties, prominently ending with that of Amiens (the peace with England of 1802), and also including the word *Concordat* to indicate the treaty with the Pope. What is depicted is Napoleon the builder of state edifices, strengthening France by wise, constructive acts.

It was not enough to reveal the wise statesman, mature in judgment though still youthful in years. 'My intention,' the Emperor wrote in 1805, 'is to turn the arts especially towards subjects tending to perpetuate the memory of what has been achieved in the last fifteen years.'[21] An almost divine side of Napoleon appeared in Gros's famous painting of the *Plague at Jaffa* [plate 149]. It is worth noting that the commission for this picture was given by Josephine: 'ordered by the Empress' is the note which approved the payment. Again Gros worked his imagination, most vividly – if we are to accept that in sheer fact Napoleon had hurried briefly through the hospital at Jaffa. It was not a very glorious page of history, nor of his personal life, until art had wrought it into this extraordinary miracle-like scene, where amid the merely human weakness of his staff and the misery of the plague-stricken, Napoleon is seen acting out the healing role of royalty, touching to cure – like a medieval king or Christ himself.[22] This divine heroism was soon complemented by the divine charity manifested in Debret's *Napoleon honouring the*

148 Gros: *Napoleon as First Consul*

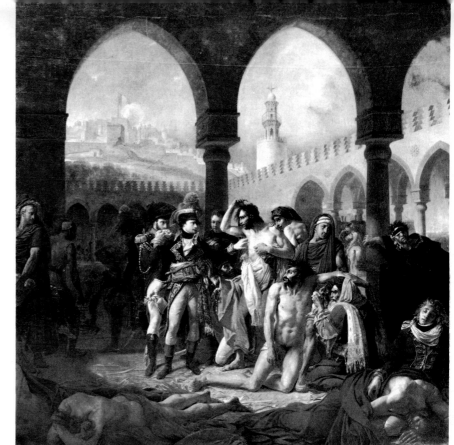

enemy wounded [plate 150], a subject which anticipated by two years Gros's much better known *Napoleon on the battlefield at Eylau*. Both pictures consecrate the Emperor as magnanimous and moved to generous sentiments on the battlefield of his victories. It is the same sort of propaganda that we see in David's *Sacre* [p. 152, plate VI], where the chivalry of Napoleon is finally emphasized – in distinction to David's original concept of the moment, conveyed by a vivid drawing [plate 151]. This preserves a good deal of actual truth: the Pope's total passivity and Napoleon's impetuous grab at the crown bringing us the moment with positive humour, making it perilously close in mood to an actual cartoon by Gillray of the scene.[23] If Napoleon thought so constantly in terms of favourable propaganda it was partly as a result of the antagonistic propaganda which had poured on him, particularly from England.

What David produced in the final painting was approved by Napoleon for its celebration of his chivalrousness and affectionate honouring of Josephine. Delécluze, better writer than painter, who had certainly seen the picture being executed and was perhaps present on the day the Emperor and his court came to inspect it in David's studio, records that Napoleon's expressed approval was that the artist had guessed his thought: 'You have made me a *chevalier français*.'[24] It was in this new guise that the hero, general, saint and healing monarch was to be transmitted to posterity – Napoleon of course mentioning this particular transmission, '*aux siècles à venir.*' It was to them that he had transmitted also the invented gesture whereby Pope Pius VII raises a weak hand in blessing at the moment of conjugal tenderness. 'I did not bring him all the way to do nothing,' is the sentence already quoted as Napoleon's in requiring this change. Whether or not he expressed it exactly in those words, its sentiment is as surely his, as is the improvement of fact.

The picture does, in many ways, sum up Napoleon's ideals as a patron. It is – if not true, at least realistic-seeming; and for the same reason it remains popular with the ordinary French public. Like Napoleon they can exclaim before its verisimilitude.[25] It is a scene which marks the highest, and perhaps the happiest, moment in Napoleon's own career: the apex of his glory. He is the first Emperor to crown himself, in the Pope's presence, not in Rome, not even at Rheims, but in Paris. He, the excessive, romantic, extreme hero, sets himself within the framework of tradition, evoking religion, secular splendour, papacy, royalty, the whole of earthly pomp, to revolve around him who even here is superhumanly calm, his own pope, as he crowns his wife.[26]

Like the sun, Napoleon lends his glory in which his wife can be reflected. It is part of the heroic myth that Josephine should be a goddess and an incarnation of charity too. She had actually been

152 Vermay: *Mary, Queen of Scots,*
hearing her death sentence

hailed as '*Notre-Dame des Victoires*' when Bonaparte was only a
general. When they entered the Tuileries as First Consul and wife
she had fearfully remembered Marie-Antoinette. Like a merciful
Madonna, she was painted in a picture of 1806 when she visited the
Hospice de la Maternité.[27] And in a letter of David's, about a further
painting with her in it, he speaks of her being '*semblable au soleil
bienfaisant.*'[28] Her patronage of the arts is a separate subject in itself,
but I think there is some rather sad relevance in looking at Vermay's
Mary, Queen of Scots, hearing her death sentence [plate 152], which was
shown at the Salon of 1808 and immediately bought, the critics
recorded, by a very high personage. That Josephine was the pur-
chaser is proved by the picture's appearance in the Malmaison
inventory at her death.[29] In 1808, when her long-threatened divorce
had become nearly a fact, she may well have identified herself senti-
mentally with past royalty, unhappy through their very position.
While Napoleon might go on evoking Charlemagne and Alexander,
her fate linked her more with the ill-treated Queen of Scotland.

It is true that there is a private side to Napoleon's own patronage,
a domestic vein which came with his second marriage and with the
birth of his son, the King of Rome. Prudhon was available to design
the cradle, as he had designed Marie-Louise's toilet set.[30] He was also
to sketch her, less graceful but more royal than Josephine, yet given

as much of the artist's shadowy charm as the subject allowed. There is frank sentiment in some of the merely pretty pictures which were painted of Marie-Louise and her son, though Napoleon did not hesitate to enlist his child in the necessary propaganda to shore his tottering empire. When in the crucial year 1814 he received a miniature by Isabey of his own son praying, it occurred to him that it could suitably be engraved with the printed text: 'I pray God that he will save my father and France.' With a text emended to conceal the desperation apparent in the verb 'save', this was done.[31] The engraving was a great success, though the prayer was not.

Yet in his fall Napoleon still lived on as a hero. It is perhaps the most truly heroic aspect of his career that the years of exile and death only enhanced the legend. He remained a hero to the painters who had not known him. In one of Delaroche's compositions [plate 153], he is a haunting, brooding presence, enthroned among high rocks in exile, a king who – it seems – promises to return to his people: still a giant and heroic figure, above the scrutiny of ordinary men, still embodying France.

Final apotheosis came in a painting by the longest-surviving artist of those who had actually known him and portrayed him in the years when he was First Consul; for the third time Ingres painted him, in 1853, in the ceiling painting for the Salon de l'Empereur in

179

the Hôtel de Ville at Paris [plate 154]. Here, naked, as in Canova's statue, Napoleon rides in triumph, ascending – at last – into heaven. It is the sort of allegorical representation Napoleon most disliked. But it is a remarkable tribute, from the painter, to the legend, in the Paris of Napoleon III, the Emperor's nephew. The original was prominently displayed in the Ingres room at the *Exposition Universelle* – heartening message to monarchs in the nineteenth century. There it must have been seen by Queen Victoria, though she mentions only the work of Horace Vernet and Winterhalter.[32]

It is one of the last seriously intended statements by a great painter serving and fostering royal, dynastic propaganda. It marks the close of one tradition which we have traced, on and off, since the fourteenth century. Yet it does not mark a total close of court painting, because there is one further exploration to be made, keeping us on solid earth. I should like to think Queen Victoria did see this picture – saw it as something old-fashioned compared with the sort of pictures she encouraged at her own court. The days of heroic royalty were over; Europe settled down to be comfortable. It is, or rather it used to be, fashionable to decry much of the painting which resulted, especially that associated with Queen Victoria herself. Yet it has not only relevance to the theme of court art but its own distinct fascination.

154 Ingres: *Apotheosis of Napoleon*

6 AT HOME AT COURT

This book has traced a course – not an artificial, arbitrary course but, I hope, the true if erratic course of history – from medieval heaven to bourgeois nineteenth-century home. That prosaic terminus is where we find ourselves; and some people may wonder that such a last, humble, rather awful close should be chosen for this chapter. Yet it is something more than a moral duty, even if it is not always a pleasure, to follow court art to what appears its conclusion and extinction.

We are dealing with the disappearance of the whole concept of art at court. To be concentrated on is one of the last European courts to have any pronounced character, ruled by one of the last European monarchs to have any pronounced character: the court, that is, of Queen Victoria. But if courts are on the wane, so, it may be admitted, is art, within our usual terms of reference. It is sometimes necessary to brace oneself for the visual shock of many of the things then created; they are in some cases artistic atrocities, even though they were often specially commissioned in the belief that the results would be art. Yet in that naive belief, and subsequent disaster, there is perhaps historical interest, even relevance.

This book opened at a point when society was a pyramid-shaped phenomenon, topped by the monarch, God's vice-regent on earth, and someone who might be called literally the impersonator of Christ, '*christomimetes*'.[1] As God is the prime mover of the cosmos, so the ruler is prime mover in the microcosm of society or kingdom. His patronage of the arts is only one aspect of his activity, and – at least in painting – he tends to require art which reflects the utterly stable, heavenly-ordained world order: with divine sanction given to the monarch either explicitly or implicitly. It is the sort of concept illustrated quite beautifully in such works of art as the *Glatz Madonna* and the *Wilton Diptych*. I have tried to show that the Renaissance did not immediately lead to more pictures of this kind, but in fact extended the – anyway more truly Renaissance – idea of a monarch on earth, involved now not so much in praying but in daily activity, ruling, acting as patron, and seen – in the most sophisticated concept – at leisure, reading or hunting. In those compositions, of which the most familiar are the fresco cycles at Palazzo Schifanoia and in the Camera degli Sposi, we encounter already the theme of being 'at home at court': graduation day with the Gonzaga family, or a joke exchanged between Duke Borso d'Este and his court jester.

Once created, this mood is something which keeps being

recreated in painting, even while demands of pageantry or propaganda, or dynastic concern, are equally or more strongly being made. That mood of intimacy and relaxation is certainly present in Raphael's portrait of Pope Leo X, and in the extraordinary panorama of a royal court which is concentrated in *Las Meninas*. By the eighteenth century that had become very much the keynote at least for royal portraiture. With Napoleon however there is a dramatic change. Even the intimate mood becomes part of a propaganda machine: if the Emperor is shown in his study, it is because he is ceaselessly at work for the good of France; if his child is shown at prayer, then it should be read as a prayer that God will save his father and the kingdom.

Whatever view we may take of Napoleon, either as ruler or as artistic patron, his attempt at absolute monarchy marks the end of romantic, dynamic royalty. He is Europe's Tamburlaine: 'A god is not so glorious as a king.' It is fitting that his attempt at an empire should have been so colossal because it needed to be on such a scale to stir an age which was growing leaden and prosaic. Only something super-colossal would impress people who had lived through the French Revolution and seen the monarchy fall – a fall, by the way, the more remarkable for the personal moderation of the monarch who happened to be Louis XVI. It could be said that his very moderateness was itself a dangerous quality for an autocrat in such a position to possess – like a poor actor finding himself in the role of Othello. 'Perhaps,' said a perceptive observer at the time, 'no man bred up in the style of an absolute King, ever possessed a heart so little disposed to the exercise of that species of power as the present King of France.' That is not some wild rhetorical defence by Burke but the measured view of Tom Paine, going on to draw a clear distinction between men and principles.[2]

Napoleon, of course, confounded in himself the distinction – quite deliberately. But the truth is that not even he could give monarchy the aura which it required – required in fact as well as in art – if it was to exercise a magical sway over people. In France it simply would not work, whether it was the Catholic reactionary monarchy of Charles X, the Orleanist liberalism of Louis-Philippe or the imperial, pseudo-Napoleonic régime of Napoleon III.

In England, the monarchy remained firmly in existence, but it remained in existence by virtue of withdrawing from most positions of real power. Queen Victoria probably had no idea that she had been forced to do that. She is splendidly in the tradition with which this book opened, positively medieval in her belief that her royal power was 'a gift of God'; and when she read a book of constitutional history which derived the sovereign's rights from the people alone, she pronounced it 'too Republican'.[3] However, she did not

155 Daumier: *Paris urchins in the Tuileries Palace*

hasten to have the blessings of her reign allegorically depicted on the ceilings of her palaces.[3A] But she did urge an ethical claim to be the sovereign, feeling that it was by literal virtue of a happy and good domestic life that she was entitled to the loyalty of her people. In this she was undoubtedly correct, and her Diamond Jubilee was to show the force of it. Yet in many ways she instinctively drew a distinction between her role as sovereign and her private existence – a thing she is often accused of not doing. Although she would have been shocked by Daumier's expression of it [plate 155], she perhaps realized that nowhere was the throne any longer in most people's eyes a completely sacred, untouchable object. That it was not is made apparent by the running comments of *Punch* through much of Queen Victoria's reign. Nor was *Punch* content with making fun of the monarchy; it was quite ready to make fun of the monarch herself and her husband.

As a tradition such mockery was not quite new. Under the Hanoverians the English had indeed had ample opportunity to build up a good fund of satire. Queen Victoria's two uncles George IV and William IV had, each in his own way, caused sufficient

mockery, much of it ribald and extravagant. It is true that some such comparable vein of satire came later when Queen Victoria got herself so closely involved with her servant, John Brown. But though royalty is always a target for speculation about its love life – or lack of love life – it was another aspect which *Punch* was busy caricaturing in 1844: royal taste in art. And the taste was not criticized for splendour or arrogance, but for its very domesticity. Thackeray was responsible for a spoof review of the Royal Academy exhibition that year, in the manner of sycophantic journalistic notes: 'Among the portraits we remarked – 691. Portrait of the hat of His Royal Highness Prince Albert; with His Royal Highness's favourite boot jack. His Royal Highness's Persian wolf-dog Mirza is lying on the latter, while the former is in the possession of His Royal Highness's diminutive spaniel, Miss Kidlumy ... This magnificent piece of Art has all that Mastery of execution, that chiaroscurity of handling – above all, that thrilling, dramatic interest which distinguishes the most popular of our painters ...'[4]

Under the very flimsy disguise of 'Mr Sandseer', this painter emerges as Landseer. If one can scarcely illustrate the exact picture so unkindly evoked by Thackeray, we can get quite a good idea of it from an actual painting by Landseer [plate 156] executed for Queen Victoria. Combined with Thackeray's comments on this sort of portraiture it probably gives a good enough idea of what I mean by suggesting that what had once been a royal court had

156 Landseer: *Queen Victoria's pets*

157 (*Opposite*) Winterhalter: *The Prince Consort*

become a home – an almost deliberately bourgeois, *gemütlich* home. Before the end of Queen Victoria's reign, George Moore was reviewing royal patronage as exemplified in the Victorian exhibition of 1892, talking about the 'family' quality of the work commissioned by the Queen, and of one group portrait by Winterhalter he sharply remarked that it was 'sufficient to occasion the overthrow of a dynasty if humour were the prerogative of the many instead of being that of the few'.[5] We might feel in fact that this amusing criticism has picked on one of the better painters: certainly Winterhalter's painting of the Prince Consort [plate 157] is one of the rare royal portraits of the nineteenth century which manages to steer a course between absurd inflation and almost equally absurd prosaicism. Poor man's Ingres, perhaps; but it retains some sort of distinction.

The nineteenth century witnessed a series of shocks given to the whole concept of art. It was not only courts which had suffered some loss of prestige. The place of art was increasingly uncertain, and was to become even more uncertain after the invention of photography. Painting at, or for, a court needed some warmth of the imagination to encourage it. If truth to nature and natural appearances is to be the watchword, after the supposed falseness of much eighteenth-century painting, this in itself is likely to inhibit any Rubensian apotheoses of monarchy. And not only may the person of the monarch be somewhat uninspiring as a subject, but it can scarcely any longer be a workable hypothesis that an artist needs court patronage. What, we may reasonably ask, could the

158 Frith: *Ramsgate Sands*

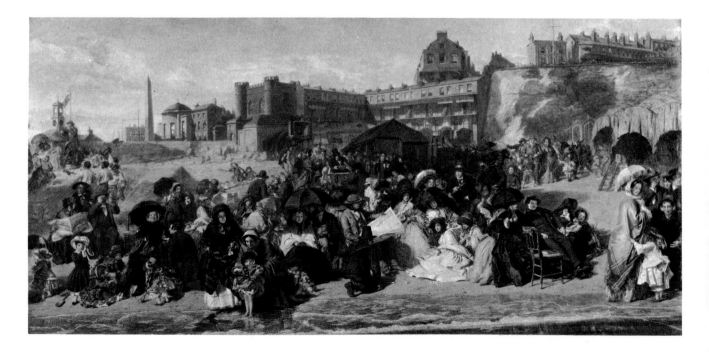

court of Queen Victoria offer such a painter as Turner? All it could have done would have been to curb his imagination.[6]

The Queen tended to agree (as so often) with the majority of her subjects, enjoying the patent truth to a patent nature represented – not by Turner but by, for instance, Frith's *Ramsgate Sands* [plate 158]. This was a popular favourite at the Academy in 1854 where the Queen speedily singled it out on her visit and bought it.[7] It was the first of Frith's panoramic views of mid-nineteenth-century life, rapidly followed by *Derby Day*, in turn followed by *The Railway Station*. *Ramsgate Sands* was exhibited again in 1897, the year of the Queen's Diamond Jubilee, and a writer then described its reception: 'Many who remembered its first appearance in 1854 warmly welcomed it, and keenly enjoyed the touch of old times that is in it – the costume of the fifties, the skilful grouping, and the numberless incidents, as familiar and recognizable as they are engaging and humorous.'[8] The sentence might almost be one of Queen Victoria's own. And although the picture was not a commission as such but only a purchase, it represents well enough the typical reassuring image of contemporary life: society a series of anecdotic groups, and a painting something which can be treated by spectators as a novel, to be read rather than seen in terms of form and colour.

A recent American enthusiast of the Prince Consort's taste has said that this picture has 'survived several generations of criticism'.[9] Well; as a canvas it has indeed survived physically, but in other ways I cannot think that it has. If not strongly criticized, it has undergone a more subtle fate of not being spoken about at all. Nor can one claim that a masterpiece has been foolishly overlooked. As a document, however, *Ramsgate Sands* is certainly interesting, and it has all the ingredients for popular mid-nineteenth-century success. A *plein air* sketch of a beach by Monet or Degas would, if juxtaposed, destroy it, but then Monet and Degas were not popular successes. Frith is not really painting a picture but describing middle class society's new way of enjoying leisure – a way Queen Victoria could easily appreciate, since she too liked a sea bathe at Osborne. In Frith's picture she could see her subjects assembled happily and informally: children, parents, lovers, old people, like one huge family. And it is fitting that, having acquired the painting, she hung it at Osborne.

In the picture's very lack of central subject, and in its basic avoidance of anything dramatic or even stirring, still less profound, it offers sovereign and society a stable image of themselves. It is, as Queen Victoria was fond of saying about things and people, 'safe' – eminently safe and inevitably successful. All honour, incidentally, to Ruskin for detecting so quickly in Frith's work (in *Derby Day* in fact, but the point is valid for this picture too) 'a kind of cross between

John Leech and Wilkie, with a dash of daguerreotype here and there, and some pretty seasoning with Dickens's sentiment'.[10] The anecdotal, the photographical and literary elements are indicated clearly, though with surprising restraint. Later he was sharply to contrast the demand for engravings of *Ramsgate Sands*, 'because you can see yourselves!' with lack of interest in Raphael's Cartoons.[10A]

In the pictures painted for George IV, and also in the earlier pictures collected by him, there had already appeared a vein of the lightly anecdotic, usually in humble surroundings. Whether acquiring typical Dutch seventeenth-century pictures or the sort of Dutch-style Wilkie that he liked, he was basically being drawn to a reality which he did not know. At the same time, he was anxious that much of the work executed for him should reflect his own period. He seized on the idea, suggested to him by an obscure poetess, that the sovereigns and statesmen associated with Napoleon's overthrow should all be painted; the result was Lawrence's wonderful gallery of portraits in the Waterloo Chamber at Windsor. And Lawrence's response to the patron himself produced a sumptuous portrait, one version of which went off to Pope Pius VII, who hung it in St John Lateran. According to good contemporary evidence, it was there believed by simple worshippers to depict some influential if obscure saint, and a knot of people was often found praying before it, until the scandal was discovered.[11]

Nor was George IV interested only in pictures that were linked to the straightforward defeat of Napoleon. It is a pity that he did not know of Goya, but at least he responded to Wilkie and bought Wilkie's Goya-like *Defence of Saragossa*, painted in Madrid in 1828, and commemorating an incident of Spanish patriotism during the siege by the French twenty years before.[12] Among the first paintings connected with Queen Victoria's reign, and executed for her, was Wilkie's *First Council of Queen Victoria* [plate 159] which interestingly blends the anecdotic, tinged with the sentimental, and the historic.[13] It was a quite conscious reversal of the truth which made Wilkie change the colour of her gown from the black, which she actually wore, to the innocent white we see, increasing the pictorial effect of what was already highly effective historically – for it was the first appearance of a queen regnant, and too a very young one, since Queen Anne. At the time the picture pleased Queen Victoria. When she looked at it again, ten years later, she thought it one of the worst pictures she had ever seen. Perhaps one trouble about it was that it reflected not only her intense loneliness but a stiff ceremonial occasion of the sort which – increasingly – she disliked. How the occasion had moved painters at the time is seen also in an effective, unexpected sort of coronation painting, by Leslie [plate 160], unashamedly romantic – yet scarcely 'Victorian'.

159 (*Above*) Wilkie: *First Council of Queen Victoria*

160 (*Below*) Leslie: *Queen Victoria at her coronation*

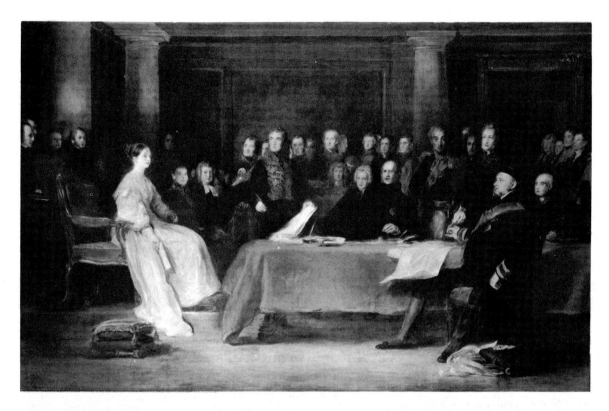

In 1847 the Queen was no longer lonely, but happily married to the Prince Consort. The painting to be fostered by them was not connected with ceremonial occasions. Exactly the opposite. It was to be concerned with celebrating a royal happy domestic life of a kind not seen since the early years of George III's reign. From the beginning it was marked by a determination to retreat – to raise the flag of family rather than royalty. 'Cosy' and 'snug' were two favourite adjectives of the Queen's, to be added to 'safe'. The places that exemplified this family life were Osborne, once a 'little house' but rebuilt on grandiose Italian villa lines by the Prince Consort, and Balmoral, a 'pretty little castle' in Queen Victoria's eyes. In these retreats, the Queen herself sketched or played with her children; in Scotland Prince Albert shot, and the Queen visited Highland cottages or organized a picnic. These things in themselves may be thought now scarcely worth the telling. Yet they were in a way remarkable in mid-nineteenth-century Europe, and they were to be made even more remarkable – in the eyes of the royal couple – by being put down in paint. 'It is quite a new conception,' the

Queen wrote truthfully in her *Journal*, up at Balmoral, 'it will tell a great deal.'[14]

The chief painter chosen to tell it was Landseer. He it was who re-created days when a faithful, handsome ghilly, like the head one at Balmoral, John Grant, had toiled with the Queen's pony up rocky tracks – leaving her yet feeling so 'safe'. A preparatory portrait drawing of Grant [plate 161] was given by the painter to the Queen, for he was now a welcome guest at Balmoral and was busy painting subjects from 'our life in the Highlands' at the very time the Queen made her *Journal* entry. These were, it was to be hoped, pictures which would tell a message about modern royalty [plate 162].

Equally, when a costume ball was planned and the Queen and Prince Consort went to it as Queen Philippa and Edward III, Landseer was on hand to record their appearance [plate 163]. History was partly a matter of dressing up, though of course as historical royalty. The medieval period was chivalrous and more edifying than later periods, but once at least the royal couple dressed up – to be recorded by Winterhalter – in Charles II costumes, with

161 (*Opposite*) Landseer: *Drawing of John Grant*

162 (*Below*) Landseer: *Loch Laggan*

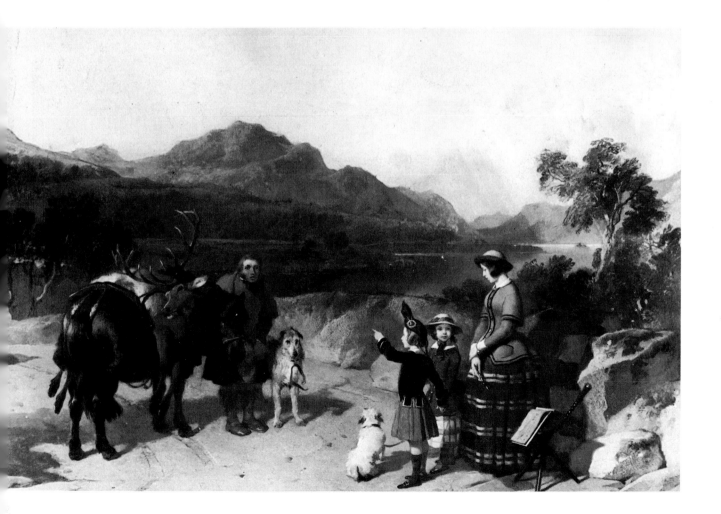

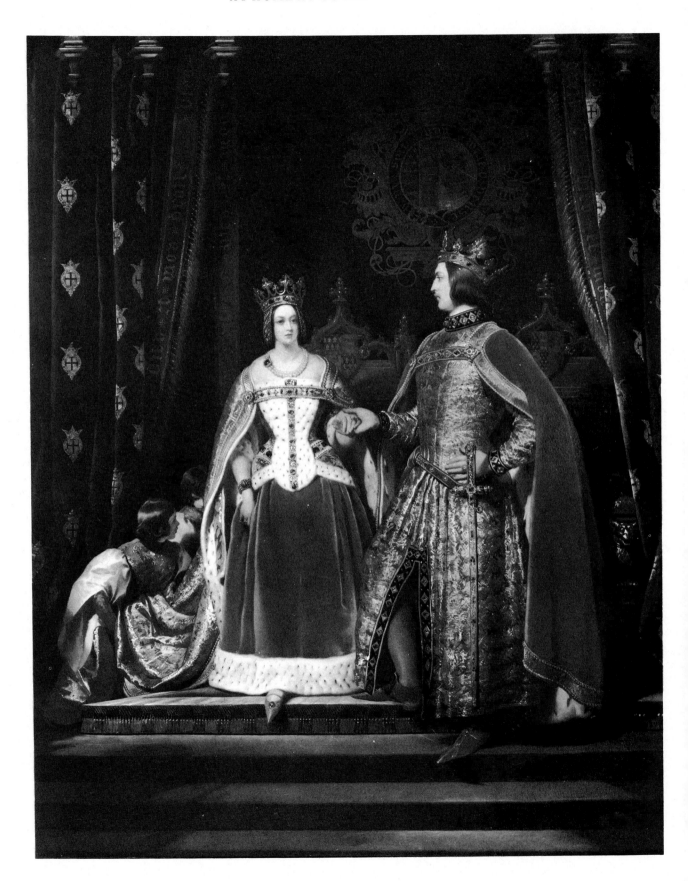

163 (*Opposite*) *Queen Victoria and Prince Albert as Queen Philippa and Edward* III

164 (*Right*) Winterhalter: *Queen Victoria and Prince Albert in Charles* II *costume*

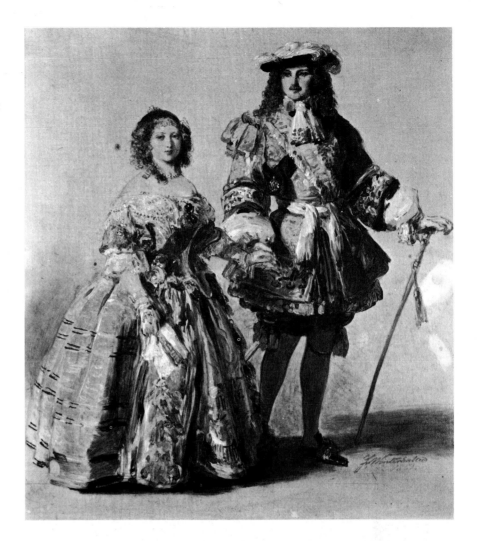

a daring but quite incongruous suggestion of recklessness [plate 164].[15] Nobody could be less like Charles II than Prince Albert. And this fancy-dress world was alien – as history or even as masquerade – to modern, dutiful, respectable royalty. Religious sanction for royalty was not required, but it was paradoxically necessary to state the claim of being simple, moral and natural. In many ways this claim is what Queen Victoria constantly urged, without realizing that there was unconscious pressure on her to do so. However, she certainly realized the value of her domestic image, drawing attention to it very clearly when she wrote to her uncle, King Leopold of the Belgians: 'They say *no* Sovereign *was more* loved than I am (I am bold enough to say), and *that* from our *happy domestic home* – which gives such a good example.'[16]

There lay her real title to reign, even while she was able to lecture one of her prime ministers on the position of monarch and people in a much higher, indeed intolerably high, tone: 'Obedience to the laws and to the Sovereign, is obedience to a higher Power, divinely

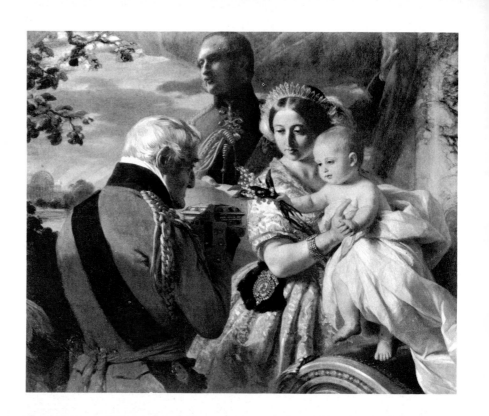

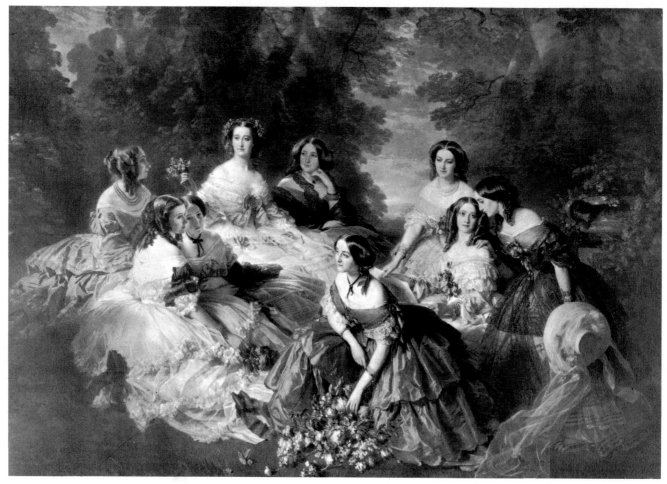

instituted for the good of the *people* ...'[17] In a submerged fashion, the belief lies perhaps behind one of the more elaborate domestic compositions commissioned from Winterhalter [plate 165]. *The First of May* celebrates the birthday of the Duke of Wellington and of Prince Arthur of Connaught, to whom his godfather, Wellington, is presenting a casket. The composition is a sort of deliberately secularized *Adoration of the Magi*, giving a holy aura to the good domestic life of Queen and Prince, which is seen at the same time to be quite royal and really only mock-simple. It is an easy picture to read, perfectly detailed in a way that would please the Queen and slightly elevated by having behind it a concept designed to flatter the Prince in more ways than one. 'Winterhalter,' the Queen wrote with her usual unconscious tartness, 'did not seem to know how to carry it out, so dear Albert with his wonderful knowledge and taste, gave W. the idea ...'[18]

Despite that advantage, it is not a successful picture even by Winterhalter's own standards. It does not present a convincing image of Queen Victoria's private or public life, but is an uneasy amalgam of both. It could be said that despite the extensive patronage given him by the English royal family, Winterhalter was not quite the right painter to catch the court tone. He was perhaps too fashionable, too elegant to convey its domestic charm – or its Germanic dowdiness, if one wishes to put the point more sharply. How much more gracefully could he respond to the graceful court presided over by the Empress Eugénie, seated amid her ladies in a flowery, bowery manner which yet avoids being ridiculous [plate 166]: 'very fine,' the Queen wrote – with her usual justice – when she saw it in Paris.[19] The trouble with literal unimaginative painters like Winterhalter is that they are dependent on the inspiration provided by their actual sitters. Winterhalter could do no more with Queen Victoria than make her tremendously regal, or rather charmlessly simple, almost simpering. Neither image can compare with the relaxed grace of Eugénie and her circle, but then the French Empress made a very different impression. To Queen Victoria, herself a scrupulous visual critic, she appeared not merely beautiful but, on more than one occasion, 'looking really like a fairy queen or nymph ... unlike anyone I ever saw.' And the Queen herself once took a pencil in hand to catch something of the beautiful-looking, but in every other way disastrous, Empress.[20]

It is usual, in discussing the taste of Queen Victoria and Prince Albert, to assume that they had divergent instincts in art. Partisans of one may reflect unfavourably on the other's taste. But the truth seems to be – as *The First of May* undoubtedly reveals – that they had grown closely in agreement, whatever their previous individual inclinations. And it is also usual to state, or imply that the Queen's

165 (*Above*) Winterhalter: *The First of May*

166 (*Below*) Winterhalter: *Empress Eugénie and her ladies*

unregenerate taste was awful, while the Prince was something of a connoisseur of old masters.[21] Only the second of these statements seems to me fair. And probably it was not altogether a good thing, from the point of view of the Prince's attitude to contemporary art. It led him, as it has led other people, to take a very conservative attitude. Besides, to deepen the offence, his interest lay particularly in the earlier 'primitive' schools of painting, with their presumed purity of intention, careful execution and supposed concern with slightly naive realism. Translated into terms of contemporary art, it brought the Prince to the insipid pseudo-primitiveness of Dyce's *Madonna and Child*,[22] but it would not carry him into displaying any interest in the extreme, hard-edge, hallucinatory art of the Pre-Raphaelites. It is easy to understand that he could not, presumably, see anything in Turner. He remained dominated by a misunderstood and quite visually inaesthetic idea of Raphael and classicism.

I do not say that just to criticize the patron in question but to indicate what seems to me the fallacy in Prince Albert's taste: it was intellectually-based rather than naturally aesthetic or visual. The Dyce is the purchase not of a connoisseur but of, alas, an art-historian. Queen Victoria was nervous before any generalization, had no sure grasp of what Art was, but she did know individually what she cared for. She therefore had positive likes and dislikes – in a word, taste. Her journals confirm a distinct eye for detail in clothes, furniture and – finally – people.

One of the attractive things about Queen Victoria is that she recognized her own tendencies. Comparing her reactions to those of Prince Albert, she wrote: '[he is] naturally much calmer ... much less under *personal* influence than I am.' (The emphasis on personal is her own.) His example had its effect on her taste. He probably made it less 'personal' and more theoretic, guiding her away from the bravura Regency painters, who anyway conveniently died off, towards more patient, petit-point appliers of paint. A gradual sobering-down took place, of lively girl into dutiful mother. And something of the same process is apparent in the paintings executed for her.

Looking again at Wilkie's *First Council* [plate 159], and recalling the Queen's different reactions at two different periods of her life, we see this sadly borne out. And her reactions came partly from a misunderstanding of the artist and his style. To begin with, this composition was the Queen's own idea: possibly the first direct commission to a painter in her reign. The Council had been held on 20 June 1837, the day of her accession. In October she summoned to Brighton Wilkie, the painter whom her uncle and predecessor William IV had knighted. 'Instead of a portrait ...,' Wilkie wrote later in a private letter, '... the Queen was strongly bent on having a

picture painted of her first Council. Finding her much interested with the subject, I sent to London for a canvas, and began the picture at Brighton.'[23]

There is no doubt that Wilkie took the theme seriously, but he wished – he was, after all, an artist – to evoke something of the drama inherent in it. A preparatory drawing helps to show how his mind focused on the idea of the youthful Queen [plate 167], not as a mere lifelike portrait but as the almost operatic heroine of the scene, white-clad against inky background and sweep of suggested

curtain – emotionally a very convincing portrayal of the girl whose *Journal* emphasized her actions that day as taken, for the first time in her life, 'alone'. On one printed page that word occurs on no less than five occasions, including the moment of entering the Council Room: 'I went in of course quite alone ...' Wilkie perhaps sought to make the moment even more effective by including the royal pet spaniel Dash – but the dog has been removed from the final painting. No doubt, like some other patrons, when Queen Victoria said 'alone' she meant it; there must be no dog.

Such tendencies to require absolute accuracy were not yet oppressive, but they hint at the problem of royal patronage – at all periods maybe but especially in the nineteenth century. We have seen enough to make it clear that patronage of that kind is seldom, if ever, disinterested. But animated by a subject like Napoleon, painting could respond because he demanded, in effect, constant exercise of the imagination. Conversely, painters like Wilkie, and Lawrence too, were ready to be fired imaginatively even by prosaic sovereigns. Wilkie, in particular, had not needed to wait for the romantic event of a young queen regnant appearing at her first Council. Well before, he had romantically responded to the apparently unrewarding task of depicting George IV entering Edinburgh [plate 168]. True the king is a faintly overblown, strutting figure: a bull-frog of a monarch, swelling as he advances and apparently on the point of bursting. George IV is directly to blame for this impression; he suggested the attitude of his own figure. Indeed, he suggested the whole subject. It is the greater tribute to Wilkie that he had actually witnessed George IV's entry into Edinburgh in 1822, and yet was able to transform the reality into this rich, theatrical sense of a hero coming among his people.[24] There is an instinctive sense, which Napoleon would have appreciated in Wilkie, of magnifying the impact of the great personage. He positively persuades us to take George IV quite seriously. No royal patron could ask for more devotion from a painter than that.

In another, more mysterious picture, perhaps of about the same date, Wilkie has anticipated the effect of his *First Council* composition in showing the very young Princess Victoria, a figure in white detaching herself from a Rubens-like throng of courtiers, men in armour, and women [plate 169]. Whatever the incident is, it is presented with a compulsive sense of drama, with solemn overtones of some religious subject like the childhood of the Virgin. It does not look like the straightforward transcript of any royal event, despite the recognizable, identifiable portrait-heads,[25] but it captures something of the fading gleam of being royal: the royal child, already the focus of attention, and steadily advancing – one might almost think – with the air of one approaching the throne.

168 Wilkie: *George* IV
entering Edinburgh

Wilkie elsewhere solved the problem, and thus anticipated some solutions for portraits of Queen Victoria, of giving interest and romantic dignity to – without telling positive lies about – the homely, plain, royal figure. He produced sparkling portraits of the most unsparkling King William IV; and, yet more remarkably, produced the moody, memorable image of William IV's wife, Queen Adelaide, riding on a white horse with fluttering veil [plate 170] – like the doomed heroine of some tragic, Gothic novel. That sketch for an equestrian portrait, which never went beyond this stage, heralds the solution adopted by more than one painter when given the subject of the young Queen Victoria. She rode, and enjoyed riding, particularly appreciating the semi-military effect of herself on horseback, where her small stature did not notice. Because of illness and lack of opportunity to ride in the period just before her accession, she was advised not to review her troops on horseback in the accession year, 1837. To the public's amusement, she cancelled the review altogether, writing privately and categorically on the subject, with typical emphasis: 'There is to be no review *this year*, as I was determined to have it only if I *could ride* ...'[26]

169 (*Opposite*) Wilkie: *Victoria,
Duchess of Kent with Princess Victoria
and members of her family*

170 (*Right*) Wilkie: *Queen Adelaide
on horseback*

In painting, at least, it was soon made up to her. Seen by one of her
early favourite painters, Sir Francis Grant, the Queen rides again,
mounted in almost Baroque bravura, and with her soldiers toy
figures in the background [plate 171]. It is indeed a traditional royal
image, one of the last,[27] and of a type that was not to be encouraged
when the Prince Consort appeared. But Grant, who began as a
sporting painter and moved on to become a successful portrait-
painter, was launched on a fashionable career by such royal pictures
as this, combining sport and portrait, frankly adding to the sitter's
glamour by the glamour of a noble animal.

In this combination, as in much else, he runs parallel to Landseer.
Landseer was much less competent as a portraitist, but he was
precociously gifted as an artist dealing with animals. Perhaps he was
at his most brilliant when he was young [plate 172]. His early nature

sketches are, however, symptomatic of Landseer's failure, when he grew up, to prove himself more than a gifted sketcher – whether in pencil or oils. The fatal nineteenth-century addiction to the machine, the large-scale, finished object, was the more fatal in his case since he had very commonplace ideas of composition and a French polisher's idea of 'finish' – mistaking the glossy for the accurate. He began by painting studies of the Queen's pets, notably her dogs [plate 156], without any sentimental anecdote or dramatic story. Like the Queen herself at this period, he could respond too to the romance of her position: young, royal, high-spirited and unmarried. It is as a figure from a page of romanticized history that she appears, rather vaguely reviewing the Life Guards in the setting of Windsor Castle [plate 173]. This is certainly more than tame delineation of any given fact; it might almost be Elizabeth at Tilbury or Mary, Queen of Scots, riding into Edinburgh. It is stirring in just the way that Wilkie had managed to be with the subject of George IV. But it is also the last view of this romantic young queen – not destined to be another Elizabeth, but tamed by marriage and moulded to the taste of a domestic, increasingly unromantic age.

The pictorial possibilities of the Duke of Wellington were exploited by nearly every painter, not forgetting Winterhalter, as well as Lawrence, Haydon and Landseer. He was virtually the last symbol of heroic romance in England. Here as commander-in-chief, immensely old and immensely wise-seeming, he rides beside the most youthful of sovereigns – one of those effective juxtapositions which always draws a tear from any crowd. He was still in request as a prop to the throne – but in significantly different guise – when Winterhalter came to paint *The First of May* [plate 165]. By then he has, like the Queen, become domesticated, taking on the role of spiritual grandfather to the family group.

In much the same way, Landseer travelled from the picturesque, stormy, semi-martial romance of Queen Victoria riding at Windsor to *Windsor Castle in modern times* [p. 182, plate VII]. His technique sobered too. It has grown glassy and smooth, faintly repulsive both for sitters and the litter of dead game which is strewn about the room. And, noticeably, the Queen is no longer the protagonist. It is part of the new Victorian demure message that she has become the admiring wife – standing while the Prince sits – who does not mind her husband in hunting boots in the drawing room, nor the carpet littered with dead birds. He is the hero: husband, father, and good shot, whose achievements in all three spheres are illustrated.

Although its vocabulary seems rather bizarre to our taste, the painting's language is certainly love. Not since Zoffany had a painter been encouraged to approach the English royal family so closely and intimately. The affinities seem more than accidental.[28]

171 (*Above*) Grant: *Queen Victoria on horseback*

172 (*Below*) Landseer: *A retriever*

173 Landseer: *Queen Victoria reviewing troops*

Tacitly rejected is the royalty implied by sweeps of curtain and yards of ermine. Open windows, sunlight, gardens, and a comparatively simply furnished room, make up a 'modern' setting for a comparatively simple 'modern' family: the young couple with their own child (yet not allowed to come between them) and the wife's mother just visible in her bathchair in the sun-filled garden. 'Very cheerful and pleasing' the Queen characterized the final picture when, after unusual delays by Landseer, it was eventually delivered.[29]

The painter of this picture had come to know the royal family quite well. Queen Victoria's eye was sharp for an attractive man, and Landseer she described as 'very good looking'. In addition, he had excellent social manners, doubtless the result of a wish to succeed in society. It would not be quite fair to say that he aimed at being court painter – a title which did not anyway exist – but he became something of a royal pet himself. He had discovered the Highlands long before the Queen did, but he was virtually to re-discover them – to be seen in a domestic light – from the windows of Balmoral. He stayed there frequently, taught the Queen and Prince Consort to etch and, in the words of the Queen's *Journal* on the day he died in 1873: 'He kindly had shown me how to draw stags' heads, and how to draw in chalks, but I never could manage

174 Landseer (after): *Queen Victoria and the Prince Consort in Scotland*

that well.' A typical royal tendency for statistics leads her to enumerate her collection of his work: 'I possess 39 oil paintings of his, 16 chalk drawings (framed), two frescoes and many sketches.'[30]

A few years later she accepted a copy of a complete photographic album of his work. In 1842 Landseer had refused the offer of a knighthood, perhaps because of his first outbreak of serious mental illness; but he took it in 1850. Ill though he was in 1867 – that is, well after the Prince Consort's death – he was still invited to Balmoral. A rather tragic letter of his, written from there, complains of sleeplessness and illness, but adds that the doctor, 'gives me leave today to dine with the Queen ...'[31] That was probably his last close contact with her, for his final years were passed in a horrific haze of alcoholism and insanity: an appalling Victorian morality lesson, of which however the exact moral is far from clear.

The Landseer to whom Queen Victoria responded unmistakably – making him her preferred artist, the painter of the portrait of herself she gave to Prince Albert before marriage – was talented but not deeply imaginative. She probably selected him for that very reason. Incurable anthropomorphism may have helped him towards sentimentalizing animals. A deeper reason may have been the failure of all emotion, leading him to exaggerate. It is not only that his funny

animals became degrading; they are also quite unfunny. There was something fatal in Landseer's facility, in the sheer dutifulness which recorded the Prince Consort and Queen Victoria in the Highlands but which failed so totally to animate them.

The result is a charade [plate 174], the more intolerable for pretending to be natural. Landseer seems drained of energy confronted by the spectacle of the Queen being handed from a boat by Prince Albert, stepping down an extraordinary tartan gangplank encumbered by dead deer. Both this picture, and the 'modern times' *Windsor Castle* took Landseer a long while to complete. Perhaps he felt the daunting nature of his duty, and he certainly threw frank light on his attitude to painting more formal occasions when he learnt that Frith had agreed to paint the scene of the Prince of Wales's marriage in 1863. Frith himself records Landseer's sympathy for him in his task, plus the significant exclamation: 'Well, for all the money in this world and all in the next, I wouldn't undertake such a thing.'[32]

As a biting satire on royalty by Goya, Landseer's own commissioned picture would be admirable. But instead it was exhibited at the Academy in 1854 as '*Royal Sports on Hill and Loch*'. That it should be exhibited contemporaneously at the Academy shows the conscious intention. It has become a formal royal group – father and mother with heir to the throne – and though stuck in a country setting with a few devotedly gazing 'people' they form a group clearly superior to both 'people' and setting. This is not only how they see themselves, delighted with Landseer's depiction, but – we may assume – how they wished to be seen by their subjects. It is a nineteenth-century '*La Reine à la ciasse.*'

Landseer's painting is also the visual equivalent of the Queen's *Leaves from the Journal of our life in the Highlands* – an extraordinary piece of only partly unconscious propaganda and of, unfortunately, unconscious humour. If the Prince Consort had been alive he would almost certainly have advised against publication; but in terms of popular success he would have been wrong, because the book sold well and went through several editions. The Highland *Leaves* confirmed public belief in a queen and family scarcely different from prosperous middle-class families all over England; its simplicity of sentiment, like the simple style of life we see in Landseer's picture, had a deliberate evangelical zeal behind it.

It was true to Queen Victoria's own taste; and that had led her to want to reform 'highborn beings' by the example of her own quiet domestic existence. Nature is the theme of Landseer's picture: something beneficent, good, uncomplicated – unlike the social life of the aristocracy with dinner parties and unhealthy pastimes: 'wretched ignorant highborn beings' they were to be called by her,

175 Roger Fenton: *Photograph of Queen Victoria and Prince Albert seated*

in distinction to the 'so intelligent' lower classes.[33] Above all, Nature is patently true and palpable – as true as the dead deer lying at the Queen's feet, shot by the Prince and destined to have their antlers mounted as decoration at Balmoral. (Like many people, Queen Victoria saw no discrepancy in combining intense fondness for domestic animals with delight in the slaughter of wild ones.) Somehow, with Nature as one's guide, there is no discrepancy: rural peace remains undisturbed by the cries of dying game.

Yet the need for truthfulness in art, urged rather differently by Ruskin, leads to a dilemma which was to be acutely felt by the nineteenth century. It is perhaps most acute in the very area of royalty, where there is something presumed, or believed, of symbolic value over and above what we see. To show that is perhaps art's duty, but it is actually clear that the most successful depictions of Queen Victoria and her Consort came from a new medium altogether: photography. While Landseer was laying his paint on in increasingly cold glazes, and fighting for a reproduction of minute accuracy that diminished owing to his poor eyesight, this new medium achieved remarkably truthful-seeming effects [plate 175]. After the death of the Prince Consort Queen Victoria was rarely painted again. Several well-known painters were refused sittings, among them Watts and Millais. But the Queen lived long enough to see herself in a newsreel, or at least a cinematograph picture, of her Diamond Jubilee which she pronounced 'very wonderful' though 'a little hazy and too rapid.'

Nevertheless, as so often, she was right in hailing the innovation. At the time of her Golden Jubilee ten years before, amid the many memorial volumes and souvenirs produced, had been two very substantial tomes, edited by *The Times* art critic, Mr Humphrey Ward, called *The Reign of Queen Victoria*. He himself wrote the chapter which deals with art during the reign; significantly, photography finds a mention there and is given approval in phrases which might well have been uttered by Queen Victoria: 'on the social side photography has done much to preserve the sense of kinship among the scattered members of English families all over the world.'[34]

We may smile at the sentiment, yet it was exactly a sense of kinship which had been one of the reasons for court art: to disseminate a corporate feeling whereby the sovereign is justified by being seen as the parent of his people. His image is at the root of it all, beginning with him kneeling humbly before the vision of the only monarch greater than himself, and extending from his own existence into presentation of a whole ethos around him. His power and his virtues are expressed either in straightforward action or in allegory: subtle propaganda for his rule, to ensure that it is unchallenged. A final shift of emphasis, in an age conscious of being prosaic,

176 Lavery: *George* v, *Queen Mary and their two eldest children*

produced the reassuring images encouraged by Queen Victoria, reserving grandeur for animals and herself appearing in rustic or homely surroundings. After all, the *Monarch of the Glen* is not a portrait of her. Indeed it is significant that such grandiloquence is applied instead to an animal. The nineteenth-century lesson to a monarch, instinctively grasped by her without – in her eyes – any withdrawal of her active role as ruler, was to be *like* other human beings. Imaginatively, Queen Victoria did not claim more than her subjects claimed for her, wisely emphasizing her private role as wife and mother.

The peculiar – and often peculiarly repellent – *mana* which surrounded royalty did not die with her. Nor can we too quickly claim that great painting, freed from the need to seek royal patronage, will necessarily always be republican in its sympathies. There may be some splendid modern apotheosis being planned for some modern monarch, but it is more likely that Daumier's urchin enjoying the throne broke a spell, very much as did the boy who pointed out that the Emperor was wearing no clothes. It is in the 'at home' if not always homely tradition established by Queen Victoria that her descendants have usually been depicted with most sympathy. Connoisseurs of the piquant and poignant will find much food for reflection in *Queen Alexandra's Christmas Gift Book* of 1908, with its 'snapshot' informal photographs, a family album for public consumption. It is '*Leaves from a Journal*' executed with a Kodak, 'used by Her Majesty'.[35]

When got up as a sort of matinée play group, wearing evening dress in the afternoon, I suspect, and somewhat uneasy about the effect [plate 176], royalty looks strangely doomed. Lavery's group is fixed halfway between public and private image, between formality and intimacy, artistically placed between fashionable subimpressionistic portraiture and the need to record likenesses. It actually looks rather flashy when compared with Fenton's sober photograph or even with *Tea at Royal Lodge* [plate 177], the perfect postscript to Landseer's domestic-royal scenes, proof of how recently there still existed painters urging on us the aspect of royalty at home at court.

Nevertheless – indeed, as we see – the spell has been broken. Photography had long, long before this was painted, challenged exactly this sort of picture, making it an artistic anachronism. If to our ears all sounds of patronage are odious, how much more odious must sound the words 'royal patronage' – especially in relation to art. Besides, the experience of Queen Victoria shows that significant retreat is really best. Posterity has not been able to vindicate her taste. Nineteenth-century England may not have been rich in artistic genius, but what there was she and her husband neglected. Well

177 Gunn: *Tea at Royal Lodge*

might George Moore end his amusing but stinging review of the Victorian exhibition in 1892 with the wish 'that Royalty would take another step and abandon its influence in art'.

As we all know, George Moore's wish has come true. Like this book, the subject has come to a close. It would be stupid to linger longer over the least inspiring aspects of a theme which yet may be justified as a subject – fascinating ultimately not for some assumed historical reason but primarily for the sheer artistic quality of what often resulted when *a* court provided the right air for *a* painter to breathe.

★ ★ ★

It is in such aesthetic terms, regardless of politics, or even morality, that we can be glad of the interplay of creativity, patronage and environment which produced the *Glatz Madonna*, or which was to lead Mantegna to celebrate his Gonzaga patrons. The strong will and highly conscious requirements of Grand Duke Cosimo I de' Medici and of Napoleon sometimes positively stiffened the art produced for them, so that under a smooth mask it has iron; yet at its best it remains art. A painter like Rubens was largely left to his own devices – but what devices they are. And how many painters are there like Rubens, responsive to court environments, devoted adherent of their ideologies in paint and yet personally able to assert freedom? Certainly Van Dyck was not one.

It is to their century, however, that one returns for that supreme masterpiece, *Las Meninas*, which concentrates the whole theme, in which the painter has indeed arrived at court and proves something of a monarch amid courtiers, subordinating even the king to being a bust-length reflection beside the painter's own full-scale physical presence. The painter, his patrons, the atmosphere in which he worked: all are present in a way that makes discussion superfluous. It is Velázquez who says the last word about painting at court.

NOTES

1 The Court of Heaven

1 Quoted by Mildred Archer in the introduction to the exhibition, *Indian Miniatures...*, Arts Council, London, 1968, p. 3 (unpaginated).

2 A reference to this commission in the unpaginated catalogue of the *Girodet* exhibition, Montargis, 1967, in the chronological portion for 1816. Among the very last combinations of saint and royal personage in one figure – itself a convention early established – was that practised by Ingres in his cartoons for the windows of the chapelle Saint-Ferdinand at Paris, executed in 1842; the chapel commemorated Ferdinand-Philippe, Duc d'Orléans, and several of the saints depicted by Ingres are portraits of the Orléans family: see further catalogue of the *Ingres* exhibition, Paris, 1967–8, pp. 274 ff.

3 R.A.Weigert, *French Tapestry*, 1962, p. 34 refers to the fact that it is not known for what building the series was intended; that it was not the chapel of the castle at Angers was established by R.Planchenault and B.Vitry in *Monuments historiques de France*, Jan–March, 1955, pp. 27–38.

4 Further for this whole theme see particularly N.Cohn, *The Pursuit of the Millenium*, 1957.

5 Cited by F.Kern, *Kingship and Law in the Middle Ages* (transl. S.B.Chrimes), 1939, p. 9.

6 For some discussion, see J. White, *Art and Architecture in Italy 1250–1400*, 1966, pp. 234–5; the painting is the colour frontispiece to that volume. The importance and significance of the picture is briefly but pertinently emphasised by C. Gilbert in *Burlington Magazine*, May, 1968, p. 285.

7 See further D. Talbot Rice, *The Art of Byzantium*, 1959, p. 313 and A. Grabar, *L'Empereur dans l'art Byzantin*, 1936, p. 116 and pl. xxv (1); for a similar scene in a twelfth-century mosaic at Palermo, cf. Grabar, *op. cit.*, pl. XXVI (II).

8 This drawing is discussed in connection with the Diptych in the article by F.Wormald in *Warburg/Courtauld Journal*, Vol. XVII, 1954, pp. 191 ff. For discussion of several theories concerning the Diptych, see M.Davies in *The French School* (National Gallery Catalogues), 1957, pp. 92–101.

9 Further cf. M.Meiss, *French Painting in the time of Jean de Berry*, 1967, p. 85.

10 See further Wormald, *loc. cit.*

11 That is assuming that the *Wilton Diptych* was produced during Richard II's own reign; I think this highly personal-seeming object is almost certainly to be so explained. The general background to the period is illuminated by G.Mathew, *The Court of Richard II*, 1968, but the specific comments on the authorship and significance of the Diptych are not very convincing.

12 The chief historical sources for the remainder of this chapter are, where not otherwise cited, K.Bosl (ed.), *Handbuch der Geschichte der böhmischen Länder*, Vol. I, 1967 (with very good bibliography); F. von Lützow, *Bohemia*, 1939; G.G.Walsh, *The Emperor Charles IV*,

1929; J.Pfitzner, *Kaiser Karl IV*, 1938. For the art: A.Matějček and J.Pešina, *Gothic Painting in Bohemia and Moravia*, 1964; *Gothic Mural Painting in Bohemia* (various authors) 1964; the Bohemian School within the context of contemporary Northern European painting is discussed in H.Th.Musper's well-illustrated *Gotische Malerei nördlich der Alpen*, 1961. The international elements in the Bohemian style, and the attribution problems are well brought out by L.Grodecki in *Bulletin Monumental* (CXV) 1957, pp. 207 ff.; see also Meiss, *op, cit.*, pp. 130–3, for stylistic links between French and Bohemian art.

13 Quoted in a valuable article by S. Harrison Thomson, 'Learning at the Court of Charles IV', *Speculum*, 1950, pp. 1–20.

14 *Vita Karoli IV*; translated into German, it is printed in *Die Geschichtsschreiber der deutschen Vorzeit*, Vol. 83, 1899 as *Kaiser Karls IV Jugendleben*.

15 For a readable if not profoundly learned account of whom, see R.Cazelles, *Jean l'Aveugle*, 1947.

16 Most recently for the Očko votive picture, originating probably as an ex-voto in the Lady Chapel of the Castle at Roudnice (consecrated by Očko in 1371), see the exhibition catalogue, *De Boheemse Primitieven*, Rotterdam (and Brussels), 1966, no. 34.

17 For the whole ethos see especially R.Branner, *St Louis and the Court Style in Gothic Architecture*, 1965.

18 This imperial genealogical cycle was destroyed in Renaissance times and the individual figures survive only in water-colour copies (several reproduced in *Gothic Mural Painting in Bohemia ...*, plates 62–70). The literary parallel to this pictorial historical setting of Charles's kingdom was his commissioning of positive histories of Bohemia, first from the Florentine John of Marignola and then from a native, the Abbot Neplach, the very title of whose work suggests its depth of perspective, *Summula chronice tam romane quam bohemice*.

19 The fundamental article on the illuminators remains the long, thorough one of M.Dvorak in Vienna *Jahrbuch*, 1901, pp. 35 ff.

20 The relevant document is printed by F.Zimmerman, *Acta Karoli IV Imperatoris Inedita*, 1891, pp. 74–6.

21 For Tommaso in general, see L.Coletti, *L'Arte di Tommaso da Modena*, 1933; Coletti states the few main facts about his connection with Bohemia and gives good grounds for believing that, though he executed pictures for Charles IV, he did not visit the country: *op. cit.*, pp. 74–6.

22 The *Glatz Madonna* was first seriously discussed by K.Chytil in Prussian *Jahrbuch* 1907, pp. 131 ff. Ernest of Pardubitz (1297–1364) had a particular devotion to the Virgin; it is worth noting that after his death he himself became something of a cult figure and virtually a local saint. Although it was not until 1350 that he founded the church at Glatz from which the picture comes, and this is usually dated, on stylistic (?) grounds, nearer to 1360, the

significance of the scene is likely to be the exchange of bishopric for archbishopric, achieved in 1346. The gesturing hands of Ernest, as if receiving the archiepiscopal cross, may be compared with those of Richard II in the *Wilton Diptych*, where the king is presumably about to receive the banner held by an angel. Ernest's blue vestments may have been less unusual at the time than today, but they seem always associated with the Virgin – in Spain they are worn by special privilege on the feast of the Immaculate Conception (W.E.Addis and T. Arnold, *A Catholic Dictionary*, 1952, ed., p. 816).

23 A. Friedl, *Magister Theodoricus*, 1956, deals fully with the painter. By a somewhat typical irony of art-history, one of the very few other painters documented as employed by Charles IV, a certain Oswald ('*pictor Caroli regis*') is an artist of whose style little can now be realised; for the painter and some presumed fragments of his work, cf. *Gothic Mural Painting in Bohemia ...*, pp. 143–4.

24 Eg. the altarpiece (now at Stuttgart) commissioned by 'Reinhart von Mülhusen burger zu Prag', set up in 1385, on St Wenceslas day, in a chapel dedicated to St Vitus at Mulhouse; see further Mǎtejček and Pešina, op. cit., pp. 59–60.

25 St Wenceslas, Duke and Martyr, feast on 28 September: mass for a martyr who was not a bishop, apart from the prayer quoted; even the introit of such a mass has, by chance, a phrase that finds literal illustration in much Bohemian painting: '*posuisti in capite ejus coronam de lapide pretioso.*'

26 The incident referred to by V.Dvořáková in *Gothic Mural Painting in Bohemia...*, p. 50. Milič was a canon of Prague cathedral and at one time vice-chancellor at court. His apocalyptic beliefs led him to suppose the end of the world was at hand, views published in his *Libellus de Antichristo*. Thus, in a way, interpretation of *Revelation* had come full cycle at Prague, from the Emperor's personal delight in its splendours to the reforming, anti-imperial concepts of Milič.

27 Quoted in E. C. S. Molnar, 'The Liturgical Reforms of John Hus's, *Speculum*, 1966, pp. 279–303, from Hus's *Expositio Decalogi*, where three reasons are given for the use of art in church, of which the third is the most interesting: the weakness of the mind which easily forgets what is heard but keeps in the memory sculpture and pictures seen.

2 Courts of Earth

1 For this verse history see the quotation by F.Wormald, *Warburg/Courtauld Journal*, Vol. XVII, 1954, pp. 202–3.

2 Cited, though without a specific source, by L.Hautecoeur, *Louis David*, 1954, p. 205.

3 Cf. M.Meiss, *French Painting in the Time of Jean de Berry*, 1967, *passim*.

4 For Federico in general, see the still valuable J.Dennistoun, *Memoirs of the Dukes of Urbino*, *1851*; also P.Alatri *Federico da Montefeltro: Lettere di Stato e d'Arte, 1470–1480*, 1949.

The portrait of the Duke reading, with his son at his knee, was part of the decoration of his *studiolo* at Urbino, where he was surrounded by famous men of the past and present; cf. P.Rotondi, *The Ducal Palace of Urbino*, 1969, pp. 80–83. The picture of the Duke and his son listening to a lecture possibly came from the *studiolo* at Gubbio (now in the Metropolitan Museum): see further C.H.Clough in *Apollo*, Oct. 1967, pp. 281 ff.

5 The scene is the frontispiece in miniature from a *Boccaccio* Ms. (Bayerisches Staatsbibliothek, Munich) and is quite unrelated to the text; cf. P.Wescher, *Jean Fouquet und seine Zeit*, 1945, pp. 42 and 97. For some further discussion of this, 'perhaps the most formal and ornate representation of a corporate body which has survived from fifteenth-century France' see M.G.A.Vale in *Gazette des Beaux-Arts*, Oct. 1969, pp. 245–6.

6 The miniature, of 1448, is the frontispiece of Jacques de Guise's *Chroniques de Hainault* and shows the Duke receiving the manuscript from Simon Nockart: stylistic questions are discussed by L.M.J.Delaissé, 'Les Chroniques de Hainaut et l'atelier de Jean Wauquelin à Mons, dans l'histoire de la Miniature Flamande', *Bull. des Musées Royaux des Beaux-Arts* (Brussels), 1955, pp. 21 ff. For the general court world, see O.Cartellieri, *The Court of Burgundy*, 1929.

7 Further for this complicated subject, see particularly the catalogue of the exhibition, *Da Altichiero a Pisanello*, Verona, 1958, no. 35; on the seasonal calendar aspects, cf. O.Pächt, *Warburg/Courtauld Journal*, Vol. XIII, 1950, pp. 37 ff.

8 Cited by J.Huizinga, *The Waning of the Middle Ages*, 1954 ed., p. 245.

9 For this room, see especially C.H.Clough in *Apollo*, Oct. 1967, cited under note 4. Of earlier undiscussed attempts to create a specific environment with paintings, mention should be made in passing of Henry III, in whose palace at Westminster there were biblical battles and a *Coronation of Edward the Confessor*, in the king's bedroom were a series of painted *Virtues*.

10 See for example E.H.Gombrich, 'The Early Medici as Patrons of Art', reprinted in *Norm and Form*, 1966, pp. 35 ff.

11 Gombrich, *op. cit.*, p. 39.

12 For what is said concerning Ferrara and its art, apart from specific citation, I have used chiefly the following: G.Gruyer, *L'Art Ferrarais à l'époque des Princes d'Este*, 1897; G.Bertoni, *La Biblioteca Estense e la Coltura Ferrarese ...*, 1903 (strictly concerned with Ferrara under Ercole I d'Este); E.G.Gardner, *Dukes and Poets in Ferrara*, 1904; *ibid. The Painters of the School of Ferrara*, 1911; C. von Chledowski, *Der Hof von Ferrara*, 1913 (for Borso, cf. pp. 52–69); D.Fava & M.Salmi, *I Manoscritti Miniati della Biblioteca Estense di Modena*, Vol. I 1950; B.Zevi, *Biagio Rossetti*, 1960. Despite its attractive title, S.Pasquazi, *Rinascimento ferrarese*, 1957, is extremely limited in its application; it is largely a re-working of his *Umanesimo ferrarese*, 1955. I have not seen

A.Lazzari, *Il Primo duca di Ferrara, Borso d'Este*, 1945.

13 For this in detail, see M.Baxandall, 'A Dialogue on Art from the Court of Leonello d'Este', *Warburg/Courtauld Journal*, Vol. XXVI, 1963, pp. 304 ff.

14 The poem is quoted by Gardner, *op. cit.*, 1904, p. 61.

15 On Strozzi see R.Albrecht, *Tito Vespasiano Strozza*, 1891. There are poems by him to Pisanello and Tura, and several to Borso, including the '*Ad Divum Borsium*' quoted in the text. Strozzi's epic *Borsias* (ed. I.Fogel & L.Juhasz, 1933) survives only in a fragmentary state and was never completed; despite its title, much of what now exists is concerned with the succeeding Duke, Ercole d'Este.

16 See the entry for *A Battle* [1062], after Piero della Francesca (?) in M.Davies, *The Earlier Italian Schools* (National Gallery Catalogues), 1961, pp. 434–5.

17 '*Ille hic, Cosmiaca, pulcherrima cuius imago/ Ac verae similis, tam bene picta manu est*': T.V.Strozzi, *Eroticon*, Book VI, ll. 3–4: *Strozzi Poetae Pater et Filius*, 1535–40, pp. 173, r. & v.

18 The latest monograph is E.Ruhmer, *Cosimo Tura*, 1958; some criticism of its limitations is made in a review in *The Times Literary Supplement*, 11 April 1958.

19 For this picture [3070] see M.Davies, *The Earlier Italian Schools* (National Gallery Catalogues), 1961, pp. 518–21.

20 Cf. P.d'Ancona, *The Schifanoia Months at Ferrara*, 1954; for the iconography, see particularly A.Warburg, *Gesammelte Schriften*, 1932, II, pp. 459 ff.; that essay was intended only as the sketch for a much fuller study, never written. Something of the court's astrological interests is discussed, without mention of the frescoes, in what is no more than an *opusculum*, F.Gabotto, 'Nuove Ricerche e Documenti sull' *Astrologia alla Corte degli Estensi e degli Sforza*' (off-print from *La Letteratura*, Turin) 1891, pp. 5 ff.

21 *The Commentaries of Pius II*, (Book III), transl. F.Alden Gragg, 1942 ed., pp. 226–7.

22 Further for this example, see C.A.J.Armstrong, 'An Italian Astrologer at the Court of Henry VII', in *Italian Renaissance Studies*, ed. E.F.Jacob, 1960, pp. 433 ff.

23 Gardner, *op. cit.*, 1904, p. 75.

24 *The Civilisation of the Renaissance* (transl. S.G.C.Middlemore), 1945 ed., pp. 30–35.

25 'Miranturq(ue) novum secula nostra Deum', as Strozzi wrote in another of his poems about Borso: 'De Adventu Borsii Ducis in Genialeis agros,' l. 14, *Strozzi Poetae . . .*, p. 145v.

26 The treatise, of which there are many manuscripts, is mentioned by Lynn Thorndike, 'Notes on some less familiar British astronomical and astrological Manuscripts,' *Warburg/Courtauld Journal*, Vol. XXII, 1959, pp. 162–3. He refers to its interesting paragraph on the relation of the planets to human occupations; these include light labour under Jupiter (? women retting flax at Schifanoia); those who serve lords come under the Sun (lost portion of *May* showed Borso seated

receiving cherries from a peasant); Mercury governs reading, writing and reckoning (Borso is shown in *June*, with his court, receiving some sort of missive).

27 For these frescoes in more detail, cf. E.Tietze Conrat, *Mantegna*, 1955, p. 187 and the catalogue of the exhibition *Andrea Mantegna* Mantua, 1961, (no. 26), pp. 38–41. The subject illustrated in part there, the return to Mantua of Cardinal Francesco Gonzaga (see text further, pp. 75–6), did not occur until 1472.

28 Gardner, *op. cit.*, 1904, p. 115.

29 Ercole Roberti's letter of 1491 ('I am a poor man ... I must provide for my living ... And for this I have attached myself to your Excellency, to serve you and ever work for you, as I have done and shall do as long as I live ...') is given by Gardner, *op. cit.*, 1911, p. 57.

3 Propaganda for the Prince

1 *The Shorter Oxford English Dictionary*, *s.v.*

2 Cf. A.H.Gilbert, *Machiavelli's 'Prince' and Its Forerunners*, 1938, p. 4.

3 Cited by M.Jenkins, *The State Portrait* (College Art Association Monographs, III), 1947, p. 4; this is a useful monograph on a subject seldom discussed extensively, and particularly relevant for the present chapter.

4 *E.g.* the rooms of pictures executed for Isabella d'Este at Mantua and Alfonso d'Este at Ferrara. And, it may be pointed out in anticipation of what is said later about Grand Duke Cosimo I de'Medici, how differently conceived from his propaganda aims was the *studiolo* of his son, Francesco, at the Palazzo Vecchio.

5 The best and liveliest discussion is F.Saxl, 'The Appartamento Borgia', in *Lectures*, 1957, Vol. I, pp. 174 ff.

6 Cited without giving the source by F. Gregorovius, *Lucrezia Borgia*, ed. L.Goldscheider, 1948, p. 28.

7 Vasari, *Le Vite*, ed. G. Milanesi, Vol. III, 1878, pp. 499–500; also Gregorovius, *op. cit.*, p. 84.

8 The letter is conveniently printed in full in W.Roscoe, *The Life of Lorenzo de' Medici ...*, 1862 ed., pp. 467–70.

9 For this mosaic's implications in connection with papal politics, and for another example commissioned by Calixtus II, see L.D. Ettlinger, *The Sistine Chapel before Michelangelo*, 1965, p. 118.

10 For some discussion of which see M.P.Gilmore, *The World of Humanism 1453–1517*, 1962 ed., p. 163; see also *Julius Exclusus* (transl. P.Pascal), ed. J.Kelley Sowards, 1968. Gilmore, *op. cit.*, pp. 129 ff., for Erasmus' 'Institution of a Christian Prince', mentioned in the text subsequently.

11 For the cartoon further, and the lost fresco for which it was prepared, see R.Strong, *Holbein and Henry VIII*, 1967.

12 Fully and clearly discussed by E.Panofsky, *The Life and Art of Albrecht Dürer*, 1955 ed., pp. 175–9, where it is characterised as needing to be enjoyed 'like a collection of quaint and sparkling jewels.'

13 The bibliography on this drawing is assembled in the catalogue, by F.Anzelewski, of the Smithsonian travelling exhibition, *Dürer and his Time*, 1967, No. 111 (the Anne Boleyn reference by a slip given as 1553).

14 The miniature is catalogued by K.T.Parker, *Holbein's Drawings at Windsor Castle*, 1945, p. 35 (and reproduced as frontispiece to the volume).

15 Reproduced by Strong, *op. cit.*, 1967, pl. 49.

16 For the whole subject, see R.C.Strong, *Portraits of Queen Elizabeth*, 1963; what immediately follows in the text is derived from this.

17 Further for the picture, and the references to the compliments paid to the Queen by Oxford and Cambridge first published by E.Wind, *Pagan Mysteries in the Renaissance*, 1958, p. 79, see O.Millar, *The Tudor, Stuart and Early Georgian Pictures in the collection of H.M. The Queen*, 1963, no. 58, p. 69.

18 *Le Vite*, ed. G.Milanesi, Vol. VI, 1881, p. 165.

19 Apart from the obvious artistic sources and works individually cited, I have used chiefly C.Conti, *La Prima Reggia di Cosimo I de' Medici*, 1893; G.Spini, *Cosimo I de' Medici e l'Indipendenza del Principato Mediceo*, 1945; G.Pieraccini, *La Stirpe de' Medici di Caffagiolo*, 1947 ed. There is an English biography: C.Booth, *Cosimo I, Duke of Florence*, 1921.

20 Cf. J.Pope-Hennessy, *Italian High Renaissance and Baroque Sculpture*, 1963, catalogue vol., p. 61; there is at Holkham Hall a comparable relief attributed to Pierino da Vinci called 'Delivery of the gates of Florence to Cosimo', which seems closely connected, though not mentioned by Vasari (and indeed unpublished?).

21 Cf. *Der literarische Nachlass Giorgio Vasaris*, ed. K.Frey, Vol. I, 1923, p. 735.

22 Tribolo was one of the most heavily engaged of all artists on schemes of Medici glorification under Cosimo. At Castello he planned, but never executed, an elaborate allegorical series of statues, for which the programme was drawn up by Varchi and is very fully described by Vasari (*Le Vite*, ed. G. Milanesi, Vol. VI, pp. 83 ff.) This would have shown the greatness of the house of Medici and confirmed that Duke Cosimo 'possessed all the virtues'. As well as personifications of the Seasons, the Virtues, Arts, etc., each leading member of the family was himself to represent a quality: Leo X was, inevitably, Liberality, but the Duke stood for Justice. It is quite likely that this scheme gave Vasari some ideas for his own series of painted decorations concerned with the Medici in the Palazzo Vecchio.

23 *Le Vite*, ed. G.Milanesi, Vol. VI, 1881, p. 91: 'quanta grazia ed ornamento ella diede a tutto quello apparato ...'

24 Recorded in the inventory of October 1553, printed by Conti, *op. cit.*, p. 117; the height given is two braccia, virtually that of the Uffizi picture (114 cm.).

25 For this and details following, see the letters printed in G.Gaye, *Carteggio inedito d'Artisti*, 1840, Vol. II, pp. 329 ff.

26 Pieraccini, *op. cit.*, Vol. II★, p. 104.

27 The picture is at Cincinnati: it is reproduced in Berenson, *Italian Pictures of the Renaissance: Florentine School*, 1963, pl. 1446, as by Bronzino. There the boy is said to be Ferdinando de' Medici (b. 1549); since the boy portrayed can be scarcely less than nine years old, this would make the picture executed in the last years of the Duchess's life, when she was ailing (and is so shown elsewhere by Bronzino). Her comparatively youthful appearance in the Cincinnati picture, combined with the prominence of the boy, would tend to confirm that Francesco (b. 1541) is shown, even without urging his likeness to established portraits.

28 Gaye, *op. cit.*, Vol. III, p. 134 (letter of 15 April, 1564). The habit of some art-historians to suppose all such letters from artists insincere and exaggerated is on a par with assuming that all beggars are frauds.

29 For his poems cf. *Sonetti di Angiolo Allori detto il Bronzino ...*, 1823, (pp. 36 ff. for those quoted on the death of the Duchess and her son); previously, on the death of her daughter Lucrezia (in 1561), he had also written mourning sonnets.

30 It would be tempting to suggest that the Wallace Collection portrait is that of the dead Duchess which was to be put under *Temperantia* in the festival decorations at Florence for the marriage of Francesco de' Medici in 1565; some discussion between Vasari and Borghini about the suitability of including such a portrait is recorded in letters printed by K.Frey, *Der literarische Nachlass Giorgio Vasaris*, Vol. II, pp. 195 ff. and in *Carteggio Artistico inedito di D. Vinc. Borghini*, ed. A.Lorenzoni, 1912, p. 28.

31 *Le Vite*, ed. G.Milanesi, Vol. I, 1878, p. 6.

32 For the building see A.Lensi, *Palazzo Vecchio*, 1929; for this aspect of Vasari cf. P.Barocchi, *Vasari pittore*, 1964.

33 *I Ragionamenti e Le lettere*, ed. G.Milanesi, 1882.

34 The quotation is from Sidney's *Arcadia* (1590), cited by Gilbert, *op. cit.*, p. 3.

35 For this drawing within the context of the funeral ceremonies, see R. and M.Wittkower, *The Divine Michelangelo*, 1964, *passim* but especially pp. 161–2. Among the other scenes from Michelangelo's life then depicted was that of Francesco de' Medici standing in homage, having offered a chair to the artist (repr., Wittkower, *op. cit.*, pl. 27).

36 J.A.Crowe and G.B.Cavalcaselle, *The Life and Times of Titian*, 1881 ed., Vol. I, p. 181; E.Tietze-Conrat, *The Art Bulletin* (xxvi), 1944, pp. 121–2, doubts if the wording of this letter is Titian's own, but it is clear that he thought it tactful to subscribe to the sentiment. Further for the concept of the court portrait, with comment particularly on Bronzino, see J.Pope-Hennessy, *The Portrait in the Renaissance*, 1966, pp. 155 ff.

4 The Courtier-Artist

1 On this subject see most recently R. and M.Wittkower, *Born under Saturn*, 1963, where there is assembled a rich variety of sources, the comment upon which, however, is often unexpectedly naive.

2 The evidence is in a letter of 27 October 1520 to Michelangelo from Sebastiano del Piombo, recording that the Pope spoke thus, 'quassi con le lagrime algli ochii'; cf. G.Poggi, *Il Carteggio di Michelangelo*, ed. P.Barocchi and R.Ristori, II, 1967, p. 253.

3 Vasari, *Le Vite*, ed. G.Milanesi, Vol. IV, 1879, pp. 384–5.

4 The chief source is Pliny's *Natural History*, XXXV, 10. A subject which seems to await its historian is that of painters' own treatments of the story of Apelles painting Campaspe in the presence of Alexander (by the time of Tiepolo, the painter shows himself as Apelles, Campaspe as his wife; cf. A.Morassi, *A complete catalogue of the Paintings of G.B.Tiepolo*, 1962, pp. 29–30). A useful list of pictures of the theme in A.Pigler, *Barockthemen*, 1956, II, pp. 351–3.

5 The reference published by A.Chastel, *Marsile Ficin et l'art*, 1954,' p. 320.

6 The patent published by F.Beltrami, *Cenni illustrativi sul monumento a Tiziano Vecellio*, 1852, pp. 99–103.

7 For Crivelli's patent, see F.Drey, *Carlo Crivelli und seine Schule*, 1927, p. 116.

8 Cited by J.A.Crowe and G.B.Cavalcaselle, *The Life and Times of Titian*, 1881 ed., I, p. 361.

9 *A Treatise concerning the Arte of Limning*, ed. P.Norman in *The Walpole Society*, Vol. I, 1911–12, p. 16.

10 For which see M.de Maeyer, *Albrecht en Isabella en de Schilderkunst*, 1955, p. 149, footnote 1.

11 The full text given in M.Rooses, *Rubens* (transl. H.Child), 1904, Vol. II, p. 629.

12 Quoted by C.White, *Rubens and his World*, 1968, p. 85, a book which contains a succinct and coherent account of Rubens' diplomatic involvement.

13 Cf. *Calendar of State Papers*: vol. XXII, *Venice 1629–1632*, ed., A.B.Hinds, 1919, p. 130

14 See for example what is said by F.Haskell, *Patrons and Painters*, 1963, especially pp. 18–19. For Mola's success (plus a comparison with Apelles and an early (?) reference to Leonardo dying in François I's arms) cf. L.Pascoli, *Vite de Pittori*, I, 1730, p. 122.

15 Cited by Haskell, *loc. cit.*

16 G.P.Bellori, *Le Vite de Pittori ...*, 1672, pp. 255–6.

17 See for example *The Book of the Courtier* (transl. C.S.Singleton), 1959, p. 123.

17A For this portrait and its meaning, see R.R.Wark in *Burlington Magazine*, 1956, pp. 53–4.

18 For a very full discussion of this picture, emphasising its hunting elements, see J.S.Held 'le Roi à la ciasse', *Art Bulletin*, 1958, pp. 139 ff.

19 On Van Dyck and Charles I, see especially O.Millar, *Tudor, Stuart and Early Georgian Pictures in the collection of H.M. The Queen*, 1963, pp. 16–20, and pp. 92 ff; on a more elusive yet intriguing subject, see E.Harris, 'Velázquez and Charles I', in *Warburg/Courtauld Journal* (xxx) 1967, pp. 414–20.

20 Millar, *op. cit.*, p. 84.

21 Cf. the passage cited by M.Jenkins, *The State Portrait* (College Art Association Monographs, III), 1947, p. 44, note 293.

22 For the incident, see Millar, *op. cit.*, p. 99, quoting the Savoy minister in London in 1635 that the king was '*fâché contre le peintre Vandec [sic] por ne leur avoir mis leur Tablié comme on accoustume aux petit enfans.*'

23 Cited by White, *op. cit.*, p. 104.

24 That he was '*bramoso di ritirarsi*' from painting portraits towards the end of his English career is reported by Bellori, *loc. cit.*

25 For some recent discussion, see M.Varchawskaya, 'Certains traits particuliers de la décoration d'Anvers par Rubens pour l'Entrée Triomphale de l' Infant Cardinal Ferdinand en 1635', *Bull. des Musées Royaux de Belgique* (Brussels), 1967, pp. 269 ff.

26 Poussin's letter, of 17 January 1649, was prompted partly by news of the trial of Charles I: cited by C.Sterling in the biography appended to the catalogue of the exhibition, *Nicolas Poussin*, Paris, May-July 1960, pp. 258–9.

27 For the general court atmosphere at Madrid, see M.Hume, *The Court of Philip IV*, 1928 ed.; the steps by which Velázquez rose at court are given by J.M. de Azcárate in *Archivo Español*, Oct.-Dec, 1960, pp. 357 ff.: '*Noticias sobre Velázquez en la corte.*' In sensitivity and historical detail (whatever advances connoisseurship has made), nothing probably equals K.Justi, *Diego Velázquez und sein Jahrhundert* (1st ed. 1888); there is an English translation by A.H.Keane, *Diego Velázquez and his times*, 1889, revised by the author. Easily overlooked but sympathetic is F.Saxl 'Velázquez and Philip IV', *Lectures*, 1957, I, pp. 311 ff. Considerable discussion of Velázquez's environment, as well as a catalogue raisonné, in J.López-Rey, *Velázquez*, 1963.

28 Cited by Justi, *op. cit.*, English ed., 1889, p. 478.

29 Azcárate, *loc. cit.*, p. 358.

30 For a discussion of the dialogues, see G. Kubler, 'Vicente Carducho's Allegories of Painting' in *Art Bulletin*, 1965, pp. 439 ff. It is surely Philip IV who is attacked by implication in the openly anti-Spanish Guez de Balzac's *le Prince* (1631) when he claims that, unlike some princes, Louis XIII is not one who spends his time painting; cf. P.Watter, 'Jean Louis Guez de Balzac's *le Prince* – A Revaluation', *Warburg/Courtauld Journal*, (XX) 1957, p. 239, note 57.

31 It is established that the subject if not composition was painted by Velázquez, cf. López-Rey, *op. cit.*, p. 199 (no. 205); he accepts the picture reproduced as a studio work 'of about 1636', possibly with Velázquez' participation.

32 *A General System of Horsemanship* (transl.), 1743, p. 18; quite seriously he speaks elsewhere (p. 34) of 'your great philosophers in horsemanship …'

33 Hume, *op. cit.*, p. 280.

34 For it most recently, see the *Jacob Jordaens* exhibition catalogue (by M.Jaffé), Ottawa, 1968, no. 88 (pp. 123–4). Mercury and Mars, who are present, could have their relevance for the rider as well as for the horses.

35 Detailed identifications, and several references to the sport being practised, are provided by N.MacLaren, *The Spanish School* (National Gallery Catalogues), 1952, pp. 79–80.

36 Quoted in this connection by O.Millar, *Rubens: The Whitehall Ceiling* (Charlton Lecture), 1958, p. 16.

37 Hume, *op. cit.*, p. 510.

38 Quoted by E.Cassirer, *The Myth of the State*, 1946, p. 186.

39 The whole conversation is given by M.E.J. Delécluze, *Louis David, son Ecole et son Temps*, 1855, p. 232.

5 A Hero to his Painters

1 The anecdote, given in W.Chappell's *History of Music*, 1874, is quoted by B.C.Hilliam in an article in *The Times Saturday Review*, 3 August 1968.

2 Further for this painting (of 1788) and the whole Edward III series, see O.Millar, *The Later Georgian Pictures in the collection of H.M. The Queen*, 1969, pp. 132–5.

3 A passing reference, which hardly does justice to the engraving, in the altogether somewhat inadequate R.Lanson, *Le Goût du Moyen Age en France au XVIIIe Siècle*, 1926, p. 47.

4 Further cf. Millar, *op. cit.*, p. 149.

5 For this, and the theme in general, see M. Jallut, *Marie-Antoinette and her Painters* (Paris; n.d.), p. 46.

6 *Viz.* the very young Duc de Montpensier (later Duc d'Orléans), signed and dated 1749, the portrait at Waddesdon; cf. E.K.Waterhouse, *The James A. de Rothschild collection at Waddesdon Manor: Paintings*, 1967, no. 94.

7 See the comments of H.Swinburne, *Travels through Spain in the years 1775 and 1776*, 1779, pp. 334–5.

8 For Hersent's picture within the context of the painted image of Virtue, see R.Rosenblum, *Transformations in late Eighteenth Century Art*, 1967, pp. 101–2. It should be mentioned that Marie-Antoinette had more than once been depicted in her lifetime involved in a '*trait de la bienfaisance*'; see particularly Jallut, *op. cit.*, pp. 18–20.
A '*trait de bienfaisance*' by Louis XVI was painted also by Debucourt in 1785, but D'Angiviller required the king's likeness to be suppressed; cf. letters in J.J.Guiffrey, *Notes et Documents inédits sur les Expositions du XVIIIe siècle*, 1873, pp. 74–6.

9 For Pigalle's letter, which contains this phrase, see L.Réau, *J.B.Pigalle*, 1950, pp. 53–4.

10 On this point see, for example, M.R.Scherer, *Marvels of Ancient Rome*, 1956, p. 135.

11 On Versailles and Louis XIV the literature is daunting; a succinct bibliography, as well as a coherent account, is available in A.Blunt, *Art and Architecture in France 1500–1700*, 1957 ed., pp. 183 ff.

12 The anecdote is from Johnson's life of Prior in the *Lives of the English Poets*, quoted by O.Millar, *Tudor, Stuart and Early Georgian Pictures in the collection of H.M. The Queen*, 1963, p. 24.

13 Several versions of this portrait exist (one or more at Versailles) but none seems quite as splendid and elaborate as the prime composition recorded by the line engraving, reproduced here, from *le Pausanias Français* of 1806.

14 Quoted in P.Lelièvre, *Vivant Denon, Directeur des Beaux-Arts de Napoléon*, 1942, p. 29, following F.Benoit, *L'Art Français sous la Revolution et l'Empire*, 1897, p. 7.

15 Lelièvre, *op. cit.*, p. 96.

16 Lelièvre, *op. cit.*, p. 66. Perhaps the most perceptive and moderate of all comments on Napoleonic patronage are those of Delécluze, *Louis David, son Ecole et son Temps*, 1855, pp. 317 ff., when discussing Vivant Denon and the style of official commissioned picture, '*comme une espèce de Moniteur visible où le fait représenté captivait toute l'attention.*' He prints (pp. 321–2) the list of pictures presented for prizes in 1810, which well brings out the Napoleonic aspect of the 'national' category of painting.

17 An interesting contemporary reference to this portrait comes from C.R.Leslie, *Autobiographical Recollections*, ed. T.Taylor, 1860, Vol. II, p. 15, in a letter of 6 August 1812 to his sister: 'I have just heard that David has finished the most excellent likeness of Bonaparte that ever was painted …'

18 For the vivid characterisation of this portrait, and reference to some prototypes for it, see R.Rosenblum, *Ingres* (n.d. but 1968), p. 68.

19 The catechism quotations are given in P.Geyl, *Napoleon: For and Against*, 1965 ed., p. 113. The whole book is an entertaining and devastatingly effective revelation of the Napoleonic myth, as much as of the man.

20 Reproduced amid other absorbing material, by J.C.Herold, *The Age of Napoleon*, 1963, p. 401.

20A *Girodet* ex., Montargis, 1967, (under 1812).

21 Lelièvre, *op. cit.*, p. 39.

22 On this aspect, see W.Friedlaender, 'Napoleon as Roi Thaumaturge'; *Warburg/Courtauld Journal*, Vol. IV, 1940–1, pp. 139 ff.

23 Gillray's cartoon is reproduced in J.C.Herold, *op. cit.*, p. 387.

24 Delécluze, *op. cit.*, p. 313.

25 That Napoleon should himself crown Josephine was, from the first, planned as part of the actual coronation ceremony; cf. F.Masson, *Napoleon and his Coronation* (transl. F.Cobb), 1911, p. 202. The detail of David's picture may be compared with the detailed attention Napoleon had given to such *minutiae* of the ceremony as the slippers which he should wear for the *Sacre*; several models (including 'une sandale à la romaine') were produced and the final white velvet slippers were designed by Isabey; cf. A.Maze-Sencier, *Les Fournisseurs de Napoléon Ier …*, 1893, p. 43 and *passim*.

26 However, Napoleon's coronation oath makes a piquant contrast to that of the restored Bourbon Charles X (Louis XVIII never underwent the *Sacre*); both are cited by the Abbé

Quéant, *Le Sacre, études historiques, philoso-phiques et religieuses*, 1868, pp. 125, and 127.

27 For this picture by Lafond, 'Sa Majesté l'Impératrice, entourée des enfants dont elle a secouru les mères,' see R.Rosenblum, *Transformations in late Eighteenth Century Art*, 1967, p. 101 (and fig. 106).

28 The letter is quoted by L.Hautecoeur, *Louis David*, 1954, pp. 210–11; the painting was to be one of the series to accompany the *Sacre*, the *Arrival of the Sovereign at the Hôtel de Ville*, for which a brilliant drawing (Louvre) survives.

29 Cf. S.Grandjean, *Inventaire après décès de l'Impératrice Joséphine à Malmaison*, 1964, p. 158 (no. 1139). C.P.Landon's *Salon de 1808*, Vol. I, p. 99, says that '*une personne au plus haut rang a même désiré en avoir un second semblable en tout à celui-ci*': one or other version was obviously for Josephine.

30 For these aspects of his work, see A.Brookner, 'Prudhon: Master Decorator of the Empire', *Apollo*, Sept. 1964, pp. 192 ff.

31 The incident is discussed in D.Creston, *In Search of Two Characters (Some Intimate Aspects of Napoleon and his Son)*, 1947, pp. 195–6; the *bon-bonnière* is reproduced in the catalogue of the exhibition *Napoléon*, Grand Palais, Paris, June–Dec. 1969, under no. 580.

32 See her comments in *Leaves from a Journal*, ed. R.Mortimer, 1961, pp. 84–5; Queen Victoria's steady interest in Napoleon himself clearly emerges from this *Journal*, in part the record of her visit to Paris in 1855.
The original Ingres ceiling picture at the Hôtel de Ville was burnt in 1871; only the oil sketch reproduced and some drawings survive. See further G.Wildenstein, *Ingres*, n.d. (1954?), p. 224 (nos. 270 and 271).

N.B. Since this chapter was drafted, see also in general the exhibition catalogue, *Napoléon dans sa légende*, Musée Paul Dupuy, Toulouse, 1969, and *The Taste of Napoleon*, Kansas City, Oct.–Nov. 1969.

6 At Home at Court

1 For this aspect of kingship, see E.H.Kantorowicz, *The King's Two Bodies*, 1957, pp. 47 ff.
2 *The Rights of Man* (Everyman ed.) 1944, p. 19.
3 Cited by E.Longford, *Victoria R.I.*, 1966 ed., p. 711, a book which has generally been much utilised for this chapter.
3A The nearest approach to such a concept is Dyce's fresco at Osborne of *Neptune resigning the empire of the sea to Britannia*.
4 *Punch*, Vol. VI, 1844, p. 209.
5 George Moore, *Modern Painters*, n.d. but 1893, p. 141.
6 Turner himself, so rarely to be found expressing his views, wrote, 'To have no choice but that of the patron is the very fetter upon genius that every coxcomb wishing to resist by choice should even a beggar stand alone. This stand is mine and shall remain my own.' This annotation to Archer Shee's *Elements of Art* is quoted by J.Ziff, ' "Backgrounds, Introduction of Architecture and Landscape": A

lecture by J.M.W.Turner,' *Warburg/Courtauld Journal*, (XXVI) 1963, p. 132, note 26.
7 This is an interesting indication perhaps of how far her childhood had by then receded in her thoughts, for it was at Ramsgate in 1835 that the then Princess had struggled desperately with typhoid and the pressure put on her by Sir John Conroy; see E.Longford, *op. cit.*, pp. 61–2.
8 A.G.Temple, *The Art of Painting in the Queen's Reign*, 1897, p. 153.
9 Winslow Ames, *Prince Albert and Victorian Taste*, 1967, p. 215.
10 *Academy Notes: The Works of John Ruskin*, ed., E.T.Cook and A.Wedderburn, 1904, Vol. XIV, p. 162.
10A *Ariadne Florentina: The Works* ..., Vol. XXII, pp. 388–9.
11 Cf. M.Lucas, *Two Englishwomen in Rome, 1871–1900*, 1938, p. 2, note 1, recording that the picture was so discovered and moved from the church to the Lateran palace, 'thanks to old Mr Severn' (viz. Joseph Severn, who had accompanied Keats to Rome in 1820).
12 For this picture, see O.Millar, *Later Georgian Pictures in the collection of H.M. The Queen*, 1969, no. 1180.
13 Further, see Millar, *op. cit.*, no. 1188 (with key to all the sitters).
14 The reference is positively to Landseer's pictures: E.Longford, *op. cit.*, p. 269.
15 The Queen later in life was most reluctant to purchase a portrait of Charles II; though she was persuaded, she annotated her approval with the comment that she did not care for that king: Ames, *op. cit.*, p. 19.
16 The italics are presumably the Queen's own; the text is given in *The Letters of Queen Victoria*, 1908 ed., Vol. II, p. 27.
17 The Prime Minister was Lord John Russell; E.Longford, *op. cit.*, p. 247.
18 For this, and further for the picture, see Ames *op. cit.*, pp. 139–140.
19 *Leaves from a Journal*, ed. R.Mortimer, 1961, p. 85.
The picture captures that 'fairy queen' aspect which Queen Victoria herself noted in the Empress (see the text further), and also solves the problem of portraying a non-royal Empress someone whose realm was to prove of fairy-like insubstantiality.
20 The drawing is reproduced in Mortimer, *op. cit.*, facing p. 48.
21 For the Prince's artistic interests, most recently, and favourably, see Ames, *op. cit.*; this, in effect, follows up, as well as filling out, the hints provided by J.Steegman, *Consort of Taste: 1830–1870*, 1950, who remarked (p. 317) that no historian had yet dealt with the Prince's 'activities in the field of art'.
22 See the *William Dyce R.A.* exhibition catalogue, Aberdeen and London (Agnew's) 1964, no. 23 (Pl. IV): bought from the painter by Prince Albert.
23 A.Cunningham, *The Life of Sir David Wilkie*, 1843, Vol. III, p. 235.
24 Further for this picture, cf. Millar, *op. cit.*, no. 1184.
25 The picture is Millar, *op. cit.*, no. 1187. There

seems some fancy element in the picture (Prince Leopold being dressed in armour, for instance) but it is just possible that it was intended for either William IV or Queen Adelaide, perhaps in connection with one of their birthdays rather than Princess Victoria's own. On the other hand, the prominence of the Duchess of Kent seems to make a commission from them not very likely and an alternative occasion might be the children's ball given by George IV in 1828, during the state visit of the child Queen of Portugal.
26 *The Letters of Queen Victoria* (1st series), 1908, Vol. I, p. 86.
27 It is possible to document Grant's awareness of prototypes, notably in Velázquez: a pen and ink copy by him (s. and d. 1829) of Velázquez's equestrian portrait of Olivares (Prado) was in the Dropmore sale, 18 March (1st day) 1969 (lot 178).
28 In technique as well as subject matter; perhaps Landseer and his royal patrons had been studying the pictures by Zoffany in the royal collection.
29 Unpublished *Journal* for 2 Oct. 1845, quoted in the exhibition catalogue *Landseer*, Royal Academy, 1961, under no. 95 (p. 20).
30 Queen Victoria's *Journal* for 1 Oct. 1873: *The Letters of Queen Victoria* (2nd series), 1926, Vol. III, pp. 282–3. In the same entry the Queen notes the last time she had seen Landseer, and how terrible he had then looked.
31 Quoted by J.A.Manson, *Sir Edwin Landseer, R.A.*, 1902, p. 169.
32 W.P.Frith, *My Autobiography and Reminiscences*, 1887, Vol. I, p. 337.
33 E.Longford, *op. cit.*, p. 441.
34 *The Reign of Queen Victoria*, 1887, Vol. II, pp. 558–9.
35 Advanced students may care to go on from this work to *The Prince of Wales Book (A Pictorial Record of the Voyages of H.M.S. Renown 1919–1920)*, n.d., though the photographs are no longer taken by a royal hand.

LIST OF ILLUSTRATIONS

Black and white illustrations

Colour plates

ACKNOWLEDGMENTS

The author and the publishers wish to express gratitude to all the owners of works of art reproduced here. They are particularly indebted to H.M. The Queen for graciously giving permission for the reproduction of several works in the Royal Collection, to H.M. The Queen Mother and also to the Trustees of the Grosvenor Estate.

Numbers refer to pages.

Colour plates

Black and white illustrations

225

ACKNOWLEDGMENTS

Prague: National Gallery 26, 35, 36, 39, 40, 41
 St Vitus Metropolitan Cathedral Library 34
 Karlštejn Castle 25, 30 (3), 37
Rome, Vatican Museum and Galleries 75, 83 (2), 84, 86, 88, 89, 101 (top)
Scotland, National Galleries of 172
Siena, Cathedral, Piccolomini Library 85
 Palazzo Pubblico 72
Stockholm, National Museum 156 (bottom)
Toledo, U.S.A. Museum of art 98 (Gift of Edward Drummond Libby, 1913)
Trento, Superintendent of Monuments and Galleries 50, 51
Turin, Galleria Sabauda 131
Urbino, Palazzo Ducale 47 (top)
Versailles, Château de 163 (Cliché des Musées Nationaux), 166
Vienna, Austrian National Library 32, 91, 92
 Kunsthistorisches Museum 121, 124, 137, 150
Washington D.C., National Gallery of Art (Samuel H.Kress Collection) 106, 130, 169

They also wish to thank all those listed below
who have contributed photographs.

Alinari 47, 55 (2), 60, 61, 65 (2), 66, 67, 69 (above, below right), 71, 77, 97 (bottom), 99, 101 (bottom),
 103, 110, 111, 112, (2), 131
Antonin Blaha 33
Foto Bulloz 158
J.Camponogara 160
A.C.Cooper Ltd. 97, 154, 156 (top), 186, 188, 191 (top), 192, 194, 195, 196 (top)
Courtauld Institute of Art 23, 24, 126, 141
Mary Evans Picture Library 207
Françoise Foliot 96, 155, 161, 173
John R.Freeman 56 (bottom), 118, 125, 185
Gabinetto Fotografico 55 (top), 87, 101 (bottom), 104, 109
Giraudon 14, 28, 46, 76, 168, 176 (top right)
Photo Hutin 196 (bottom)
Konrad Keller 178
Mansell Collection 83 (2), 84, 85, 86, 87, 88, 166
Bruno Novarese 54
Panora Ltd. 202
Foto Rensi 50, 51
Scala 44, 69 (bottom, left), 70, 73
Tom Scott 172
Urheberrecht des Fotos 17

INDEX OF PERSONS